FUGITIVE CULTURES

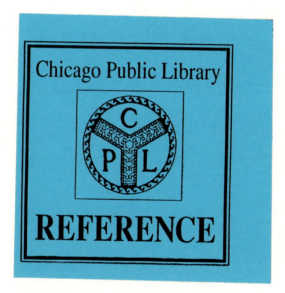

FUGITIVE CULTURES:

RACE,

VIOLENCE,

AND YOUTH

HENRY A. GIROUX

ROUTLEDGE NEW YORK LONDON

Published in 1996 by

Routledge
29 West 35th Street
New York, NY 10001

Published in Great Britain in 1996 by

Routledge
11 New Fetter Lane
London EC4P 4EE

© Routledge 1996

Printed in the United States of America on acid-free paper

Library of Congress Cataloging-in-Publication Data

Giroux, Henry A.
Fugitive Cultures : race, violence, and youth / by Henry A. Giroux.
p. cm.
Includes bibliographical references and index.
ISBN 0-415-91577-5 (cloth). ISBN 0-415-91578-3 (pbk.)
1. Youth—United States—Social Conditions. 2. Mass media and
youth—United States. 3. Popular Culture—United States. 4. Working
class—United States. 5. United States—Race relations. 6. Multicultural-
ism—United States. I. Title.
HQ796.G526 1996 95-50495
305.2'35'0973—dc20 CIP

TABLE OF CONTENTS

To Susan

ACKNOWLEDGMENTS

A number of people read different versions of this manuscript as I was putting it together. I am especially grateful to Susan Searls who read and edited the manuscript in its entirety. I am also grateful to Donaldo Macedo, my "brother," for his unwavering emotional and intellectual support. I also want to thank my former graduate assistant, Uriel Grunfleld, for his enormous help in researching this work. I am grateful to Ron Bettig for letting me examine his files on Disney's financial holdings. Thanks to David

Theo Goldberg, Larry Grossberg, Doug Kellner, Stanley Aronowitz, Pepi Leistyna, Carol Becker, Harvey Kaye, David Trend, bell hooks, Stephen Haymes, Candace Mitchell, Joe Kincheloe, Shirley Steinberg, Jeffrey Nealon, Bernard Bell, Abdellatif Khayati, Michael Ludwig, Jon Epstein, Peter McLaren, Barry Kanpol, Kostas Myrsiades, Jerry McGuire, Roger Simon, and Valerie Janesick for their help and criticisms. Of course, I am solely responsible for any shortcomings in the manuscript. I am also grateful to Northeastern University, especially Jim Fraser and Jane Scarborough, for providing me with research funding through the Asa A. Knowles Chair Professorship in order to enable me to finish the book during the summer of 1995. I would also like to thank my editor, Jayne Fargnoli, for supporting this project from the beginning. Her help has gone far beyond the demands of her job. Paul Williams from Routledge was especially helpful in encouraging me to develop the chapter on radio pedagogy. Finally, I would like to thank my children, Jack, Brett, and Chris Giroux, who put up with a dad who plagued them with endless questions and made me realize how powerful popular culture is in shaping children's culture in the United States.

Earlier and much different versions of some of these essays have appeared in *Social Identity*, *Harvard Educational Review*, *Socialist Review*, *Art Papers*, *Educational Forum*, *College Literature*, and *The Minnesota Review*.

Introduction

Introduction:

The kids

aren't

YOUTH, PEDAGOGY, AND CULTURAL STUDIES

Alright

A s a concept, youth represents an inescapable intersection of the personal, social, political, and pedagogical. Beneath the abstract codifying of youth around the discourses of law, medicine, psychology, employment, education, and marketing statistics, there is the lived experience of being young. For me, youth invokes a repository of memories fueled by my own journey through an adult world that was in the way, a world held together by a web of regulations and restrictions that were more oppressive than liberating.

Lacking the security of a middle-class childhood, my friends and I seemed suspended in a working-class culture that neither accorded us a voice nor guaranteed economic independence. Identity didn't come easy in my neighborhood. It was painfully clear to all of us that our identities were constructed out of daily battles waged around masculinity, the ability to mediate a terrain fraught with violence, and the need to find an anchor through which to negotiate a culture in which life was fast and short-lived. I grew up amid the motion and force of mostly working-class male bodies—bodies asserting their physical strength as one of the few resources we had control over.

Dreams for the youth of my Smith Hill neighborhood were contained within a limited number of sites, all of which occupied an outlaw status in the adult world: the inner-city basketball court, located in a housing project, which promised danger and fierce competition; the streets on which adults and youth collided as the police and parole officers harassed us endlessly; the corner drug store where talk was quick and frequently hazardous; the New York System hole-in-the-wall restaurant operated by a guy who always had ten "hot dogs" and buns in various stages of preparation on his arm on a Saturday night waiting for us to do business after a night of hanging out, drinking, and dancing.

For many of the working-class youth in my neighborhood, the basketball court was one of the few public spheres in which the cultural capital we took seriously could be exchanged for respect and admiration. If you weren't good enough you didn't play, and if you were good you performed with a kind of humility arbitrated by a code that suggested you didn't lose easily. Nobody was born with innate talent. Nor was anybody given instant recognition. The basketball court became for me a site of passage and a referent for developing a sense of possibility. We played day and night and we played in any space that was available. Even when we got caught breaking into St. Patrick's Elementary School one Friday night around 1:00 A.M., the cops who found us knew we were there to play basketball rather than to steal money from the teachers' rooms or Coke machine. Basketball was taken very seriously because it was a neighborhood sport, a terrain where respect was earned. It offered us a way out that seemed to fly in the face of the need for high status, school credentials, or the security of a boring job.

With the exception of a talented few, the promise of the basketball court evaporated when high school ended and the young men in the

neighborhood moved from school to any one of a number of dead-end jobs. The best opportunities came from taking a civil service test, and if one were lucky one got a job as a policeman or fireman. Job or no job, one forever feels the primacy of the body: the body flying through the rarefied air of the neighborhood gym in a kind of sleek and stylized performance; the body furtive and cool existing on the margins of society filled with the possibility of instant pleasure and relief, or tense and anticipating the danger and risk; the body bent by the weight of grueling labor.

The body, with its fugitive status within working-class culture, allowed us to cross racial borders and rewrite the endemic racism of our white, working-class neighborhoods. We were white boys, and race and class positioned our bodies in turf wars marked by street codes that were both feared and respected. At the age of eight, I became a shoeshine boy and staked out a route inhabited by black and white nightclubs in Providence, Rhode Island. On Thursday, Friday, and Saturday nights I started my route about 7:00 P.M. and got home around 12:00 A.M. I loved going into the bars watching adults dance, drink, steal furtive glances from each other. Most of all I loved the music. Billie Holiday played in the background against the sound of glasses clinking, men and women talking and talking as if their only chance to come alive was compressed into the time they spent in the club. Whenever I finished my route, I had to navigate a dangerous set of streets to get back home. I learned how to talk, negotiate, and defend myself along that route. I was too skinny as a kid to be a tough guy; I had to learn a street code that was funny but smart, fast but not insulting. That's when my body and head starting working together.

I saw too much in that neighborhood and I couldn't seem to learn enough to make sense of it or escape its pull. Peer groups formed early and kids ruptured all but the most necessary forms of dependence on their parents at a very young age. I saw my parents when I went home to eat or sleep. We all left home too early to notice the loss until later in life when we became adults or parents ourselves.

Leaving home for me was made all the more complicated because my mother had severe epilepsy and had repeated seizures. My sister and I were not distant observers to my mother's suffering—we often had to hold her down in bed when the seizures erupted. Shuffled between hospitals and institutions, my mother wasn't home much. As a result of my mother's absence, my sister was taken away by the social services and

placed in a Catholic residence for girls. Losing my sister to an orphanage, I experienced for the first time what it meant to be homeless in my own home. As with many working-class youth, home was neither a source of comfort nor a respite from the outside world. The neighborhood was home, and my friends provided the sanctuary for talk and security along with a cool indifference to the fact that none of us looked forward to the future. When I was in high school, I remember visiting my mother in state hospitals and being alarmed at the fact that many of the attendants were guys from my neighborhood, guys who seemed dangerous and utterly indifferent to human life, guys that I both knew and avoided. Everybody was warehoused in that neighborhood irrespective of age.

I eventually left my neighborhood, but it was nothing less than a historical accident. I never took the requisite tests to apply to a four-year college. When high school graduation came around, I was offered a basketball scholarship to a junior college in Worcester, Massachusetts. It seemed better to me than working in a factory, so I went off to school with few expectations and no plans except to play ball. I was placed in a business program but had no interest in what the program offered. The culture of the college seemed terribly alien to me, and I missed my old neighborhood. After violating too many rules and drinking more than I should have, I saw clearly that my life had reached an impasse. I left school and went back to my old neighborhood hangouts.

My friends' lives had already changed. Their youth had left them and they now had families and lousy jobs and spent a lot of time in the neighborhood bar waiting for a quick hit at the racetrack or the promise of a good disability scheme. After working for two years at odd jobs, I managed to play in the widely publicized Fall River basketball tournament and did well enough to attract the attention of a few coaches who tried to recruit me. Following their advice, I took the SATs and scored high enough to qualify for entrance into a small college in Maine that offered me a basketball scholarship. But nothing came easy for me when it came to school. Although I made the starting lineup on the varsity and managed to be the team high-scorer my freshman year, the coach resented me because I was an urban kid—too flashy, too hip, and maybe too dangerous for the rural town of Gorham, Maine. I left the team my sophomore year, took on a couple of jobs to finance my education, and eventually graduated with a degree in secondary education.

After getting my teaching certificate, I became a community organizer and a high school teacher. Worn thin after six years of teaching high school social studies, I applied for and received another scholarship, this one to attend Carnegie-Mellon University. I finished my course work early and spent a year unemployed while writing my dissertation. I finally got a job at Boston University. Again politics and culture worked their strange magic as I taught, published, and prepared for tenure. My tenure experience changed my perception of liberalism forever. Thinking that if I worked hard at teaching and publishing I would easily get tenure, I did my best to follow the rules. I was dead wrong about the rules and the alleged integrity of the tenure process.

Having published fifty articles, two books, and given numerous talks, I went through the tenure process unanimously at every level of the university. I was finally denied tenure by John Silber, President of Boston University, who not only ignored the various tenure committee recommendations but solicited letters supporting denial of my tenure from notable conservatives such as Nathan Glazer and Chester Finn. Glazer's review was embarrassing in that it began with the comment, "I have read all of the work of Robert Giroux." The Dean of Education had threatened to resign if I did not receive tenure. Of course, he didn't. Silber's actions had a chilling effect on many faculty who had initially rallied to my support. Slowly, over the course of the year, they backed away from challenging Silber, realizing that the tenure process was a rigged affair and that anyone who complained about it might compromise their own academic career. One faculty member apologized to me for his refusal to meet with Silber to protest my tenure decision. Arguing that he owned two condos in the city, he explained that he couldn't afford to act on his conscience since he would be risking his investments. Of course, his conscience took a back seat in his list of assets.

By the time I met Silber to discuss my case, I was convinced that my fate had already been decided. Silber met me in his office, asked me why I wrote such "shit," and made me an offer. He suggested that if I studied the philosophy of science and logic with him as my personal tutor, I could maintain my current salary and would be reconsidered for tenure in two years. The only other catch was that I had to agree not to write or publish anything during that time. I was taken aback, and responded with a joke by asking him if he wanted to turn me into George Will. He missed the

humor, and I left. I declined the offer, was denied tenure, and after send-
ing off numerous job applications finally landed a job at Miami University.
Working-class intellectuals do not fare well in the culture of higher edu-
cation, especially when they are on the left. I have been asked many times
since this incident whether I would have continued the critical writing
that has marked my career if I had known that I was going to be fired
because of the ideological orientation of my work. Needless to say, for me,
it is better to live standing up than on one's knees. Maybe the lesson here
is that the success that many working-class kids achieve in this culture may
be more accidental than the result of an unswerving commitment to the
ethic of hard work and individual responsibility.

My kids can't quite understand the stories I tell them about my youth,
with its working-class traditions—its sexism, racism, and violence, along
with its emotional intensity, sense of community, solidarity, and most of
all loyalty. My kids go to public schools inhabited by mostly white,
middle-class children and teachers. My history seems strange and alien to
them, with its references to fugitive knowledge, cultures, and relation-
ships. All of the institutions they inhabit offer a measure of comfort and
affirmation; but for the youth of my neighborhood, schools and other
mainstream public spaces both positioned and excluded us. As an outlaw
culture, we were labeled as alien, other, and deviant because we were from
the wrong culture and class. Class marked us as poor, inferior, linguisti-
cally inadequate, and dangerous. We were feared and denigrated more than
we were affirmed, and the testimony of being part of a fugitive culture
penetrated us with a trauma that we could hardly navigate theoretically
but felt in every fiber of our being.

The term, fugitive culture, designates less a rigid cultural formation
than it does a conflicting and dynamic set of experiences rooted in a
working-class youth culture marked by flows and uncertain interventions
into daily life. Such experiences were often both oppressive and resisting,
scorned and feared, constrained by the dictates of poverty but unafraid of
risk-taking inventiveness. The working-class culture in which I grew up
wore its fugitive status like a badge, but all too often it was unaware of the
contradictions that gave it meaning. We weren't smart enough to see the
contradiction between the brutal racism, violence, and sexism that marked
our lives and our constant attempts to push against the grain by investing
in the pleasures of body, the warmth of solidarity, and the appropriation

of neighborhood spaces as outlaw publics. As kids, we were border crossers and had to learn to negotiate the power, violence, and cruelty of the dominant culture through our own lived histories, restricted languages, and narrow cultural experiences. Recognizing our fugitive status in all of the dominant institutions in which we found ourselves—including schools, the workplace, and social services—we were suspicious and sometimes vengeful of what we didn't have or how we were left out of the representations that seemed to name American youth in the 1950s. We hated Pat Boone, tennis, and prep schools, and lost ourselves in the grittiness of working-class neighborhood gyms, abandoned cars, and street corners that offered a haven for escape but also invited police surveillance and brutality. Being part of a fugitive culture meant that we lived almost exclusively on the margins of a life that was not of our choosing. And as for the present, it was all we had since it made no sense to invest in a future that for many of my friends either ended too early or pointed to the dreaded possibility of becoming an adult, which usually meant working in a boring job by day and hanging out in the local bar by night. We bore witness to the future only to escape into the present, and the present never stopped pulsating. Like all fugitive cultures embraced by youth, we were time-bound. The memory work would have to come later.

Bearing witness always implicates one in the past and gives rise to conditions that govern how youth act and are acted upon within a myriad of public sites, cultures, and institutions. Shoshana Felman and Dori Laub have suggested that the practices of witnessing and testimony lie at the heart of what it means to teach and to learn. Witnessing and testimony, translated here, mean listening to the stories of others as part of a broader responsibility to engage the present as an ethical response to the narratives of the past. I have often wondered how my own formation as a young person and border crosser, moving often without an "official passport" between cultures, ideologies, jobs, and fugitive knowledges, might be invoked as a form of bearing witness. How might the testimony I give help me to interrogate my own shifting location as a critical educator, but also provide for my children the pedagogical conditions in which they can understand the complexity and significance of the different conditions that have shaped my history, theirs, and those of other youth in this society? Through bits and pieces of exchange with my children, they have slowly heard the testimony of how my youth was constructed in sharp counter-distinction to

how theirs is being shaped. The pedagogical challenge that emerges out of this interaction proposes that "if teaching does not hit upon some sort of crisis, if it does not encounter either the vulnerability or the explosiveness of a (explicit or implicit) critical and unpredictable dimension, it has perhaps not truly taught."[1] The crisis in this instance is about youth as a social and political category in an age of increasing symbolic, material, and institutional violence, and the crisis of youth is represented through the imagery and discourse of popular culture. I don't believe that George Lipsitz overstates the nature and uniqueness of such a crisis in his comment: "Our time is a time of crisis for youth, a time of unprecedented damage and danger to young people. Since the 1970s, deindustrialization, economic restructuring and a resurgence of racism have created fundamentally new realities for young people."[2]

As a metaphor for historical memory and a marker that makes visible the ethical and political responsibility of adults to the next generation, youth is both an enabling and disabling category. Youth haunts adult society because it references our need to be attentive to a future that others will inherit. It simultaneously serves as a symbol of how a society thinks about itself and as an indicator of changing cultural values, sexuality, the state of the economy, and the spiritual life of a nation. My own concern with writing this book is rooted in both of these considerations. As the single father of three young boys, I am not merely concerned about their future, as important and frightening as the thought is at times. I am equally concerned about the symbolic world they inhabit and how this world of mainstream and popular culture hails them to think about history, race, violence, and the conditions of their own moral and political agency. At the same time, I have been extremely interested in how youth has become a central focus in the attack waged by the New Right against subordinated public cultures, especially those occupied by young single mothers on welfare, poor inner-city youth, black youth, gays and lesbians, and working-class students. In part, the deepening crisis in democracy is revealed by a systemic attack on those groups who occupy a fragile if marginal location in the structures of power that command the American economy and its various cultural apparatuses.[3]

For the purposes of this book, youth is a personal, historical, and social construction that operates under many signs. It is an empty signifier whose complex meanings and representations are produced and expressed in a variety of sites and through a number of determinations. Clearly, the con-

struction of youth is no longer limited to the primary areas of schooling and the family. Diverse in its desires, marked by a continuum of lifestyles, and negotiated within and across a range of class, racial, gender, and sexual orientations, youth formations inhabit many fronts ranging across the cultures of the mall, computer bulletin boards, rock music, gangsta rap, urban basketball courts, hacker coffee shops, and an urban underground where sex is traded, drugs exchanged, politics created, and sexuality expressed. These are sites of fugitive cultures not because they are inherently oppositional, which is often not the case in the most politically progressive sense, but because they often do not conform to the imperatives of adults and mainstream culture. Youth as a self and social construction has become indeterminant, alien, and sometimes hazardous in the public eye. A source of repeated moral panics and the object of social regulation, youth cannot be contained and controlled within a limited number of social spheres. Youth cultures are often viewed in the popular press as aberrant, unpredictable, and dangerous in terms of the investments they produce, social relations they affirm, and the anti-politics they sometimes legitimate. Contemporary youth, especially from the inner city, increasingly signify for the mainstream public an unwarranted rejection of an idealized past, a homogeneous culture, and an evangelical Christian future. In spite of themselves, the influences that shape youth are coded in the popular press as the antithesis of the values expressed in the blockbuster film *Forrest Gump* (1995), with its attempt to substitute for the hypocrises and mistakes of the American past a nostalgic rendering of history, a sycophantic version of citizenship, and a prescription for anti-intellectualism that reads like an advertisement for the right-wing moral majority. Historical amnesia has become a hallmark of the politics of the New Right, and meanspiritedness the defining principle behind policies constructed as part of a response to the current moral panic over youth, especially youth who constitute the urban poor and nonwhite in our inner cities.

This book is not written to simply affirm that many groups of youth in this country are at risk; instead, it attempts to reclaim the importance of critical pedagogy as an eminently political discourse and practice. It does so by engaging how youth are being constructed differently within a popular culture that is both oppressive and resistant, filled with democratic possibilities and yet deadly serious in representing violence as a legitimate practice to define one's identity and negotiate the terrain of

everyday life. Media and popular culture represent a terrain in which violence registers symbolically with the portrayal of black youth, women, and many of those who occupy marginal locations, fugitive spaces, in the broader context of political and social life.

I will also make a case in this book for making pedagogy one of the defining principles in addressing children's culture, and for making cultural studies a primary area through which to analyze how youth as a social category is constructed within various contexts and spheres of popular culture. Cultural studies is one of the few fields that provides an interdisciplinary approach to youth cultures and popular culture. Moreover, it has the potential to bring together cultural workers and educators across a variety of sites of learning, including but not limited to the university. Finally, it provides the possibility for affirming the necessity of politics and theory as central to educational work, while offering a polycentric, transcultural, and decentered understanding of how politics should be engaged, used, and transformed. In what follows, I will develop briefly some of these theoretical considerations as an introduction to the central preoccupations of the book.

THE CRISIS OF YOUTH

Youth in the United States appear increasingly caught between two related historical moments. The first springs from the cultural and economic institutions of modernism. Held hostage to the bankrupt reality of modernization, many youth find themselves facing an economic future in which there will be an excess of service jobs but few viable economic opportunities. Such opportunities will be needed to propel large numbers of youth, with the exception of the most privileged, into a future often associated with a middle-class dream of home ownership, a comfortable lifestyle, and job security. The dreams of a better life that were on the horizon for earlier generations of youth appear dysfunctional within a declining economy that condemns a vast number of working-class white and black youth to minimum-wage, low-skill, part-time work. Youth between the ages of fifteen and twenty-nine not only have the highest unemployment rate in the labor market, but polls further indicate "that 75% think they will be worse off than their parents."[4]

Coming-of-age narratives for inner-city youth are now mediated by cautionary tales about the AIDS crisis, the vocationalization of schooling, the grim rewards of "the drug economy and the militarisation of inner-city

life."[5] The convenience store and the basketball court have come to symbolize a future of ambivalence poised between dead-end labor, on the one hand, and the dream of gaining prosperity and fame as a professional athlete on the other. Neither of these positions, with their mix of despair and false hope, offers youth from subordinate groups much meaning in imagining a better future. Youth not only face the consequences of economic downsizing, they often find themselves being educated and regulated within institutions that have little relevance for their lives. This is expressed most strongly in schools. Strongly tied to the technology of print, located within a largely Eurocentric curriculum, and often resistant to analyzing how racial, class, and gender differences intersect in shaping that curriculum, schooling appears to many youth to be as irrelevant as it is boring.[6]

The second historical moment shaping the ideological and material context at work in the formation of diverse youth cultures stems from the proliferation of cultural differences and the restructuring of urban space, national identity, and the syntax of white ethnicity. For many youth, difference is an urgent signifier offering multiple, competing, and overlapping referents for representing themselves in a postmodern culture. Far from producing new languages through which youth can critically rewrite their relationship to the world, difference is often stripped of any critical content. In this scenario, difference functions primarily to generate new markets and expanding patterns of consumption, asserts itself within rigid cultural boundaries, and serves to deepen strains of racial and class antagonisms. In addition, it becomes a spatial signifier in which new, electronic, popular forms offer a wide range of identifications and new challenges to traditional forms of authority. In a rapidly changing postmodern cultural landscape, the voice of authority no longer resides exclusively in the modernist spheres of the school, family, and workplace. Authority has been refashioned in the legitimating discourses and images of an electronic media culture which has dramatically altered the course and content of the social and cultural relations of youth.[7]

DOMINANT PEDAGOGY AND THE THREAT OF CULTURAL STUDIES

In many ways the tensions that youth face within and across these two historical moments have come to the fore within the disparate fields of pedagogy and cultural studies. In the first instance, dominant forms of

13

pedagogy have largely viewed schools as the only relevant sites of learning, and have refused to deal with the teacherly influence and pleasures of popular culture. Consequently, traditional educators have more often than not either ignored the relevance of popular culture as a serious object of knowledge or simply trivialized it; while being more critical of school knowledge, they have often exercised such criticism within the boundaries of the traditional disciplines and the parameters of high culture. Rather than embracing cultural democracy, mainstream educators have largely embraced the modernist distaste for difference and fiercely promoted cultural uniformity as an aim of schooling. Wedded to the modernist infatuation with reason, mainstream educators have had little to say about the affective investments that mobilize student identities or how the mobilization of desire and the body is implicated in the pedagogical regulations of schooling.

For many youths, the experience of schooling becomes synonymous with the disciplining of the body and the policing of knowledge. As John Fiske points out, "School graduates are not just knowledgeable and talented, they are disciplined. Schools produce . . . 'docile bodies.'"[8] Largely technical and behavioral in its focus and effects, pedagogy historically has embraced the practical at the expense of the theoretical and subordinated politics and ethics to questions of management and control. Far from employing neutral educational techniques, schools exercise discipline in both controlling what people know and how they behave.

Of course, schools are not merely disciplinary factories exercising power in a relatively seamless and frictionless way. They are also spaces of contradiction, resistance, and accommodation. But modernism's obsession with regulation, social control, and certainty has placed powerful limits on even progressive and radical challenges to contemporary schooling and its highly discriminatory attempts to prepare young people to adapt to the existing social order. For example, although progressive and radical educators have challenged many assumptions of public schooling, both traditions have often ignored issues regarding who had control over the ownership and production of knowledge. They have seldom asked how pedagogy could reinsert the political back into the everyday by linking transformative teaching to knowledges circulated in popular culture and other marginalized public spheres while avoiding academic voyeurism or dominant appropriations of the everyday concerns that shaped the lives of youth outside of schools.

Cultural studies, on the other hand, with its ambiguous founding moments spread across multiple continents and diverse institutional spheres, has always been critically attentive to the changing conditions influencing the socialization of youth and the social and economic contexts producing such changes.[9] The self and social formation of diverse youth subcultures mediated by popular cultural forms such as television, advertising, pulp fiction, rock music, rap, and films remain a prominent concern of cultural studies. Cultural studies has a long-standing tradition of mapping the contours of media culture and the ways in which it educates youth to think, feel, desire, and act. Youth in this perspective is less an element to be controlled than a complex social formation to be analyzed, interpreted, and engaged within the largely repressive apparatuses of youth socialization. In many ways, cultural studies has unconsciously and indirectly challenged the conventional wisdom of teachers and offered progressive educators a new language and a new set of questions and social relations through which to address the "problem" of youth as symptomatic of a wider crisis in public life.

Cultural studies has also performed an important theoretical service by expanding the politics of culture to include analyses of its global reach across a wide spectrum of social spheres and signifying practices. Cultural studies views culture as pluralistic, shifting, and hybrid. Shaped within unequal relations of power and diasporic in its constant struggle for narrative space, culture becomes the site where youth make sense of themselves and others. At the same time, cultural studies has stressed the importance of developing contextualized inquiries that address how popular texts such as rap music, media news, popular films, and rock music are taken up within situated contexts and provide political possibilities "for the recovery of and attention to actual histories of in/subordination."[10] Culture is where the social gravity of power is organized in both the circulation and use of representations and in the material experiences that shape everyday life. What is especially pertinent regarding the "problem" of youth and its construction is that cultural studies has never reduced education to the study of schooling and that, by refusing to do so, it has contributed to the theoretical possibilities for understanding education as a political, pedagogical practice that unfolds in a wide range of shifting and overlapping sites of learning.

Given the popularity of cultural studies for a growing number of scholars, I have often wondered why so few academics have incorporated its

insights into the language of educational reform. For educators, such indifference may be explained, in part, by the absence of critical cultural theory in the technocratic models that dominate mainstream reform efforts and structure education programs. Within such a tradition, management issues take precedence over understanding and furthering schools as democratic public spheres.[11] Moreover, the regulation, certification, and standardization of teacher behavior is emphasized over creating the conditions for teachers to undertake the sensitive political and ethical roles they might assume as public intellectuals who selectively produce and legitimate particular forms of knowledge and authority. Similarly, licensing norms and managing differences among students is more significant than treating students as bearers of diverse social memories with a right to speak and represent themselves in the quest for learning and self-determination. While other disciplines have appropriated and engaged new theoretical languages in keeping with changing historical conditions, traditional educators have maintained a deep suspicion of theory and intellectual dialogue and thus have not been receptive to the introduction of cultural studies.[12]

Other considerations in this willful refusal to know would include a history of educational reform that has been overly indebted to practical issues. Paradoxically, such concerns have promulgated a long tradition of anti-intellectualism among teachers. Moreover, educators frequently pride themselves on being professional, scientific, and objective. Cultural studies poses a threat to this type of professionalism by challenging any claim to ideological and political neutrality around the production, distribution, and circulation of ideas and texts.[13] It also offers a conceptual challenge to educators who pride themselves on speaking objectively, outside of the shadow of ideology and politics. Rejecting the relationship between knowledge and authority as an issue that resolves itself through the mastery of particular methods, cultural studies in its more radical versions offers a critical language for understanding teaching as social practice produced and negotiated within considerations of history, politics, power, and culture. Given its concern with everyday life, its increasing focus on the silences regarding race in the dominant culture, its linking of the personal to the political, and its emphasis on multidisciplinary knowledge, cultural studies is less concerned with issues of certification and testing than it is with how knowledge, texts, and representations are produced, circulated, and used within institutions and relations of power. In this perspective, culture is the

ground "on which analysis proceeds, the object of study, and the site of political critique and intervention."[14] This, in part, explains why some advocates of cultural studies are increasingly interested in "how and where knowledge needs to surface and emerge in order to be consequential" with respect to expanding the possibilities for a radical democracy.[15]

Comprehending schooling as a mechanism of culture and politics is at odds with the largely depoliticized view of schooling embraced by dominant educational models.[16] Contrary to this view, cultural studies focuses on the critical relationship among culture, knowledge, and power; therefore, it is not surprising that mainstream educators often dismiss the field as being too ideological, or simply ignore its theoretical implications for addressing how education generates a privileged narrative space for some social groups and a space of inequality and subordination for others.

Historically, schools and colleges of education have been organized around either traditional subject-based studies (math education) or largely disciplinary/administrative categories (curriculum and instruction). Within this intellectual division of labor, students generally have had few opportunities to study the larger social issues that define the conditions under which teachers and students labor and learn. Education's slavish adherence to structuring the curriculum around the core disciplinary subjects is at odds with the field of cultural studies. The explicitly social, theoretical, and political orientation of cultural studies necessitates a focus on interdisciplinary issues, such as textuality and representation refracted through the dynamics of gender, sexuality, subordinate youth, national identity, colonialism, race, ethnicity, and popular culture.[17] Offering educators a critical language through which to examine the ideological and political interests that structure reform efforts in education (such as nationalized testing, standardized curriculum, and efficiency models), cultural studies nonetheless frequently incurs the wrath of mainstream and conservative educators who are silent about the political agendas that underlie their own language and reform agendas.[18]

In the century to come, educators will not be able to ignore the hard questions that schools will have to face regarding issues of multiculturalism, race, identity, power, knowledge, ethics, and work. These issues will play a major role in defining the meaning and purpose of schooling, the relationship between teachers and students, and the critical content of their exchange in terms of how to live in a world that will be vastly more

globalized, high-tech, and racially diverse than at any other time in history. Cultural studies offers enormous possibilities for educators to rethink the changing nature of educational theory and practice as well as what it means to educate future teachers for the twenty-first century.[19]

In what follows, I want to focus on how cultural studies and more recent variants of critical pedagogy might inform each other through a shared concern with what Dick Hebdige calls the "problem of youth."[20] In producing this line of thought I will make the case that pedagogy must become a defining principle of any critical notion of cultural studies in order to expand the meaning and relevance of pedagogy for those engaged in cultural work both in and outside of the university.

CULTURAL STUDIES AND THE
ABSENCE OF CRITICAL PEDAGOGY

Educational theorists demonstrate as little interest in cultural studies as cultural studies scholars do in more recent radical theories of schooling and pedagogy. Challenging the ways in which the academic disciplines have been used to secure particular forms of authority, cultural studies has opened up the possibility for both questioning how power operates in the construction of knowledge and redefining the parameters of what is being taught in institutions of higher education. In this instance, struggles over meaning, language, and textuality have become symptomatic of a larger conflict over cultural authority, the role teachers might play as public intellectuals, and the meaning of national identity.

Cultural studies has also played an important role in expanding the range of knowledge open to serious analysis; it has critically addressed and challenged how knowledge is organized within disciplinary structures and how texts can be deconstructed within a range of oppositional theoretical frameworks. Similarly, cultural studies theorists have problematized the politics of cultural authority by calling for a critical engagement with both dominant institutions and all those who wield cultural authority. But in spite of its focus on a number of educational issues as they operate both within and outside of the academy and schools, cultural studies often fails to address how the politics of pedagogy actually operates within schools and other educational sites.

Few theorists within the field of cultural studies make pedagogy central to their work; nor do they read the politics and practice of cultural studies

as fundamentally pedagogical. Largely ignoring work produced in the field of radical educational theory in the last decade, cultural studies theorists have rarely addressed the connection between the organization and production of what circulates as "knowledge" in the academy, on the one hand, and the politics of its transmission and the implications of such questions for their own work, on the other. Challenging the practices of disciplinarity and the institutional operations of power have become commonplace in cultural studies. Yet little has been said about how privileged texts get taken up by particular students or how relations of classroom power work. Such relations continue to prevent students from decentering traditional forms of authority in order to produce their own texts as part of a wider effort to develop spaces in which they can narrate themselves.

Cultural studies theorists must grasp the importance of pedagogy as a mode of cultural criticism, useful for questioning the very conditions under which knowledge, values, and social identities are produced, appropriated, and often challenged. It is important to note that the relationship between pedagogy and cultural studies has been addressed within the corpus of writing on cultural studies, but such analyses remain marginal to the field itself.[21] The haunting question here is, What is it about pedagogy that allows cultural studies theorists to ignore it?[22]

The pedagogical void in contemporary cultural studies is also evident in the refusal to engage pedagogy as a principle terrain for resisting power through the contestation of cultural authority. The mechanisms of power cannot be exclusively located in analyses of how ideology works through canonical texts, or through various popular texts when they are taken up, or how such texts can be demystified and recoded. Power also resides in the cultural authority of those who name, define, and legitimate how knowledge is selected and framed; and more often than not, the underlying principles that structure teacher-student relationships are neither open to critical analysis nor are they legitimated by virtue of an alternative set of ethical and political referents. In providing a space for critical dialogue, critical pedagogical practices point to more than the relationship between knowledge and power; they also signal how power operates in meeting the criterion of relevance (as an act of empowerment) by taking seriously students' interests, desires, and pleasures. Critical pedagogical practices also allow students to produce and appropriate space for the production of fugitive knowledge forms, those forms of knowledge that often

exist either outside of the mainstream curriculum or are seen as unworthy of serious attention.

In making the case for the importance of pedagogy as a defining principle of cultural studies, I want to reassert the importance of teaching as a cultural practice in the work of Raymond Williams, a central figure in the shaping of cultural studies in England in the 1950s. I choose Williams not to legitimate his role as an icon of cultural studies, but to illustrate the centrality of teaching and education to his notion of cultural politics. At odds with some recent variants of cultural studies, Williams made clear that the "deepest impulse [informing cultural studies] was the desire to make learning part of the process of social change itself."[23] By linking learning to politics, Williams attempted to think through the dynamics at work in providing the conditions for expanding human agency and giving political action a pedagogical dynamic. Moreover, Williams was not only keenly attentive to how culture is produced within a wide variety of sites, he refused to engage such issues without addressing how people actually negotiate culture within and between such sites.

According to Williams, pedagogy is an act of cultural production, a process through which power regulates bodies and behaviors as "they move through space and time."[24] While pedagogy is deeply implicated in the production of power/knowledge relationships and the construction of values and desire, its theoretical center of gravity is located not within a particular claim to new knowledge, but with real people articulating and rewriting their lived experiences within rather than outside of history. In this sense pedagogy, especially in its critical variants, clarifies how power works within particular historical, social, and cultural contexts in order to engage and, when necessary, to change such contexts.[25]

Williams reminds us that the importance of pedagogy to the content and context of cultural studies lies in its relevance for illuminating how knowledge and social identities are produced in a variety of sites in addition to schools. Williams believed, as a founding concept of cultural studies, that cultural education was just as important as political education that included knowledge of labor and trade unions. Though he argued that limiting the study of culture to higher education ran the risk of depoliticizing it, Williams believed that education in the broader political sense made it possible for active citizens in a democracy to engage, challenge, and transform policy. Further, he saw education as a necessary referent for stressing the pedagog-

ical preeminence of the work of all those who engage in the production of knowledge, as his notion of permanent education makes clear:

> This idea [permanent education] seems to me to repeat, in a new and impor-
> tant idiom, the concepts of learning and of popular democratic culture which
> underlie the present book. What it valuably stresses is the education force of our
> whole social and cultural experience. It is therefore concerned, not only with con-
> tinuing education, of a formal or informal kind, but with what the whole envi-
> ronment, its institutions and relationships, actively and profoundly teaches. To
> consider the problems of families, or of town planning, is then an educational
> enterprise, for these, also, are where teaching occurs. And then the field of this
> book, of the cultural communications which, under an old shadow, are still called
> mass communications, can be integrated, as I have always intended, with a whole
> social policy. For who can doubt, looking at television or newspapers, or reading
> the women's magazines, that here, centrally, is teaching, and teaching financed
> and distributed in a much larger way than in formal education? [26]

Building upon Williams's notion of permanent education, pedagogy in this sense provides a theoretical discourse for understanding how power and knowledge mutually inform each other in the production, reception, and transformation of social identities, forms of ethical address, and "desired versions of a future human community."[27]

FORECAST

I will extend the above analysis of critical pedagogy and popular culture in the next few chapters by analyzing how Hollywood has employed spe-cific forms of racial and ideological coding in a number of films. Part I analyzes how white and black youth are depicted through the mutually related codes of race and violence. The crisis of youth as taken up in films such as Slacker, Juice, and New Jersey Drive is not treated in an undifferentiated way. In fact, the angst, alienation, and despair that affects white youth is treated quite differently from the ways in which black youth are repre-sented. These chapters attempt to show that race is the key signifier in these films about youth.

I also analyze the culture of violence from the perspective of the devel-opment of a new form of cinematic violence that has appeared in the 1990s. Focusing on films such as Pulp Fiction, I analyze this form of violence

in terms of the political and pedagogical implications it has for parents, teachers, and other cultural workers who are concerned about the spread of violence in American culture.

Part I concludes with an analysis of the representations offered youth in a range of Disney animated films. These films provide the pretext for examining how the often rigid distinction between entertainment and innocence, on the one hand, and social criticism and politics, on the other, alters how a critical politics and pedagogical analysis of media culture might be developed.

Part II highlights the importance of resistance and hope as central to any theory of media culture and pedagogical criticism. Focusing primarily on the importance of the university as a democratic public sphere and the emergence of talk radio as an important site of learning, I discuss the implications radio has for thinking about who public intellectuals might be and what role they might play in altering the sites of learning that youth inhabit.

Part III examines the pedagogical and political implications of the anti–political correctness movement of the last decade and how it has shaped both the discourse of schooling and the moral regulation and disciplining of youth. The book concludes with an analysis of the relationship between what might be called an insurgent multiculturalism and the problematic concept of national identity. Central to this chapter is the assumption that the crisis of youth cannot be abstracted from either the politics of difference or the discourse of national identity.

It is important to stress that Fugitive Cultures offers partial insights regarding how elements of critical pedagogical work can inform and be informed by selective appropriations from the field of cultural studies, especially with regard to its emphasis on popular culture and youth as a terrain of political and pedagogical importance.[28] In addition, Fugitive Cultures consistently stresses the premise that the relationship between the culture of violence and the crisis of youth in the United States must be understood against rapidly changing economic conditions, an escalating wave of violence, and the emergence of a discourse that Ruth Conniff has aptly called the culture of cruelty.[29] If there is a new mean-spiritedness at work in American culture, it is present in the material experiences of youth, especially among those who are poor, black, and unemployed. Such a spirit is evident in the discourses about youth produced in conservative

policy initiatives coming out of Congress; it is also manifested increasingly in the wave of representations flooding the media culture. How youth are seen through popular representations becomes indicative of how they are viewed by mainstream society and points to pedagogical practices that offer youth themselves images through which to construct their own identities and mediate their perceptions of other youth formations. The political and pedagogical implications of such representations pose serious challenges to progressives and other cultural workers who can no longer sit back and allow popular teaching machines to go unchecked in their attempts to peddle violence for profit.

Race,

Violence,

and

Children's Culture

WHITE PANIC

AND THE

RACIAL CODING

OF VIOLENCE

1

In our society, youth is present only when its presence is a problem, or is regarded as a problem. More precisely, the category "youth" gets mobilized in official documentary discourse, in concerned or outraged editorials and features, or in the supposedly disinterested tracts emanating from the social sciences at those times when young people make their presence felt by going "out of bounds", by resisting through rituals, dressing strangely, striking bizarre attitudes, breaking rules, breaking bottles, windows, heads, issuing rhetorical challenges to the law.

—Dick Hebdige, *Hiding in the Light*

Youth have once again become the object of public analysis. Headlines proliferate like dispatches from a combat zone, frequently coupling youth and violence in the interests of promoting a new kind of commonsense relationship. For example, gangsta rap artist Snoop Doggy Dogg is featured on the front cover of *Newsweek*.[1] The message is that young black men are spreading violence like some kind of social disease to the mainstream public through their

music. But according to *Newsweek*, the violence is not just in the music—it is also embodied in the lifestyles of the rappers who produce it. The potential victims in this case are a besieged white majority of male and female youth. Citing a wave of arrests among prominent rappers, the cover story reinforces the emergence of crime as a racially coded word for associating black youth with violence.[2]

The statistics on youth violence point to social and economic causes of crime that lie far beyond the reach of facile stereotypes about kids today. On a national level, United States society is witnessing the effects of a culture of violence in which

> close to 12 U.S. children aged 19 and under die from gun fire each day. According to the National Center for Health Statistics, "Firearm homicide is the leading cause of death of African-American teenage boys and the second-leading cause of death of high school age children in the United States."[3]

What is missing from news stories reported in *Newsweek* and other popular media is any critical commentary on the relationship between the spread of the culture of violence in this society and the representations of violence that saturate the mass media. In addition, there is little mention in such reports of the high numbers of infants and children killed every year through "poverty-related malnutrition and disease." Nor is the United States public informed in the popular press about "the gruesome toll of the drunk driver who is typically white."[4] But the bad news doesn't end with a one-sided commentary on violence in the United States.

The representations of white youth produced by dominant media within recent years have increasingly portrayed them as lazy, sinking into a self-indulgent haze, and oblivious to the middle-class ethic of working hard and getting ahead. Of course, the dominant media do not talk about the social conditions producing a new generation of youth steeped in despair, violence, crime, poverty, and apathy. For instance, to talk about black crime without mentioning that the unemployment rate for black youth exceeds forty percent in many urban cities, serves primarily to conceal a major cause of youth unrest. Or to talk about apathy among black and white youth without analyzing the junk culture, poverty, social disenfranchisement, drugs, lack of educational opportunity, and commodi-

fication that shape daily life removes responsibility from a social system that often sees youth as simply another market niche.

With the production of goods shifting to third world countries and corporate downsizing streamlining American businesses, the present economy offers most youth the promise of service sector jobs and dim prospects for the future. Against the scarcity of opportunity, youth face a world of infinite messages and images designed to sell products or peddle senseless violence. In light of radically altered social and economic conditions, educators need to fashion alternative analyses about how youth are being constructed pedagogically, economically, and culturally within the changing nature of a postmodern culture of violence. Such a project seems vital in light of the rapidity with which market values and a commercial public culture have replaced the ethical referents for developing democratic public spheres. For example, since the 1970s, millions of jobs have been lost to capital flight, and technological change has wiped out millions more. In the last twenty years alone, the U.S. economy lost more than five million jobs in the manufacturing sector.[5] In the face of extremely limited prospects for economic growth over the next decade, schools will be faced with an identity crisis regarding the traditional assumption that school credentials provide the best route to economic security and class mobility for a large proportion of our nation's youth. As Stanley Aronowitz and I have pointed out elsewhere:

> The labor market is becoming increasingly bifurcated: organizational and technical changes are producing a limited number of jobs for highly educated and trained people—managers, scientific and technological experts, and researchers. On the other hand, we are witnessing the disappearance of many middle-level white collar subprofessions. . . . And in the face of sharpening competition, employers typically hire a growing number of low paid, part-time workers. . . . Even some professionals have become free-lance workers with few, if any, fringe benefits. These developments call into question the efficacy of mass schooling for providing the "well-trained" labor force that employers still claim they require.[6]

In light of these shattering shifts in economic and cultural life, it makes more sense for educators to reexamine the mission of the school and the changing conditions of youth rather than to blame youth for the economic slump, the culture of racially coded violence, or the hopelessness that seems endemic to dominant versions of the future.

Rethinking the conditions of youth is also imperative in order to reverse the mean-spirited discourse of the 1980s and 1990s, a discourse that has turned its back on the victims of United States society and has resorted to both blaming and punishing them for their social and economic problems. For example, in states such as Michigan and Wisconsin, which subscribe to "Learnfare" programs, a single mother is penalized with a lower food allowance if her kids are absent from school. In other states, welfare payments are reduced if single mothers do not marry. Mickey Kaus, an editor at the *New Republic*, argues that welfare mothers should be forced to work at menial jobs, and if they refuse, Kaus suggests that the state remove their children from them. Illiterate women, Kaus argues, could work raking leaves.[7] We are now witnessing the indifference and callousness in this kind of language as it spills over into national discussions about youth and their future. Instead of confronting the economic and social conditions that cripple the nation's youth, leaving many without food, shelter, access to decent education, and safe environments, conservatives such as former Secretary of Education William Bennett seek repressive institutional reforms. Conservatives argue for imposing national standards on public schools, creating voucher systems that benefit middle-class parents, and doing away with the concept of the "public" altogether. However, there is more at work here than simply ignorance of the issues and neglect that results from the convenience of not knowing.

It is perhaps in the dominant discourse on families and cultural values that one gets a glimpse of the pedagogy at work in the culture of mean-spiritedness. Bennett, for instance, in his new, best-selling book, *The Book of Virtues: A Treasury of Great Moral Stories*, finds hope in "Old Mr. Rabbit's Thanksgiving Dinner," in which the rabbit instructs us that there is more joy in being helpful than being helped. The discourse of moral uplift may provide soothing and inspirational help for children whose parents send them to private schools, establish trust-fund annuities for their future, and connect them to the world of political patronage. But it says almost nothing about the culture of compressed and concentrated human suffering that many children have to deal with daily in this country—a culture of suffering made evident by the fact that over seventy percent of all welfare recipients are children. In what follows, I want to draw from a number of insights provided by the field of cultural studies to chart out a different cartography that might be helpful for educators to address the changing conditions of youth.

FRAMING YOUTH

The instability and transitoriness characteristic of a diverse generation of eighteen- to twenty-five-year-olds is inextricably rooted in a larger set of postmodern cultural conditions. These conditions are informed by the following: a general loss of faith in the narratives of work and emancipation; the recognition that the indeterminacy of the future warrants confronting and living in the immediacy of experience; an acknowledgment that homelessness as a condition of randomness has replaced the security, if not misrepresentation, of home as a source of comfort and security; an experience of time and space as compressed and fragmented within a world of images that increasingly undermine the dialectic of authenticity and universalism. For many youth, plurality and contingency—whether generated by the mass media or through the dislocations spurned by the economic system, the rise of new social movements, or the crisis of representation and authority—have resulted in a world with few secure psychological, economic, or intellectual markers. This is a world in which one wanders within and between multiple borders and spaces marked by excess, otherness, and difference. This is a world in which old certainties are ruptured and meaning becomes more contingent, less indebted to the dictates of reverence and established truth. While the circumstances of youth vary across and within terrains marked by gender, racial and class differences, the modernist world of certainty and order that has traditionally policed, contained, and insulated such difference has given way. In its place is a shared postmodern space in which cultural representations merge into new hybridized forms of cultural performance, identity, and political agency. As the information highway and MTV condense time and space into what Paul Virilio calls "speed space," new desires, modes of association, and forms of resistance inscribe themselves into diverse spheres of popular culture.[8] Music, rap, fashion, style, talk, politics, and cultural resistance are no longer confined to their original class and racial locations. Middle-class white kids take up the language of gangsta rap spawned in neighborhood turfs far removed from their own lives. Black youth in urban centers have created a hip hop style fashioned amid a combination of sneakers, baseball caps, and oversized clothing that integrates forms of resistance, a style later appropriated by suburban kids whose desires and identities resonate with the energy and vibrancy of rap, hip hop culture, and the new urban funk. Music displaces older forms of textuality and references a terrain of

cultural production that marks the body as a site of pleasure, resistance, domination, and danger.[9] Within this postmodern youth culture, identities merge and shift rather than becoming more uniform and static. No longer associated with any one place or location, youth increasingly inhabit shifting cultural and social spheres marked by a plurality of languages, ideologies, and cultures. Youth can no longer be seen as either bearers of counter-hegemonic cultures or as drop outs, sheepishly slacking off into an aimless and dreary accommodation to the status quo.

Communities have been refigured as space and time mutate into multiple and overlapping cyberspace networks. Bohemian and middle-class youth now talk to each other over electronic bulletin boards in coffee houses. Cafes and other public salons, once the refuge of beatniks, hippies, and other cultural radicals, have given way to members of the hacker culture. Middle-class youth reorder their imaginations according to virtual reality technologies. They produce forms of exchange through electronic texts and icons that have the potential to wage war on traditional meaning, but they also run the risk of reducing critical understanding to the endless play of random access spectacles.

Of course, calling attention to the often contradictory nature of popular culture is not meant to endorse a Frankfurt School dismissal of popular culture in the postmodern age.[10] On the contrary, I believe that the new electronic technologies, with their proliferation of narratives and open-ended forms of interaction, have altered the pedagogical context for the production of identities as well as how people "take in information and entertainment."[11] Produced from the centers of power, media culture has spawned in the name of profit and entertainment a new level of instrumental and commodified culture. On the other hand, popular culture offers resistance to the notion that useful culture can only be produced within dominant regimes of power. Black inner city youth, for example, have reinvented such old technologies as the mixing board and the drum machine to articulate rap as a unique form of musical expression.[12] At the same time, the distinction between mass and popular culture is not meant to suggest that popular culture is strictly a terrain of resistance. Popular culture does not escape commodification, racism, sexism, and other forms of oppression, but it is marked by fault lines that reject the high/low culture divide while simultaneously attempting to affirm a multitude of histories, experiences, cultural forms, and pleasures. Within the conditions

of postmodern culture, values no longer emerge unproblematically from the modernist pedagogy of foundationalism and universal truths, or from traditional narratives based on fixed identities with their requisite structure of closure. For many youths, meaning is in rout, media has become a substitute for experience, and what constitutes understanding is grounded in a decentered and diasporic world of difference, displacement, and negotiation.

The intersection among cultural studies and pedagogy can be made more clear through an analysis of how the pedagogy of Hollywood has attempted to portray in some recent films the plight of young people within the conditions of a postmodern American culture. I will focus on five films: River's Edge (1986), My Own Private Idaho (1991), Slacker (1991), Juice (1992), and Kids (1995). These films both frame the ways in which youth can be taken up by diverse audiences and argue for particular pedagogical readings over others. They point to some of the economic and social conditions at work in the formation of different racial and economic strata of youth, but they often do so within a narrative that combines a politics of despair with a fairly sophisticated depiction of the alleged sensibilities and moods of a generation of youth growing up amid the fracturing and menacing conditions of a postmodern culture. The challenge for progressive educators is to formulate the ways in which a critical pedagogy might be employed to appropriate the more radical aspects of children's culture. Its radical notions will be useful in addressing the new and different social, political, and economic contexts that inform and shape the twenty-something generation. At the same time, progressive educators must consider how the interface of cultural studies and critical pedagogy might be analyzed to create the conditions for social agency and institutionalized change among diverse sectors of youth.

WHITE YOUTH AND THE POLITICS OF DESPAIR

For many youth, showing up for adulthood at the fin de siècle means pulling back on hope and trying to put off the future, rather than taking up the modernist challenge of trying to shape it.[13] Popular cultural criticism has captured much of the alienation among youth and has made clear that "What used to be the pessimism of a radical fringe is now the shared assumption of a generation."[14] Cultural studies has helped to temper this broad generalization about youth in order to investigate the more complex

representations at work in the construction of a new generation of youth, representations that cannot be abstracted from the specificities of race, class, or gender. And yet, cultural studies theorists have also pointed to the increasing resistance of a twenty-something generation of youth who seem neither motivated by nostalgia for some lost conservative vision of America nor at home in the New World Order paved with the promises of the expanding electronic information highway.[15]

While "youth" as a social construction has always been mediated, in part, as a social problem, many cultural critics believe that postmodern youth are uniquely "alien," "strange," and disconnected from the real world. For instance, in Gus Van Sant's *My Own Private Idaho* (1991), the main character, Mike, who hustles his sexual wares for money, is a dreamer lost in fractured memories of a mother who deserted him as a child. Caught between flashbacks of Mom shown in 8mm color and the video world of motley street hustlers and their clients, Mike moves through his life by falling asleep in times of stress only to awaken in different geographic locations. What holds Mike's psychic and geographic travels together is the metaphor of sleep, the dream of escape, and the ultimate realization that even memories cannot fuel hope for the future. Mike becomes a metaphor for an entire generation of lower middle-class youth forced to sell themselves in a society governed by the market, a generation that aspires to nothing, works at degrading McJobs, and lives in a world in which chance and randomness rather than struggle, community, and solidarity drive their fate.

A more disturbing picture of white, working-class youth can be found in the cult classic, *River's Edge* (1986). Teen-age anomie and drugged apathy are given painful expression in the depiction of a group of working-class youth who are casually told by their friend John that he has strangled his girlfriend, another of the group's members, and left her nude body on the riverbank. The group members at different times visit the site to view the dead body of the girl. Seemingly unable to grasp the significance of the event, the youths initially hold off from informing anyone of John's murderous act and with varying degrees of concern and self-interest try to protect the teen-age sociopath from being caught by the police. Framed in conservative terms, the youths in *River's Edge* drift through a world of broken families, blaring rock music, schooling marked by dead time, and a general indifference towards the future. In *River's Edge*, history as social mem-

ory is reassembled through vignettes of 1960s types portrayed as either burned-out bikers or as the ex-radical turned teacher whose moralizing relegates politics to simple cheap opportunism. Decentered and fragmented, the youths in the movie view death, like life itself, as a mere spectacle, a matter of form rather than substance. In one sense, these youths share the quality of being "asleep" that is depicted in My Own Private Idaho. But what gives a more disturbing aura to River's Edge is that lost "innocence" gives way not merely to teen-age myopia, but also to a culture in which human life is experienced as a voyeuristic seduction, a video game, good for passing time and diverting oneself from the pervasiveness of despair. Hopelessness and indifference cancel out the language of ethical discriminations and social responsibility while elevating the immediacy of pleasure to the defining moment of agency. Exchanges among the young people in River's Edge appear like projections of a generation waiting either to fall asleep or to self-destruct. After talking about how he murdered his girlfriend, John blurts out "You do shit, it's done, and then you die." Another character responds, "It might be easier being dead." To which her boyfriend, a Wayne's World type, replies, "Bullshit, you couldn't get stoned anymore." In this scenario, life imitates art when committing murder and getting stoned are given equal moral weight in the formula of the Hollywood spectacle, a spectacle which in the end flattens the complex representations of youth while constructing their identities through ample servings of pleasure, violence, and indifference.

River's Edge and My Own Private Idaho reveal the seamy and dark side of a youth culture while employing the Hollywood mixture of fascination and horror to titillate the audiences drawn to these films. Employing the postmodern aesthetic of revulsion, locality, randomness, and senselessness, these films present youth who appear to be constructed outside of a broader cultural and economic landscape. Hence, they become visible only through visceral expressions of psychotic behavior or the brooding experience of a self-imposed comatose alienation. River's Edge has spawned a number of youth films that extend and deepen its picture of youth as restless, bitter, and filled with rage. The release of Kids (1995) is an urban revision of the youth in River's Edge. The turf this time is Manhattan, and the narrative unfolds by telling the story of seventeen-year-old Telly, who describes himself as a "virgin surgeon." As the camera follows Telly and his friends through the course of a hot day in the city, an image emerges of youth who seem lost except for the

thrill of sex, drugs, skateboarding, and goofing around. Casual physical brutality combines with Telly's equally brutal act of sexually transmitting the HIV virus to the girls he seduces. Utilizing an unflinching documentary style, Kids presents itself as a realistic look at New York youth in the 1990s. Portraying teen-agers as mindless, hormone-crazed, and indifferent to the consequences of their impulsive actions, Kids shatters the Disney image of innocence that all too often is invoked by conservatives when looking for role models for youth. But in Kids, as in a number of recent films modeled after River's Edge, attempts to transgress and rupture middle- and working-class depictions of youth often slip too easily into a cynicism that has as its only defense an appeal to artistic expression. Kids continues a long cinematic tradition of viewing youth as dull, aimless, and shorn of any idealism. As critic Jon Pareles points out, "in Kids . . . teen-agers [are] no longer treated as a problem to be recognized and solved but as something chronic and inevitable. . . . Numbed by drugs and mass culture, restless but affectless, they [are] portrayed [less] as alienated [than] as simply aliens."[16]

Whereas Larry Clark, the director, invokes Kids as a hard-edged, representative look at urban youth, Newt Gingrich invokes conservative family values and Boys Town. Both cancel each other out. Clark evokes a paralyzing cynicism about the absence of adult authority and depravity of street life. Gingrich provides a utopian rendering of middle-class family values for white suburban youth while simultaneously offering the revamped authority of the nineteenth-century orphanage as the model for disciplining working-class, urban teen-age youth. What both positions share is an essentialist rendering of youth that is either heartful and productive or despairing and bitter. Neither position captures the complexity of representations and range of identities that youth inhabit nor the limits and possibilities that diverse youth face in the nineties. Both positions also share a racism in which black youth and the urban center become sites of contamination. For example, the white youth in Kids speak in a black street vernacular and appear to have appropriated the form and style of hip hop culture. The message here is that the culture of criminality is an urban culture, it is black, and it is spreading. Black teen-age welfare mothers in Gingrich's world and black street culture in Clark's universe share the same characteristics of depravity and hopelessness.

One of the more celebrated white-youth films of the 1990s is Richard Linklater's Slacker (1991). A decidedly low-budget film, Slacker attempts in

both form and content to capture the sentiments of a twenty-something generation of middle-class, white youth who reject most of the values of the Reagan/Bush era in which they came of age, but have a difficult time imagining what an alternative might look like. Distinctly non-linear in its format, *Slacker* takes place in a twenty-four-hour time frame in the college town of Austin, Texas. Building upon an antinarrative structure, *Slacker* is loosely organized around brief episodes in the lives of a variety of characters, none of whom are connected to each other except to provide the pretext to lead the audience to the next character in the film. Sweeping through bookstores, coffee shops, auto-parts yards, bedrooms, and rock music clubs, *Slacker* focuses on a disparate group of young people who possess little hope in the future and drift from job to job speaking a hybrid argot of bohemian intensities and New Age pop-cult babble.

The film portrays a host of young people who randomly move from one place to the next, border crossers with little, if any, sense of where they have come from or where they are going. In this world of multiple realities, youth work in bands with names like "Ultimate Loser" and talk about being forcibly put in hospitals by their parents. One neo-punker even attempts to sell a Madonna pap smear to two acquaintances she meets in the street. "Check it out, I know it's kind of disgusting, but it's like sort of getting down to the real Madonna." This is a world in which language is wedded to an odd mix of nostalgia, pop/corn philosophy, and MTV babble. Talk is organized around comments like: "I don't know . . . I've traveled . . . and when you get back you can't tell whether it really happened to you or if you just saw it on TV." Alienation is driven inward and emerges in comments like "I feel stuck." Irony slightly overshadows a refusal to imagine the needs of anyone outside the self, forcefully precluding any kind of collective struggle. Reality seems too despairing to care about. This is humorously captured in one instance by a young man who suggests: "You know how the slogan goes, workers of the world, unite? We say workers of the world, relax." People talk but appear disconnected from themselves and each other; lives traverse each other with no sense of community or connection.

At rare moments in the film, the political paralysis of narcissistic forms of self-absorption is offset by instances in which some characters recognize the importance of the image as a vehicle for cultural production, as a representational apparatus that can not only make certain experiences

available but can also be used to produce alternative realities and social practices. There is a pronounced sense in *Slacker* of youth caught in the throes of new technologies that both contain their aspirations and at the same time hold out the promise of some sense of agency. The power of the image is present in the way the camera follows characters throughout the film, at once stalking them and confining them to a gaze that is both constraining and incidental. In one scene, a young man appears in a video apartment surrounded by televisions that he claims he has had on for years. He points out that he has invented a game called "Video Virus" in which, through the use of a special technology, he can push a button and insert himself into any screen and perform any one of a number of actions. When asked by another character what this is about, he answers: "Well, we all know the psychic powers of the televised image. But we need to capitalize on it and make it work for us instead of working for it." This theme is taken up in two other scenes. In one short clip, a graduate history student shoots the video camera he is using to film himself, indicating a self-consciousness about the power of the image and the ability to control it at the same time. In the concluding scene, a carload of people, each equipped with a Super-8 camera, drive up to a large hill and throw their cameras into a canyon. The film ends with the images being recorded by the cameras, as they cascade to the bottom of the cliff in what suggests a moment of release and liberation.

In many respects, these movies largely focus on a culture of white youth who are both terrified of and fascinated by the media, who appear overwhelmed by "the danger and wonder of future technologies, the banality of consumption, the thrill of brand names, [and] the difficulty of sex in alienated relationships."[17] The significance of these films rests, in part, in their attempt to capture the sense of powerlessness that increasingly affects working-class and middle-class white youth. However, missing from these films as well as from the various books, articles, and reportage concerning what is often called the "Nowhere Generation," "Generation X," "13thGen," or "Slackers" is any sense of the larger political, racial, and social conditions in which youth are being framed, as well as the multiple forms of resistance and racial diversity that exist among different youth formations.[18] What in fact should be seen as a social commentary about "dead-end capitalism" emerges simply as a celebration of refusal dressed up in a rhetoric of aesthetics, style, fashion, and solipsistic protests. Here

postmodern criticism is useful but limited because of its often theoretical inability to take up the relationships between identity and power, biography and the commodification of everyday life. Such criticism also fails to address the limits of agency in an increasingly globalized world order as part of a broader project of possibility linked to issues of history, struggle, and transformation.[19]

In spite of the totalizing image of domination that structures *River's Edge*, *My Own Private Idaho*, and *Kids*, and despite the lethal hopelessness that permeates *Slacker*, all of these films provide opportunities for examining the social and cultural contexts to which they refer in order to enlarge the range of understandings and strategies that students might bring to them to create a sense of resistance and transformation. For instance, many of my students who viewed *Slacker* did not despair over the film. They interpreted it to mean that "going slack" was a moment when young people could, with the proper resources, have time to think, move around the country, and "chill out" in order to make some important decisions about their lives. Going slack, however, might become increasingly more oppressive as the slack time became drawn out beyond their ability to end or control it. The students also pointed out that this film was made by Linklater and his friends with a great deal of energy and gusto, which in itself offers a pedagogical model for young people to take up in developing their own narratives.

BLACK YOUTH AND THE VIOLENCE OF RACE

Unwanted as workers, underfunded as students, and undermined as citizens, minority youth seem wanted only by the criminal justice system.[20]

While films about white youth provide a suggestive, if often politically conservative view of the twenty-something generation, they say something altogether new and problematic when placed in juxtaposition to films about black youth. With the explosion of rap music into the sphere of popular culture and with the intense debates that have emerged around the crisis of black masculinity, the issue of black nationalism, and the politics of black urban culture, it is not surprising that the black cinema should produce a series of films about the coming of age of black youth in urban America. Unlike the black exploitation films of the 1960s and

1970s, which were made by white producers for black audiences, the new wave of black cinema is being produced by black directors and aimed at black audiences.[21] With the advent of the 1990s, Hollywood has cashed in on young, talented black directors such as Spike Lee, Allen and Albert Hughes, Charles Burnett, Ernest Dickerson, and John Singleton. Films about black youth have become big box office hits—in 1991 New Jack City and Boyz N the Hood pulled in over one hundred million dollars between them. Largely concerned with the forms of inequality, oppression, daily violence, and the diminishing hope that plague black communities in the urban war zone, the new wave of black films has attempted to accentuate the economic and social conditions that have contributed to the construction of "black masculinity and its relationship to the ghetto culture in which ideals of masculinity are nurtured and shaped."[22]

Unlike many of the recent films about white youth, whose coming-of-age narratives are developed within traditional sociological categories such as alienation, restlessness, and anomie, black film productions such as Ernest Dickerson's Juice (1992), Nick Gomez's New Jersey Drive (1995), and Spike Lee's Clockers (1995) depict a culture of nihilism that is rooted directly in a violence whose defining principles are hopelessness, internecine warfare, cultural suicide, and social decay. It is worth noting that just as the popular press has racialized crime, drugs, and violence as a black problem, some of the most interesting films to appear recently about black youth have been given the Hollywood imprimatur of excellence and have moved successfully as crossover films to a white audience. In what follows, I want to briefly probe the treatment of black youth and the representations of masculinity and resistance in the exemplary black film, Juice.

Juice (street slang for respect) is the story of four Harlem African-American youth who are first portrayed as kids who engage in the usual antics of skipping school, fighting with other kids in the neighborhood, clashing with their parents about doing homework, and arguing with their siblings over using the bathroom in the morning. If this portrayal of youthful innocence is used to get a general audience to comfortably identify with these four black youths, it is soon ruptured, as the group, caught in a spiraling wave of poverty and depressed opportunities, turns to crime and violence as a way to both construct their manhood and survive their most immediate dilemmas. Determined to give their lives some sense of agency, the group moves from ripping off a record store to burglarizing a grocery

the group moves from ripping off a record store to burglarizing a grocery market to the ruthless murders of the store owner and eventually each other. Caught in a world in which the ethics of the street are mirrored in the spectacle of TV violence, Bishop, Quincy, Raheem, and Steel (Tupac Shakur, Omar Epps, Kahalil Kain, and Jermaine Hopkins), decide, after watching James Cagney go up in a blaze of glory in *White Heat*, to take control of their lives by buying a gun and sticking up a neighborhood merchant who once chased them out of his store.

Quincy is the only black youth in the film who models a sense of agency that is not completely caught in the confusion and despair exhibited by his three friends. Quincy is hesitant about participating in the stickup because he is a talented disc jockey and is determined to enter a local deejay contest in order to take advantage of his love of rap music and find a place for himself in the world. Positioned within the loyalty codes of the street and the protection it provides, Quincy reluctantly agrees to participate in the heist. Bad choices have major consequences in this typical big city ghetto, and Quincy's sense of hope and independence is shattered as Bishop, the most violent of the group, kills the store owner and then proceeds to murder Raheem and hunt down Quincy and Steel, since they no longer see him as a respected member of the group. Quincy eventually buys a weapon to protect himself, and in the film's final scene confronts Bishop on the roof of a run-down apartment. A struggle ensues and Bishop plunges to his death. As the film ends, one onlooker tells Quincy "You got the juice," but Quincy rejects the accolade ascribing power and prestige to him and walks away.

Juice reasserts the importance of rap music as the cultural expression of imaginable possibilities in the daily lives of black youth. Not only does rap music provide the musical score which frames the film, it also plays a pivotal role by socially contextualizing the desires, rage, and independent expression of black male artists. For Quincy, rap music offers him the opportunity to claim some "juice" among his peers while simultaneously providing him with a context to construct an affirmative identity. It also offers him the chance for real employment. Music in this context becomes a major referent for understanding how identities and bodies come together in a hip-hop culture that at its most oppositional moments is testing the limits of the American dream. But *Juice* also gestures, through the direction of Ernest Dickerson, that if violence is endemic to the black

ghetto, its roots lie in a culture of violence that is daily transmitted through the medium of television. This is suggested in one powerful scene in which the group watches on television both the famed violent ending of James Cagney's *White Heat* and another scene where a news bulletin announces the death of a neighborhood friend as he attempted to rip off a local bar. In this scene, Dickerson draws a powerful relationship between what the four youth see on television and their impatience over their own lack of agency and need to take control of their lives. As Michael Dyson points out:

> *Dickerson's aim is transparent: to highlight the link between violence and criminality fostered in the collective American imagination by television, the consumption of images through a medium that has replaced the Constitution and the Declaration of Independence as the unifying fiction of national citizenship and identity. It is also the daily and exclusive occupation of Bishop's listless father, a reminder that television's genealogy of influence unfolds from its dulling effects in one generation to its creation of lethal desires in the next, twin strategies of destruction when applied in the black male ghetto.*[23]

While Dyson is right in pointing to Dickerson's critique of the media, he overestimates the importance given in *Juice* to the relationship between black-on-black violence and those larger social determinants that black urban life both reflects and helps to produce. In fact, it could be argued that the violence portrayed in *Juice* and similar films such as *Boyz N the Hood*, *New Jack City*, *Sugar Hill*, *Menace II Society*, *Jason's Lyric*, and *Clockers* "feeds the racist national obsession that black men and their community are the central locus of the American scene of violence."[24]

Although the violence in these films is traumatizing in an effort to promote an antiviolence message, it is also a violence that is hermetically sealed within the walls of the black urban ghetto. While the counterpart of this type of violence in controversial white films such as *Reservoir Dogs* is taken up by most critics as part of an avant-garde aesthetic, the documentary-style violence in the recent wave of black youth films often reinforces for middle-class viewers the assumption that such violence is endemic to the black community. The only salvation gained in portraying such inner-city hopelessness is that it be noticed so that it can be stopped from spreading like a disease into the adjoining suburbs and business zones that form a colonizing ring around black ghettoes. Because films

It is important to note that films such as *Juice* and more recently *Clockers* refrain from romanticizing violence; in the concluding scenes of *Juice*, Quincy does not want the juice if it means leading a life in which violence is the only capital that has any exchange value in African-American communities. Similarly, Strike, the teen-age crack dealer in *Clockers*, neither glamorizes nor embodies the fascination with violence so often found in black youth films. The violence Strike sees all around him and increasingly experiences himself is played out in not only the revolt of his conscience, but also in a bleeding ulcer that debilitates his body. If there is a refusal to endorse the spectacle of violence in films such as *Juice* and *Clockers*, it is undercut by the riveting assumption that there are no positive choices, no way out, for black men in these communities. The violence of the streets is matched by the violence of confinement and the loss of any notion of racial justice or social agency. As violence becomes hermetic in these films, any notion of resistance, social change, and collective agency disappears as well.

One pedagogical challenge presented by *Juice* is for educators and students to theorize about why Hollywood is investing in films about black youth that overlook the complex representations that structure African-American communities. Such an inquiry can be taken up by looking at the work of black feminist filmmakers such as Julie Dash, who offers black women powerful and complex representations in *Daughters of the Dust*, or the work of Leslie Harris, whose film *Just Another Girl on the IRT* challenges the misogyny that structures the films currently available about black male youth. Another challenge for educators involves trying to understand why black, urban, male youth readily identify with the wider social representations of sexism, homophobia, and misogyny, in exchange for a form of "respect" that comes at such a high cost to themselves and the communities in which they live. It is important to engage films about black youth in order to both understand the pedagogies that silently structure their representations and how such representations pedagogically work to educate both black and white audiences. Needless to say, these films should not be dismissed because they are in their worst moments reductionistic, sexist, or one-dimensional in their portrayal of the rite of passage of black male youth. At most, they become a marker for understanding how complex representations of black youth get lost in racially coded films that point to serious problems in the urban centers, but do so in ways that

erase the accountability of the dominant culture and racist institutions, on the one hand, and any sense of viable hope, possibility, resistance, and struggle on the other. Furthermore, educators and other cultural workers must address the critical importance of representations of blackness emerging from black artists, while taking into account that such lived experience might not translate into a progressive understanding of the social relations depicted.

Contemporary films about black youth offer a glimpse into the specificity of otherness; that is, they cross a cultural and racial border and in doing so perform a theoretical service in making visible what is often left out of the dominant politics of representation. And it is in the light of such an opening that the possibility exists for educators and other cultural workers to take up the relationship among culture, power, and identity in ways that grapple with the complexity of youth and the intersection of race, class, and gender formations.

Before I detail more broadly what combining cultural studies with a critical pedagogical theory would mean for educators engaging a new generation of postmodern youth, I want to elaborate on the pedagogical importance of some popular youth films. In short, I am arguing that teachers and students should engage popular films seriously as legitimate forms of social knowledge that reveal different sets of struggles among youth within diverse cultural sites. For white youth, these films mimic traditional coming-of-age narratives indicting the aimlessness and senselessness of life produced within a larger culture of commercial apathy and violence; on the other hand, black youth films posit a not-coming-of-age narrative that serves as a powerful indictment of the violence being waged against and among African-American youths. Clearly, educators can learn from these films and in doing so bring these different accounts of the cultural production of youth together within a common project that addresses the relationship between pedagogy and power, on the one hand, and democracy and the struggle for equality, on the other. The widespread influence of popular films suggests that educators ask new questions, develop new models and new ways of producing an oppositional pedagogy. Such pedagogy must be capable of understanding the different social, economic, and political contexts that produce youth differently within varied sets and relations of power.

Further, teachers must address the desires that different students bring to these popular cultural texts. In other words, what does it mean to mobilize

the desires of students by using forms of social knowledge that constitute the contradictory field of popular culture? The answer lies in part with recognizing that while students are familiar with such texts, they bring different beliefs, political understandings, and affective investments to the learning process. Hence, pedagogy must proceed by acknowledging that conflict will emerge regarding the form and content of popular youth films and how students address the issues the films raise. For pedagogy to work as an empowering practice, Fabienne Worth argues that "students must become visible to themselves and to each other and valued in their differences."[27] This suggests giving students the opportunity to decenter the curriculum by structuring, in part, how the class should be organized and how popular films can be addressed without putting any one student's identity on trial. Using films means recognizing the complexity of mobilizing students' desires as part of a pedagogical project that directly addresses representations affecting their lives, and also means acknowledging the emotional tensions that will emerge in such teaching.

At the same time, pedagogy that engages youth cultures must reverse the cycle of despair that often informs apocalyptic accounts of young people today and it must address how the different postmodern conditions and contexts of youth can be changed in order to expand and deepen the promise of a substantive democracy. In part, engaging youth around questions of their own agency in relation to the world they will inherit means using films about youth that capture the complexity, sense of struggle, and diversity that marks different segments of the current generation of young people. In this instance, reading popular cultural texts becomes part of a broader pedagogical effort to develop a sense of agency in students based on a commitment to changing oppressive contexts by understanding the relations of power that inform them. In this case, cultural studies and pedagogical practice can mutually inform each other by using popular cultural texts as serious objects of study. Such texts can be used to address the limits and possibilities that youth face in different social, cultural, and economic contexts.

CULTURAL STUDIES AND YOUTH: THE PEDAGOGICAL ISSUE

The pedagogical challenge represented by the emergence of a postmodern generation of youth has not been lost on advertisers and market research analysts. According to a 1992 study by the Roper Organization, the current

generation of eighteen- to twenty-nine-year-olds have an annual buying power of 125 billion dollars. Addressing the interests and tastes of this generation, "McDonald's, for instance, has introduced hip-hop music and images to promote burgers and fries, ditto Coca-Cola, with its frenetic commercials touting Coca-Cola Classic."[28] Benetton, Esprit, The Gap, and other companies have followed suit in their attempts to identify and mobilize the desires, identities, and buying patterns of a new generation of youth.[29] What appears as a despairing expression of the postmodern condition to some theorists becomes for others a challenge to invent new market strategies to promote corporate interests. In this scenario, youth may be experiencing the indeterminacy, senselessness, and multiple conditions of postmodernism, but corporate advertisers are attempting to theorize a pedagogy of consumption as part of a new campaign to appropriate postmodern differences among youth across racial, class, gender, and sexual lines. The lesson to be learned from the market's approach to multiculturalism is that differences among youth matter politically and pedagogically, but not simply as a way of generating new markets or registering difference as a fashion index.

What educators need to do is to make the pedagogical more political by addressing both the conditions through which they teach and the question of what it means to learn from this generation. It is a generation that is experiencing life in a way vastly different from the representations offered in modernist versions of schooling. This is not to suggest that modernist schools do not attend to popular culture, but they do so on very problematic terms, which often confine it to the margins of the curriculum. Moreover, modernist schools cannot be rejected outright. As I have shown elsewhere, the political culture of modernism, with its emphasis on social equality, justice, freedom, and human agency, needs to be refigured within rather than outside of an emerging postmodern discourse.[30]

The emergence of the electronic media, coupled with a diminishing faith in the power of human agency, has undermined the traditional visions of schooling and the meaning of pedagogy. The language of lesson plans and upward mobility and the forms of teacher authority on which it was based have been radically delegitimated by the recognition that culture and power are central to the authority/knowledge relationship. Modernism's faith in the past has given way to a future for which traditional markers no longer make sense.

Educators and cultural critics need to address the effects of emerging postmodern conditions on the current generation of young people. These youth appear hostage to the vicissitudes of a changing economic order and its legacy of diminished hopes, on the one hand, and a world of schizoid images and the increasing fragmentation, uncertainty, and randomness that structures postmodern daily life, on the other. Central to this issue is how educators will deal with young people whose identities are forged within the intersection of the economic imperatives of the New World Order, deal with the reconstituting of knowledge and identity through the proliferating electronic media, and deal with a dire sense of indeterminacy about the future.

The field of cultural studies offers educators a theoretical framework for addressing the changing contexts, shifting desires, attitudes, representations, and texts of this new generation of youth being produced within the current historical, economic, and cultural juncture. But cultural studies does more than simply provide a lens for resituating the construction of youth within a shifting and radically altered social, technological, and economic landscape; it also provides the context for rethinking the relationships between culture and power, knowledge and authority, learning and experience, and the role of teachers as public intellectuals. In concluding, I want to point to some of the theoretical elements that link cultural studies and critical pedagogy, and I want to speak briefly to their implications for cultural work.

First, cultural studies is premised on the belief that we have entered a period in which the traditional distinctions that separate and frame established academic disciplines cannot account for the great diversity of cultural and social phenomena that characterize an increasingly hybridized, postindustrial world. The university has long been linked to a notion of national identity that is largely defined by and committed to transmitting traditional Western culture.[31] Traditionally, this has been a culture of exclusion, one that has ignored or marginalized the multiple narratives, histories, and voices of culturally and politically subordinated groups. The emerging proliferation of diverse social movements arguing for a genuinely multicultural and multiracial society has challenged schools that use academic knowledge to license cultural differences in order to regulate and define for students who they are and how they might narrate themselves. Moreover, the spread of electronically mediated culture to all spheres of everyday intellectual and artistic life has shifted the ground of scholarship

away from the traditional disciplines designed to preserve a "common culture" to the more hybridized fields of comparative and world literature, media studies, ecology, society and technology, and popular culture.

Second, advocates of cultural studies have argued strongly that the role of culture, including the power of the media with its massive apparatuses of representation and its regulation of meaning, is central to understanding how the dynamics of power, privilege, and desire structure the daily life of a society.[32] This concern with culture and its connection to power has necessitated a critical interrogation of the relationship between knowledge and authority, the meaning of canonicity, and the historical and social contexts that deliberately shape students' understanding. But if a sea change in the development and reception of what counts as knowledge has taken place, it has been accompanied by an understanding of how we define and apprehend the full range of texts and cultural practices that are open to critical interrogation and analysis. For instance, instead of connecting culture exclusively to the technology of print and to the book as the only legitimate academic artifact, there is a great deal of academic work going on which analyzes how textual, aural, and visual representations are produced and distributed through a variety of cultural forms. These forms include the media, popular culture, film, advertising, mass communications, and other modes of cultural production.[33]

In short, theorists who engage cultural studies attempt to produce new theoretical models and methodologies for addressing the production, structure, and exchange of knowledge. Cultural studies' commitment to inter/post-disciplinary studies is valuable because it addresses the pedagogical issue of organizing dialogue across and outside of the disciplines in order to promote alternative approaches to research and teaching about culture and the newly emerging technologies and forms of knowledge. Hence, some advocates for cultural studies argue that rather than organize courses around strictly disciplinary concerns arising out of English and social studies courses, it might be more useful and relevant for colleges of education to organize courses that broaden students' understanding of themselves and others by examining events that evoke a sense of social responsibility and moral accountability. A course on "Immigration and Politics in Fin-de-Siècle United States" could provide a historical perspective on the demographic changes confronting America and on how such changes are being felt within the shifting dynamics of education,

own stories, and engage in respectful dialogue with others. In this instance, cultural studies must address how dialogue about other cultures and voices is constructed in the classroom by critically addressing both the position of the theorists and the institutions in which such dialogues are produced. Peter Hitchcock argues forcefully that the governing principles of any such dialogic exchange should include some of the following elements:

> 1) attention to the specific institutional setting in which this activity takes place; 2) self-reflexivity regarding the particular identities of the teacher and students who collectively undertake this activity; 3) an awareness that the cultural identities at stake in "other" cultures are in the process-of-becoming in dialogic interaction and are not static as subjects; but 4) the knowledge produced through this activity is always already contestable and by definition is not the knowledge of the other as the other would know herself or himself.[35]

Fourth, another important contribution of cultural studies is its emphasis on studying the production, reception, and use of various texts, and how they are used to define diverse notions of self, values, community, social relations, and the future. Texts in this sense do not merely refer to the culture of print or the technology of the book, but to all those audio, visual, and electronically mediated forms of knowledge that have prompted a radical shift in the construction of knowledge and the ways in which knowledge is read, received, and consumed. It is worth repeating that contemporary youth increasingly rely less on the technology and culture of the book to construct and affirm their identities. The new technologies which construct and position youth represent interactive terrains that cut across "language and culture, without narrative requirements, without character complexities. . . . Narrative complexity [has given] way to design complexity; story [has given] way to a sensory environment."[36] Cultural studies is profoundly important for educators in that it focuses on media not merely in terms of how it distorts and misrepresents reality, but also on how media plays "a part in the formation, in the constitution, of the things they reflect. It is not that there is a world outside, 'out there,' which exists free of the discourse of representation. What is 'out there' is, in part, constituted by how it is represented."[37]

I do not believe that educators and schools of education can address the shifting attitudes, experiences, knowledge, representations, and desires

of this new generation of youth within the dominant disciplinary configurations of knowledge and practice. On the contrary, as youth are constituted within languages and new cultural forms that intersect with issues of race, class, gender, and sexual difference, how youth narrate themselves must be understood through both the specificity of their struggles and the necessity of a shared language of agency, a language that points to a project of hope and possibility rather than a crippling determinism. It is precisely this language of difference, specificity, and possibility that is lacking from most attempts at educational reform.

Fifth, when critical pedagogy is established as one of the defining principles of cultural studies, it is possible to generate a new discourse for moving beyond a limited emphasis on the mastery of techniques and methodologies. Critical pedagogy represents a form of cultural production implicated in and critically attentive to how power and meaning are employed in the construction and organization of knowledge, desires, values and identities. Critical pedagogy in this sense is not reduced to the mastering of skills or techniques, but is defined as a cultural practice that must be accountable ethically and politically for the stories it produces, the claims it makes on social memories, and the images of the future it deems legitimate. As both an object of critique and a method of cultural production, it refuses to hide behind claims of objectivity and works vigorously to link theory, context, and practice to enhance the possibilities for human agency in a world of diminishing returns. The notion of critical pedagogy as a cultural practice has been challenged by liberals and conservatives who suggest that because critical pedagogy attempts to both politicize teaching and teach politics, it represents a species of indoctrination. However, by asserting that all teaching is profoundly political and that critical educators and cultural workers should operate out of a project of social transformation, I am arguing that as educators we need to recognize the political nature of education while avoiding pedagogical practices legitimated through forms of cultural authority that are not open to critical interrogation by students, and that often function to impose beliefs rather than open them up to critical dialogue.

A political education is different from a politicizing education. "Political education" means teaching students to take risks, challenge those with power, honor critical traditions, and be reflexive about how authority is used in the classroom. On the other hand, a "politicizing education"

refuses to address its own political agenda, silences through an appeal to a teacher driven methodology, objectivity, or notion of balance. Politicizing education perpetuates pedagogical violence, while a political education expands the pedagogical conditions for students to understand how power works on them, through them, and for them in the service of constructing and deepening their roles as engaged thinkers and critical citizens. I will develop the distinction between political and politicizing education in more detail throughout the remaining chapters of this book.

CONCLUSION

The conditions and problems of contemporary youth will have to be engaged through a willingness to interrogate the world of public politics. At the same time, while teachers and students might appropriate modernity's call for a better world, it is necessary to abandon its linear narratives of Western history, unified culture, disciplinary order, and technological progress. Hence, the pedagogical importance of uncertainty and indeterminacy needs to be rethought through a modernist notion of the dream-world, in which youth and others can shape, without the benefit of master narratives, the conditions for producing new ways of learning, engaging, and positing the possibilities for social struggle and solidarity. Critical educators cannot subscribe neither to an apocalyptic emptiness that adopts the worst form of relativism nor to a politics of refusal that celebrates the abandonment of authority. They cannot embrace the immediacy of experience over the more profound dynamic of social memory and moral outrage forged within and against conditions of exploitation, oppression, and the abuse of power.

The intersection of cultural studies and critical pedagogy offers the possibility for educators to confront history as more than simulacra and ethics as something other than the casualty of endless language games. Educators need to assert a politics that makes the relationship among authority, ethics, and power central to a pedagogy that expands rather than closes down the possibilities of a radical democratic society. Within this discourse, images do not dissolve reality into another text: On the contrary, representations become central to revealing the structures of power at work in schools, in society, and in the larger global order. Pedagogy does not succumb to the whims of the market place nor to the latest form of educational chic; instead, critical pedagogy engages cultural studies as part

Racism and the

Aesthetic

of Hyper-real

PULP FICTION AND OTHER VISUAL TRAGEDIES

Violence

I have no responsibility to anything other than my shit and the charac-
ters and being as true to them as I possibly can....They [the audience]
don't have to watch, and that's fine. I don't have any patience with all
that self-righteous shit. Just don't watch it, man.

—Quentin Tarantino

American cinema has increasingly provided a
site of convergence for depicting both the inner-city "reality" of
black-on-black youth violence and for promoting a renewed
"acceptability and/or tolerance of straightforward racist doctrine."[1]
Recent films focusing on black urban violence, such as Boyz N the Hood
(1991), Juice (1992), Menace II Society (1993), Sugar Hill (1994), Fresh
(1994), and New Jersey Drive (1995) have attracted national media cov-
erage because they do not simply represent contemporary urban

realities but also reinforce the popular perception that everyday black urban life and violent crime mutually define each other. Cinema appears to be providing a new language and aesthetic in which the city becomes the central site for social disorder and violence, and black youth in particular become agents of crime, pathology, and moral decay.

Real life and celluloid images blur as the representations of race and violence proliferate more broadly through the news media's extensive coverage of youth violence. Such coverage not infrequently highlights gore, guts, hysteria, and other tawdry Hollywood effects to punctuate its sensationalist, often racist, commentary. The relationship between the everyday and cinematic representations is often taken up as causal, as when the national media recently focused on Hispanic youth in Los Angeles, New York, and New Jersey who rioted or fought each other outside of the movie theaters in which gangsta films were being shown. In examining these real and symbolic representations of black-on-black violence, the popular press used the incident to link exposure to media violence with aggressive, antisocial behavior in real life. The press did not use these events to call public attention to the "violence to the mind, body, and spirit of crumbling schools, low teacher expectations, unemployment and housing discrimination, racist dragnets and everyday looks of hate by people who find [black youth] guilty by suspicion."[2] Instead of focusing on how larger social injustices and failed policies, especially those at the root of America's system of inequality, contribute to a culture of violence that is a tragedy for all youth, the dominant media transformed the growing incidence of youth violence into a focus on black-on-black fratricide. In this particular instance, the representation of black youth was used as a vehicle to thematize the causal relationship between violence and the discourse of pathology. Such racially coded discourse serves to mobilize white fears and legitimate "drastic measures" in social policy in the name of crime reform.[3] Moreover, the discourse of race and violence provides a sense of social distance and moral privilege that places dominant white society outside of the web of violence and social responsibility.

Another example of how cinematic representations and "objective" reporting mutually reinforce a narrow, racial coding of violence can be seen in an incident that happened at a local movie theater in Oakland, California. A group of Castlemont High School students in Oakland, California were taken to see *Schindler's List* (1993) on Martin Luther King

Day as part of the school's effort to deepen their sense of the history of oppression, and to broaden their understanding of the struggle for human rights. The students, most of them black and Hispanic, laughed at some of the most violent scenes in the film. The manager of the theater reacted in shock and asked them to leave. The story received national attention in the popular press, and echoed the stereotypical assumption that these students mirrored in their own personalities the nihilism and pathology that inevitably led to increased disorder and criminality. In the age of Newt Gingrich, pathology has become a characteristic of the racially marginal space of the urban city, a space of gruesome violence that threatens to spread outward to the "safe" confines of middle-class America.

Hardly a paragon of objectivity, the media betrays through its portrayal of this episode a certain tragic irony in representing black youth as the source rather than the victims of violence. In fact, recent statistics reveal that "young black males constituted 17.7 percent of all homicide victims, even though they made up only 1.3 percent of the U.S. population. [Moreover] black men over age 24 were victims of homicide at a rate of 65.7 per 100,000, compared with 7.8 per 100,000 for white men."[4] The media portrait nonetheless reflects the conservative mood of the country: treating violent youth as dangerous urban aliens is a guaranteed crowd pleaser; focusing on the devastating effects of (white) racism, rising poverty, and unemployment for a generation of black youth is less popular.[5]

What is so crucial about the above examples is that the largely white dominant media, while critical of the particular response of black and Hispanic children to the inhumane consequences of Nazi violence, refused to analyze in any significant way the larger culture of violence that permeates the United States. Such an investigation might explain the insensitive response of the school children to the violence portrayed in *Schindler's List*, but it would also demand that white society examine its own complicity in producing an ever spreading culture of violence, whose hip nihilism makes it difficult for anyone to draw a meaningful line between the normal and the pathological. Moreover, as the context and the conditions for the production of violent representations are justified in the name of entertainment and high box office profits, youth increasingly experience themselves as both the subject and the objects of everyday violence and brutality. The cheap editorializing by the popular press and dominant media offer skewed portrayals of youth that cover over the fact that "young

people ages 12 to 17 are the most common victims of crime in America, with a 1 in 13 chance of being raped, robbed, or assaulted."[6] While the relationship between representational violence and its impact on children and youth is not clear, the culture of violence spawned by television, videos, and film is too pervasive to be ignored or dismissed.

I want to argue that media culture is the central terrain on which the new racism has emerged. What counts as a source of education for many youth appears to reside in the spawning of electronic media, including radio talk shows, television, and film. This is evident in the resurgent racism that has become popular among talk show hosts such as Bob Grant, who refers to African-Americans as "primates." It is also apparent in films such as *Just Cause* (1995), in which traditional stereotypes of young black males as rapists are recycled in order to fuel conservative enthusiasm for legalizing the death penalty. Television culture increasingly reduces black youths to the figure of the urban gangsta and rap music to that of musical signifier for legitimating a drug culture, violence, and sexism. Violence has become increasingly a source of pleasure in a media-saturated culture. Either displayed as a site of voyeuristic titillation and gory spectacle or defined primarily as an ideology of the aesthetic, violence functions as a defining principle in all the major mediums of information and entertainment. Given the ways in which violence becomes part of a new aesthetic, it is all the more imperative for educators and cultural workers to find ways of scrutinizing its mechanisms. They must explore its political and pedagogical implications for producing and legitimizing particular ideologies and representations of youth. How do educators prepare youth and others to think through representations of violence in order to understand them critically as "vehicles through which society's racial contradictions, injustices, and failed policies are mediated?"[7] Educators need pedagogical strategies that move between dominant and oppositional appropriations of violence. These will enable them to develop alternative understandings of how violence is produced, framed aesthetically, circulated, and ruptured. Violence may then be connected with broader considerations of critique, social engagement, and public discourse.[8]

The moment of violence in films is never arbitrary nor innocent. Yet, there is no singular reading or simple yardstick that can be used to either condone or condemn how violence is represented, taken up by diverse audiences, or used to maximize pleasure so as to give the aesthetics and

RACE, VIOLENCE, AND CHILDREN'S CULTURE

content of violence a liberatory or oppressive edge. Cinematic violence can be used to probe the depths of everyday life in ways that expand one's understanding of tyranny and domination; such violence can also be used to maximize the sleazy side of pleasure, reinforce demeaning stereotypes, or provoke cheap voyeurism. Cinematic violence operates on many registers, and any theoretical attempt to deal with complex representations of violence must be discriminatory in taking up such distinctions. As widespread as the culture of violence might be, it is especially imperative that educators, parents, and citizens challenge the representations of violence that have become a defining principle of the visual media. Such a challenge needs to be enunciated critically as part of a broader public policy, one that would both protect youth, especially young children, and enable them to distinguish between two kinds of violence—the violence of the spectacle and the representational violence that allows them to identify with the suffering of others, display empathy, and bring their own ethical commitments to bear.

In what follows, first I want to offer an arbitrary and schematic definition of different representations of violence in order to provide a theoretical groundwork for making important discriminations about how violence is constructed in films, how it mobilizes specific forms of identification, and how it might be addressed pedagogically. Second, I will examine how the ultraviolence emerging in popular films heralded as part of a new avant-garde constructs forms of cultural racism. (This ultraviolence is an aestheticized violence that appeals to a generation of youth raised on the fast-paced programming of MTV and the ethical indifference of the 1980s.) In addition, I will take up how racially coded violence works to exclude dominant white society from any responsibility or complicity with the larger culture of violence while simultaneously shifting the burden of crime and social decay to people of color, working-class whites, and other subordinate groups. In developing this perspective, I will explore the important intersections of what can be called entertainment, politics, and pedagogy in the electronic media by addressing the widely acclaimed films by Quentin Tarantino, *Reservoir Dogs* (1992) and *Pulp Fiction* (1994). Finally, I will conclude by suggesting how educators and other cultural workers can think through pedagogical and political strategies to understand and critically engage racism as inextricably linked to the rising culture of violence in the United States.

RITUALISTIC, SYMBOLIC, AND HYPER-REAL VIOLENCE

Statistics regarding the representation of violence in media culture border on the outrageous. George Gerbner, a professor and dean emeritus at the Annenberg School for Communication at the University of Pennsylvania, has been monitoring violence on television for the last twenty years. According to Gerbner's studies, the major broadcast networks average about five acts of violence an hour in their prime-time programming. This is an alarming figure given that the visual media has become an overwhelming fact of cultural life. "The [television] set is on an average of 7 hours a day in the average American home. . . . Most viewers watch by the clock and not by the program."[9] For example, it has been reported that for the last fifteen years on Saturday morning, when children do most of their viewing, the networks averaged about twenty-five acts of violence an hour. Moreover, "researchers estimate that the average child will watch one hundred thousand acts of simulated violence before graduating from elementary school. And studies have shown that poor children see even more."[10] In addition, "by the age of 18, the average American child has witnessed 18,000 simulated murders on television."[11] Increasingly, motion picture violence has followed the path of television, especially since much of the profits generated from theater movies will be made through videocassette sales. Serious films have given way to the blockbuster, and the tradeoff has been an increase in the number of violent films shown in movie theaters across the United States.

If educators are going to move beyond simply condemning representational violence in a wholesale fashion, it becomes necessary to draw distinctions, however crudely, between the stylized violence of the spectacle and violence that can illuminate important messages about the basis of humanity and inhumanity. Thus, the imperative for teachers and others goes beyond simply quantifying violence in the visual media. For example, the violence portrayed in films as different as *Schindler's List* (1993) and *Die Hard with a Vengeance* (1995) registers disparate interests and assumptions. In the former, violence is used to inscribe in public memory the tragic event of the Holocaust, an historical event that should be neither forgotten nor repeated. However, the violence in spectacle films such as *Die Hard with a Vengeance* is kitsch serving up cheap entertainment. This particular form of violence celebrates the sensational and the gruesome; it contains no redeeming value except to parade its endless stream

of blood and gore at the expense of dramatic structure, emotional depth, and social relevance.

Hence, in analyzing visual violence, I will loosely distinguish three forms: ritualistic, symbolic, and hyper-real. First, there is what I will call ritualistic violence, ritualistic in the sense that violence is at the center of the genres that produce it—horror, action-adventure, Hollywood drama—utterly banal, predictable, and often stereotypically masculine. This type of violence is pure spectacle in form and superficial in content. Audiences connect with such depictions viscerally; yet it is not edifying in the best pedagogical sense, offering few insights into the complex range of human behavior and struggles. Ritualistic violence is racy, sensationalist, and testosterone laden. It does not recast ordinary events or critically attempt to shift sensibilities. On the contrary, it glows in the heat of the spectacle, shock, and contrivance, yet it is entirely formulaic. This is the Bruce Willis and Arnold Schwarzenegger school of violence, fueling blockbusters such as *Die Hard with a Vengeance* (1995) and *True Lies* (1994). Other examples can be found in films such as *Speed* (1994), *Blown Away* (1994), and *The Fugitive* (1994). Within these films there is an "echo of the pornographic in maximizing the pleasure of violence."[12] Representations of ritualistic violence derive their force through countless repetitions of graphic cruelty, serving to numb the senses with an endless stream of infantilized, histrionic flair. For example, the hero of *Robocop II* (1990) massacres eighty-one people, while Bruce Willis yields a body count of 264 in *Die Hard 2*.[13] Excessive violence, in this case, is valorized to the degree that it reproduces the genre with new psychological and visual twists, yet never asking more from the audience than the programmed response. Referencing only itself as heightened spectacle, violence in the Hollywood blockbuster film offers viewers voyeuristic identification rather than providing an opportunity for the audience to think through and scrutinize the mechanisms and implications of violence.

One of the pedagogical consequences of ritualistic violence is that it contributes to the commonsensical assumption that Hollywood film is strictly about entertainment and need not be judged for its political and pedagogical implications. Hence, as a formalist principle, it is complicitous with other forms of media culture that offer no challenge to the current conservative attempt to construct public memory as part of a broader effort to demonize the legacy of the 1960s, with their association of youth and resistance. Passing for simply entertainment, ritualistic violence in film

draws attention away from representational politics, which often codes black youth as criminals, welfare recipients as morally depraved, and the city as a site of degeneracy. But ritualistic violence in films does more than entertain, it erases history as it rewrites it and in doing so appeals to an earlier age when the model of youth was suburban, white, and raised by down-to-earth parents of the Ozzie and Harriet look-alike variety.

Ritualistic violence in many ways serves as a prop to evoke and legitimate a largely conservative view of public memory. Ritualistic violence often plays to both the fear of crime and the desire for another time in history when minorities knew their place and women were not on the picket lines fighting for their rights. Amid the glut of violent, blockbuster films, Hollywood movies like *Forrest Gump* (1994), *Nell* (1994), *I.Q.* (1994), and *Dumb and Dumber* (1995) appear as welcomed, clean family fun, a cinematic antidote that harks back to a nostalgic past. But such films do more than serve as relief from the overdose of cinematic violence; they are also indicative of how public memory gets rewritten Hollywood-style. Such "harmless" films serve largely both to entertain and legitimate a past cleansed of conflict. Within this cinematic script, cultural differences become un-American, and a willfully anti-intellectual individualism provides the model for citizenship. But Hollywood films do more than induce historical amnesia; they are also sites of struggle and resistance both in terms of what they try to say and how they are taken up by diverse audiences. It is precisely through the defining principles of a critical self-consciousness regarding their own location within the larger culture and their concern with social criticism that Hollywood film has engaged and taken up what can be called symbolic violence.

The second type of violence, symbolic violence, has a long cinematic tradition and can be recognized in more recent films such as Oliver Stone's *Platoon* (1987), Clint Eastwood's *Unforgiven* (1992), Neil Jordan's *The Crying Game* (1992), and Steven Speilberg's *Schindler's List* (1993). Symbolic violence attempts to connect the visceral and the reflective. It couples the mobilization of emotion and the haunting images of the unwelcome with an attempt to "give meaning and import to our mortal twitchings. . . . [I]t shakes everything up, reforming the fictive environment around itself."[14] Symbolic violence does not become an end in itself; it serves to reference a broader logic and set of insights. Instead of providing the viewer with stylistic gore that offers the immediacy of visual pleasure and escape, sym-

bolic violence probes the complex contradictions that shape human agency, the limits of rationality, and the existential issues that tie us to other human beings and a broader social world. Symbolic violence refuses the techniques of fast-paced rhythmic frames, or a dizzying pattern of repetitious images. Instead, it attempts to "find ways of scrutinizing the mechanisms and implications of violence through different processes of framing, juxtaposing, repeating and quoting images"[15] within a context that invites critical and meaningful commentary.

For example, in *Platoon* Oliver Stone uses violence as a vehicle for rewriting the Hollywood war movie and in doing so attempts to demystify national chauvinism as a legitimation for waging war in Vietnam. *Platoon* also foregrounds violence as an explosive index of class and racial tensions that give rise to contradictory loyalties, acts of aggression, and the painful psychological experiences many troops endured in the jungles of Vietnam. In this case, violence has a determining role, that is, it has consequences portrayed in the film that connect morality and human agency.

A similar example of symbolic violence can be seen in Clint Eastwood's film *Unforgiven*, which virtually rewrites the traditional John Wayne version of the American West. Against the romantic narratives of helpless heroines, shootouts at sundown, and cowboy heroism, Eastwood creates a film in which violence serves as both a spectacle and an ethical referent for exploding the myth of a West in which women are only ornaments, justice is pristine and unadulterated, and white male heroes bask in the splendor of the fast draw. *Unforgiven* rewrites the traditional and revisionist Western and in doing so raises ethical questions concerning how violence has been mythologized and decontextualized so as to reinvent a nostalgic and utterly false version of the American past, a past that once again seemed to shape public memory and national identity with the election of Ronald Reagan in 1980.[16] Through a cinematic rupturing of the culture of violence, *Unforgiven* engages in a critical form of memory-work that ruptures a conservative rendering of history.

The third type of cinematic violence I want to address is hyper-real violence. This form of violence has emerged relatively recently and can be seen in a number of contemporary films, including these: *Reservoir Dogs*, a nicely textured film that boldly chronicles the gang violence and torture of a police officer after a botched jewelry heist; *Natural Born Killers* (1994), which tells the story of Mickey and Mallory, two young serial killers who

63

become media sensations; Killing Zoe (1993), which tells the story of a failed bank robbery as a pretext for exploring the loss of intimacy, romance, and the psychological depths of psychotic violence; and Pulp Fiction (1994), the most celebrated of films depicting the new violence. Pulp Fiction is constructed loosely around three stories that pay homage to the pulp crime genre of the 1930s in the United States. On the international scene, hyper-real violence can be seen in films such as John Woo's Hong Kong production, The Killer (1989), and in the 1992 Belgian movie Man Bites Dog by Remy Belvaux and Andre Bonzel.

What is new in these films is the emergence of a form of ultraviolence marked by technological overstimulation, gritty dialogue, dramatic storytelling, parody, and an appeal to gutsy realism. Whereas ritualist violence is shorn of any critical social engagement, hyper-real violence exploits the seamy side of controversial issues. It appeals to primal emotions and has a generational quality that captures the actual violence that youth encounter in the streets and neighborhoods of an increasingly racially divided America.

Hyper-real violence—with its technological wizardry and its formalist appeals, irony, guilt-free humor, wise guy dialogue, genuflection to the cultural pap of the '70s—represents a marker of the age. In some ways it both demonstrates and redefines Hannah Arendt's insightful comment about the banality of violence.[17] For Arendt, violence is banal because its ubiquity makes it more difficult for human beings in the twentieth century not to be implicated or addressed by it. It was precisely the ubiquity and the mundane nature of violence that Arendt believed made it a serious danger to civil society. The hyper-real violence of the new gangsta genre parading as film noir appears to mock Arendt's insight by isolating terrifying events from wider social context. Films in this genre are filled with an endless stream of characters who thrive in a moral limbo and define themselves by embracing senseless acts of violence as a defining principle of life legitimated by a hard dose of cruelty and cynicism. For the mostly young directors of the new hyper-real violent films, it is precisely the familiarity and commonality of everyday violence that renders it a prime target to commodify, sensationalize, and subordinate to the ideology of the aesthetic of realism. Audiences can gaze at celluloid blood and gore and comfortably refuse any complicity or involvement for engaging the relationship between symbolic and real violence.

But hyper-real violence in the new cinema represents more than moral indifference coupled with cultural slumming. The form and content of the new hyper-real films go beyond emptying representations of violence of any ethical content; they also legitimate rather than contest, by virtue of their documentary appeal to what is, the spreading acts of symbolic and real violence rooted in and shaped by a larger racist culture.[18] Representations of violence can no longer be separated from representations of race; they mutually inform each other in terms of what is both included and left out of such representations. Nowhere is this more evident than in the wave of new avant-garde films informed by hyper-real violence. But before I discuss *Reservoir Dogs* and *Pulp Fiction* as exemplary films in this regard, I want to map out briefly some representative signposts indicating the extent to which race, white panic, and dominant media images of violence circulate in the wider culture of representations so as to lend credibility to the racism being produced in the new wave of hyper-real violent films.

WHITE PANIC AND THE RACIAL CODING OF VIOLENCE

Incidents of material violence in the United States have become so commonplace that they seem to constitute the defining principle of everyday life. Acts of violence ranging from the banal to the sensational increasingly dominate the contents of newspaper accounts, television news programs, and popular magazines. What I want to explore, however, are the ways in which the never-ending images of violence seem to cancel out the actual experience and suffering caused by violence as the American public is bombarded with daily images ranging from coverage of the O.J. Simpson trial to reports of serial killers who maim and murder victims with bombs sent in packages through the mail. Featured in the newspaper, the evening news, or talk radio, the reality of everyday violence is supplemented by a culture of violence produced as entertainment for broadcast and cable television programs, movie theater films, and video games. Within this expanding culture of violence, the relationship between fact and fiction becomes more difficult to comprehend as real life crimes become the basis for television and movie entertainment and newscasting becomes increasingly formulaic, sensational, and less neutral and objective.

While violence appears to cross over designated borders of class, race, and social space, the representation of violence in the popular media is largely depicted in racial terms.[19] As the fact-reporting and entertainment

spheres merge in media culture, representations of violence are largely portrayed through forms of racial coding that suggests that violence is a black problem, a problem outside of white suburban America. In fact, white Americans fancy themselves the new besieged group of the '90s—voiceless and powerless before the thought police of the political correctness movement. No longer safe from the threat of urban violence, they increasingly view themselves as prisoners in their own homes and neighborhoods.

Beneath the growing culture of violence, both real and simulated, there lies a deep-seated racism that has produced what I want to call a white moral panic. The elements of this panic are rooted, in part, in a growing fear among the white middle class over the declining quality of social, political, and economic life that has resulted from an increase in poverty, drugs, hate, guns, unemployment, social disfranchisement, and hopelessness. Expressions of the white panic can be seen in the passing of Proposition 187, which assigns increasing crime, welfare abuse, moral decay, and social disorder to the flood of Mexican immigrants streaming across the borders of the United States. White panic can also be read in the depictions of crime that appear in national newspapers and magazines. For example, *Time Magazine*, following the arrest of O.J. Simpson, presented his jail mug shot on its cover with a much darkened face, feeding into the national obsession of the black male as a dreaded criminal—a racist gesture for which the magazine had to subsequently issue an apology. Even more aggressively, *The New York Times Magazine* ran a cover story on June 27, 1993 titled "A Predator's Struggle to Tame Himself," accompanied by a picture of a tall, black male prisoner on the cover. In August of 1994, *The Times Magazine* ran another cover story on youth gangs, and put a picture of an African-American woman on the cover. Again in December of 1994, it ran yet another story titled, "The Black Man Is in Terrible Trouble. Whose Problem Is That?" The story was accompanied by a cover picture of the back of a black man's shaved head, displayed with a gold ring prominently hanging from his ear. The following week *The New York Times Magazine* ran a lead story on welfare and referenced it with the image of a black woman on the cover.[20] What is reprehensible about the endless repetition of these images is that they not only reproduce racist stereotypes about blacks by portraying them as criminals and welfare cheats, but they remove whites from any responsibility or complicity for the violence and poverty that has become so endemic to American life. Racist representations feed and valorize the

assumption that unemployment, poverty, disenfranchisement, and violence are a black problem. One of the more recent expressions of resurgent racism in the media can be seen in the massive popular news, television, and magazine coverage given to *The Bell Curve* by Richard Herrnstein and Charles Murray, a book that legitimates the position that racism "is a respectable intellectual position, and has a legitimate place in the national debate on race."[21] Herrnstein and Murray, among others, provide a discourse in which the white majority righteously situates itself in the role of moral witness and judge of the fate of black people in this country.

The racial coding of violence is especially powerful and pervasive in its association of crime with black youth. As Holly Sklar points out, "In shorthand stereotype, black and latino boys mean dangerous, girls mean welfare, they all mean drugs. They are all suspect."[22] One need only consider widespread popular media coverage linking black rap music with gang violence, drugs, and urban terror, or Senator Bob Dole's attack on rap artists for contributing to violence in the social order. This is the same Bob Dole who is a major supporter of the National Rifle Association and is leading the charge in the Senate to repeal the ban on assault weapons. Motion pictures depicting "realistic" portrayals of black ghetto life add fuel to the fire by becoming a register in the popular mind for legitimating race and violence as mutually informing categories.[23] The consequences of such racist stereotyping produce more than prejudice and fear in the white collective sensibility. Racist representations of violence also feed the increasing public outcry for tougher crime bills designed to build more prisons and legislate get-tough policies with minorities of color and class. All of this is accompanied by the proliferation of pseudoscientific studies that envision the creation of a custodial state to contain "some substantial minority of the nation's population, while the rest of America tries to go about its business."[24]

In the mass-mediated cultural spheres that shape individual and social consciousness, social and political causes of violence are often elided. The media highlights the simplistic calls of conservative politicians for more prisons, orphanages for the children of poor black and white mothers, and censorship of the arts and public broadcasting. Fueled by a ruthless indifference to human suffering coupled with a penchant for simplistic answers, the conservative approach to violence and other social issues ignores pedagogically appropriate alternatives such as education, community building,

and public debate. Whether in the portrayal of popular black music or in Hollywood movies, a predisposition toward violence becomes the defining attribute and justification for indicting an entire racial group. Of course, violence is not absent from representations of white youth and adults, but it is rarely depicted so as to suggest that aggression and violence represent an inherent quality of what it means to be white, or that violence is a central construction in the formation of the history of dominant white society in the United States.

On the contrary, violence in films about white youth is framed almost exclusively through the language of individual pathology, political extremism, or class specific nihilism. For example, the white youth portrayed in *Natural Born Killers* (1994) become acceptable to white audiences because the possibility for identification never emerges. They are pathological killers, children of grossly dysfunctional families, clearly outside of the parameters of normalcy that prevail in white society in general.[25] Another critically acclaimed avant-garde youth film, *True Romance* (1993), couples a certain postmodern pension for popular culture, amoralism, and a slick aestheticism with violence. In this film, 1970s retro trash and pop cultural icons inform contemporary white youth culture, including an Elvis character with a gold jacket who dispenses advice in bathrooms, a heroin addict who enjoys kung fu movies, and a leading character who works in a comic book store. Youth in this film become a metaphor for the end of civilization. Exhaustion and despair define their connection with a society in which the only stimulation left appears to be in the spectacle of sensation and the thrill machine of gratuitous violence.

Youth are isolated and estranged in these films and can offer no indictment of American society not only because they embrace a disturbing nihilism, but also because they appear marginal, shiftless, and far removed from Dan Quayle's notion of American family values. Youth are on the margins, and the hip violence in which they engage has the comfortable aura of low-life craziness about it. You won't find these kids in a Disney film. The portrayal of white youth violence emerges through an endless series of repugnant characters whose saving grace, for those who might have to endure the shock of recognition, resides in their being on the extreme psychological and economic edges of society. Often when the media focuses on white youth who commit violent acts, anguished questions of agency, moral accountability, and social responsibility do not apply.

Agency for violent white youth is contaminated by a personal pathology that never questions the social and historical conditions at work in its own construction. On the other hand, in the racially coded representations of violence in black films, violence does not register as the result of individual pathology. Here the violence of representation serves to indict blacks as an entire racial group while legitimating the popular stereotype that their communities are the central sites of crime, lawlessness, and immorality.

For example, in films about violent white youth such as *Laws of Gravity* (1992), *Kalifornia* (1993), *Natural Born Killers* (1994), and *Kids* (1995), the language of hopelessness and desperation cancels out any investigation into how agency is constructed as opposed to simply guaranteed in the larger political and social sense. But in black youth films such as *Menace II Society* (1993), *Jason's Lyric* (1994), and *New Jersey Drive* (1995) there is the haunting sense that blacks are solely responsible for the narrow range of possibilities that inform their lives and result in an everyday existence with little hope amid a culture of nihilism and deprivation.[26] In the end, black powerlessness becomes synonymous with criminality. By refusing to explore the complex constraints black youth have to face in everyday life, these films avoid altogether the role that historical, social, and economic determinants play in setting limits to human agency within poor urban neighborhoods. Consequently, such films offer no language for illuminating social forces outside of the discourse of racism, Social Darwinism, pathology, and cynicism. In short, dominant representations of black and white youth violence feed right-wing conservative values in the Newt Gingrich era while offering little recognition of the densely populated landscape of violence at the heart of white dominant society.

The racist coding of representations of black youth tells us less about such youth than it does about how white society configures public memory, stability and disorder, and the experiences of marginal groups in America. At the same time, the resurgence of racist culture poses a challenge to educators for redefining the politics of transformative teaching through a broader notion of what it means critically to engage various sites of learning through which youth learn about knowledge, values, and social identities. Racism in film and public life points to a widening crisis of vision, meaning, and community in the United States. It is within this broader public crisis that the emergence of hyper-real violence takes on a significance that exceeds the cur-

rent fascination with films that employ a combination of nihilistic violence and formalistic inventiveness, a biting sense of irony, and scornful cynicism.

Functioning as teaching machines, the new hyper-real, avant-garde films become both an expression of the erosion of civil society and a challenge for educators and others to rethink how such representations of violence "can be wrested away from a reality in which madness reigns."[27] In what follows, I want to address the work of writer and film director Quentin Tarantino, focusing in particular on *Reservoir Dogs* (1992) and his most recent and controversial film, *Pulp Fiction* (1994). Both of these films are exemplary for analyzing the new genre of hyper-real violent films characteristic of the 1990s, and how film functions as part of a broader public discourse.

VIOLENCE AS ART IN *RESERVOIR DOGS*

In 1992, Quentin Tarantino wrote and directed *Reservoir Dogs*, a low-budget gangster film made in the cinematic tradition of earlier films directed by Robert Altman, Martin Scorsese, and Stanley Kubrick. But unlike his famous predecessors, Tarantino redefines the staple elements of the pulp genre—murder, drugs, sex, violence, and betrayal—by introducing self-consciously witty dialogue, formal inventiveness, and slick, yet casual violence so as to elevate what had been judged traditionally a B-movie genre into an avant-garde art form.

Organized around a botched jewelry story robbery by a group of young white men, the film follows the group to a warehouse where they hide out after the blood bath that ensued after the heist. The warehouse becomes the set as the film unfolds around the fates of a wounded undercover cop posing as one of the robbers and a police officer kidnapped after the robbery, and around the disputes that emerge among the tense and restless gangsters. Focusing less on the anatomy of the crime, *Reservoir Dogs* explores in decelerated time how white male identities under siege construct their lives through an endless stream of smutty jokes, racist and sexist language, hard-edged sentiment, and gratuitous, casual violence. Tarantino rewrites the aesthetic of violence in this film in postmodern terms. Rather than relying on fast-paced images of brutality, Tarantino slows down the violence and gives it a heightened aesthetic twist, as the film unfolds between an homage to realism and rupturing scenes of numbing sadism. From the onset, the plot develops in a graphic scene in which Mr. Orange (Tim Roth), who has been wounded in the robbery, lies on the barren ware-

house floor slowly bleeding to death. As the film develops, the pool of blood that surrounds his body gets progressively wider until Mr. Orange appears like a small boat set adrift in a river of his own blood. In the most riveting scene in the film, one that has become a hallmark of Tarantino's style, the captive police officer is tortured by Mr. Blonde (Michael Madsen). Cranking up the volume on the radio, Mr. Blonde dances across the floor to the tune of "Stuck in the Middle With You," he then flicks open a straight razor and cuts off the police officer's right ear. He then pours gasoline over his victim's body but before he can set the cop on fire, Mr. Orange (Tim Roth) becomes conscious long enough to fatally shoot Mr. Blonde. Combining elements of stylized violence, brutal sadism, cruel irony, and pop cultural retro-kitsch, Tarantino revels in stylistic excess in order to push the aesthetic of violence to its visual and emotional limits.

The graphic violence in *Reservoir Dogs* refuses to stand alone as the centerpiece of the film. It is mediated and authenticated by a tough guy vernacular that rivals the film's bankrupt sensationalism, offering the audience the scandal of horror and the seduction of realism without any understanding of the link between violence and larger social forces. The violence embedded in language, a central structural principle of the film, becomes clear in its opening scene. A group of working-class men dressed in black suits sit around a restaurant table discussing in great detail the meaning of Madonna's song, "Like A Virgin." One of the characters, Mr. Brown, played by Tarantino, provides the following tough guy monologue:

> Let me tell you what "Like a Virgin"'s about. It's about this cooz who's a regular fuckin' machine. I'm talkin' mornin' day night afternoon dick dick dick dick dick dick dick. Then one day she meets this John Holmes motherfucker and it's like, Whoa baby. I mean this cat is like Charles Bronson in The Great Escape: he's diggin' tunnels. All right, she's gettin' some serious dick action and she's feelin' somethin' she hasn't felt since forever. Pain Pain. It hurts, it hurts her . . . just like it did the first time. You see the pain is remindin' the fuck machine what it was once like to be a virgin. Hence, "Like a Virgin."
> (Reservoir Dogs, 1992)

Working-class machismo emerges in *Reservoir Dogs* as Tarantino's assembly of characters talk and trade insults as if they are off the streets of Bensonhurst, splintering their language with terms like "cooz," "niggers," and "jungle

bunnies." Sexist and racist language adds to the realistic temper of their personalities but carries with it a naturalism that makes it complicit with the very relations it so casually portrays. This is a white boys' film, unapologetic in its use of racism and sexism as rhetorical strategies for privileging an overabundance of testosterone. Their language and protracted conversations revolve around small talk, bravado laced with profanities, and street-wise insults. Abusive language parading as a gutsy realism appears hermetic and self-contained, removed from any self-conscious consideration of how it objectifies and belittles blacks and women. This is in-your-face language, guilt-free and humorously presented so as to mock even the slightest ethical and political sensibility.[28]

Reservoir Dogs serves as a significant model for a number of films that have attempted to cash in on its overly self-conscious treatment of language, aesthetics, humor, and violence. Moreover, it seems to be a film perfectly suited for the racial, ethnic, and sexual backlash that conservatives have been mobilizing in full force throughout the 1980s and 1990s. The attack on politically correct behavior offered Tarantino and other youthful directors such as Roger Avery the opportunity to exploit the cultural mean-spiritedness of the times by taking visual and linguistic liberties that might not have been tolerated a decade ago. All of a sudden it has become fashionable to blame the poor for their plight, to criticize blacks for swelling the welfare rolls or to pathologize their alleged violent tendencies, to blame unemployed youth for their inability to find jobs, and to point a cynical finger at wimpy liberals and others who dare resurrect the language of compassion and social justice.

Quentin Tarantino, capitalizing on his growing reputation with the critical acclaim of Reservoir Dogs, wrote and produced Pulp Fiction (1994), a film that made him an instant star in the pantheon of Hollywood auteur directors. Pulp Fiction garnered a number of prestigious awards, including the Palme d'Or at 1995's Cannes Film Festival and an Oscar for best screenplay. Highly praised by liberal and conservative film critics alike, Pulp Fiction received an extraordinary amount of media attention and public recognition. Given the prominence of media and public enthusiasm for this film and the cultural politics it suggests, I want to explore not only the themes at work in this text, but who this film addresses and how its representations of cinematic violence resonate with the racist construction of white and black identities in America.

CINEMA AS *PULP FICTION*

Pulp Fiction consists of three interconnected stories.

The film begins with a pair of petty crooks, Pumpkin and Honey Bunny (played by Tim Roth and Amanda Plummer), who decide over coffee to change their luck by robbing the very diner in which they are eating. Just as they jump up on the table and announce their intent to the patrons of the diner, the scene shifts to the first main story which involves two hit men, Vincent (John Travolta) and his black partner, Jules (Samuel Jackson), who are on their way to do a hit for their boss, Marsellus, the local drug czar (Ving Rhames). On their way to do the job, Travolta and Jackson discuss whether their boss overreacted when he had a man tossed out of a window because he massaged the feet of his wife. With perfect seriousness, the dialogue explores the moral limits of foot massaging and whether it deserves an act of revenge worthy of adultery. The conversation then shifts to Travolta's concern about being asked by Marsellus to entertain his wife, Mia (Uma Thurman), for the evening while he goes out of town.

What Jules and Vincent don't talk about is the task at hand, which is to fetch a briefcase stolen from their boss by some young college boys. The hit men succeed in getting the briefcase, and in doing so casually kill all but one of the young men in the room. The violence is quick and unexpected, totally out of character with the conversations that preceded it. But the accelerated shock of the killing doesn't end there. As Vincent and Jules leave the apartment they take a young, frightened Afro-American male with them as a hostage. While driving in the car, Vincent accidently shoots the kid, blowing his head off and splattering bone and blood all over the car with requisite pieces of bone fragments and brain lodged in Jules's jerricurls.

That evening Vincent escorts his boss's wife out for dinner and dancing. Mia, with an endless appetite for coke, snorts the stuff as Vincent appears at the door to begin the evening. After dinner, Vincent brings her back to her apartment and, while he runs off to the bathroom, Mia finds some heroin in his jacket packet and, believing it is coke, tunnels it up her nose. Vincent comes back and finds that she has overdosed, and is now lying unconscious on the floor with blood and saliva streaming out of her nose and mouth. He panics, puts Mia in his car, and rushes over to his drug dealer's apartment. The scene climaxes in a moment so appalling that the viewer will either be riveted to the screen or driven out of the theater.

Gruesome spectacle joins with black comedy as Vincent revives Mia with a jolt of adrenaline administered through a foot-long needle plunged directly into her heart. Mia appears to come back from the dead and the wife of the dealer who is watching the event comments, "trippy."

The third story concerns Butch (Bruce Willis), a boxer, who has been ordered by Ving Rhames, the drug czar, to throw a fight. Butch double-crosses him and quickly leaves the boxing arena in order to avoid being knocked off by Jules and Vincent. The following day, Butch finds out that his lover has left his father's watch in his old apartment and Butch is forced to drive back to retrieve it. On the way, he accidently hits Rhames, who spots him as he is walking across the street. Openly brawling, both men stumble into a pawn shop and are taken captive by the owner and his corrupt cop partner. They end up as prisoners in an S&M dungeon. While Rhames is being raped, Butch manages to set himself free. Hearing Rhames's screams as he is about to make his escape, Butch plucks a Samurai sword from the pawn shop's wares and goes back to both save Rhames and square his debt to him. Rhames is rescued and one of the assailants is killed by Butch. The remaining rapist is then turned into a eunuch with a shotgun blast carefully executed by Rhames. Rhames gives Butch a reprieve and tells him to get out of town, while making it clear that he is never to mention the rape to anyone or the deal will be off and he will be a dead man. (One wonders what would have happened to Willis's acting career if he had been raped in this particular scene.)

Picking up the second story line, Tarantino circles back to Vincent and Jules, who have to find a way to get rid of a car filled with blood and a decapitated body. Jules drives to the house of his friend Jimmie, played by Tarantino, and parks the car in his garage. Jules then calls his boss, who enlists the services of a gentleman hood named Wolf (Harvey Keitel). Mr. Wolf appears in a tux at Jimmie's house and the cleanup operation gets underway. In the meantime, Jimmie is enraged that Jules has shown up at his house. Fearing that his wife, an Afro-American woman, will return home to find the body in the garage, Jimmie asks Jules in wise-guy tones if he saw a sign for "Dead Nigger Storage" on his front lawn. To say the least, Tarantino paints himself into an interesting scene, playing a yuppie creep turned gangsta, spewing racist epithets and complaining that his favorite linens will be ruined in the cleanup process. Reducing the death of the boy to an inconvenience, Tarantino whines about cleaning up the garage,

replacing his linens, and warding off his wife's anger. Comic irony under-cuts the racist nature of Tarantino's character, which is doubly dispensed through racist language and through the assumption that since Jimmie's wife is black he can assume a familiarity with black culture that makes him an insider, a white man comfortably situating himself outside of the legacy and pitfalls of racist behavior. The film's final scene takes place back in the diner where Jules and Vincent find themselves in the midst of a holdup. Jules overtakes Honey Bunny and Pumpkin; rather than kill them he goes through what appears to be a New-Age conversion and allows them to escape. The film ends with Jules and Vincent casually walking out of the diner.

Pulp Fiction takes its name from the popular crime stories of Dashiell Hammett, Raymond Chandler, and others that were published in the first half of the twentieth century. "Pulp" signifies an indebtedness to the pulp-wood paper on which these novels were printed, but it also serves as a more gruesome slang referent for beating somebody "to a pulp." *Pulp Fiction* appropriates a number of elements from the pulp tradition. All of the char-acters are from the seamy side of society, and as a collection of society's sorriest outcasts they have no dreams, hopes, or possibilities other than to cash in big on the crimes they commit. Justice and morality appear removed from their sensibilities, while violence without remorse remains one of the few legitimate options for giving meaning to their identity.

Cynicism reigns supreme in Tarantino's characters, but this is not the dead-pan realism and cynicism that leaves audiences either bored or in the throes of despair. On the contrary, blurring the line between hard-boiled realism and playful if brutal irony, Tarantino seizes upon the post-modern practice of scrambling chronologies as stories leak into each other, lacking any clear cut beginning or end. For example, in one par-ticular scene, Vincent (John Travolta) and Mia (Uma Thurman) visit a glowing retro restaurant/club called Jackrabbit Slim's. The headwaiter imi-tates Ed Sullivan while the help dress up like fifties idols such as Marilyn Monroe, Mamie Van Doren, Jerry Lewis, and Dean Martin. The menu sub-stitutes film history for a range of culinary choices, offering junk food such as Douglas Sirk steaks and Martin & Lewis shakes. Every move in the restaurant appears stylized for dramatic, postmodern effect, and the dia-logue is brisk but empty, straining to be hip and cool. *Pulp Fiction* appro-priates retro culture and cultural trash and redeems both through irony that functions as an inside joke for those film viewers in the know.

Spectacle and action never become self-referential in Tarantino's films. They always work hand in hand with swiftly executed dialogue and monologues. The acts of stylish violence that pump the adrenaline up to race car speed are always preceded by endless streams of talk. Talk gives Tarantino's characters a connection with the geographies of violence through which they endlessly travel. Experimenting with formalist devices, Tarantino mixes aesthetics and language and succeeds in elevating the crime genre to a species of avant-garde filmmaking. He delights in mixing what he calls "horrible tension and creepy feelings with really funny stuff."[29]

At his best, Tarantino mediates gratuitous violence with a hard-edged realism, authenticating street dialogue, and a slick, cynical humor in order to create a novel aesthetic radicalism, one that pushes "to an extreme the pleasures of pulp . . . sensation and cheapness, and moods of shallow, voluptuous despair."[30] Tough guy sincerity and a working-class code of honor are replaced in Tarantino's films with the rhetoric of insult, hyperbole, and a kind of irony for irony's sake, within an amoral universe that consciously shuns political or social engagement or the possibility of social transformation. In fact, at the heart of Tarantino's success lies his ability to focus on highly charged issues such as drug dealing, murder, corruption, rape, sex, and sadism, and recast them in an aesthetic formalism that undercuts their social and moral significance. For example, Tarantino often mixes styles and combines realism and artifice so as to render the victims of such crimes either scornful or utterly foolish. Put bluntly, victims are not the object of either compassion or sympathy in Tarantino's films.

Borrowed from the media's one-dimensional portrayal of youth as Generation X, Tarantino's films delight in mundane narcissism and nihilistic self-indulgence parading as a hip postmodern posture. Cynically disposed towards any notion of political and moral accountability, this constructed view of society relegates the concept of the social to the bygone era of the failed '60s. Despair surfaces as a form of sublime nihilism, and any viable notion of collective action gives way to often pathological actions governed by the immediacy of the moment and mediated by personal gain and whimsy. Indeed, part of my purpose in these pages is to explore how Tarantino articulates through his films an amoralism that legitimates the neo-conservative ideology of the '90s, one that is consistent with what Ruth Conniff has called a culture of cruelty; that is, a growing contempt in American society for those who are impoverished, disenfranchised, or

powerless.[31] *Pulp Fiction* appropriates crime and violence as an everyday presence and turns it into popular cinema; but in doing so Tarantino produces a racially coded, reactionary cultural politics and pedagogy that transforms neo-conservative callousness and contempt for the underclass into a hip representation of avant-garde high art.

VIOLENCE, RACE, AND THE POLITICS OF REALISM

I have no more of a problem with violence that I do with people who like bedroom comedy versus slapstick comedy. It's an aesthetic thing.[32]

Extreme violence in Tarantino's films represents a central element of his cinematic style. Tarantino first generated a great deal of controversy through a sadistic torture scene in *Reservoir Dogs*, gruesomely played out by Michael Madsen, who cuts off a hostage policeman's ear and then holds it in his hand while talking to it. *Pulp Fiction* continues the tradition of hyper-real violence—for example, when Jules, while spewing out judgment day prophecy, just for effect shoots a defenseless college kid. This act of sudden violence is not aimed at some wooden, Hollywood gangsta. On the contrary, the victim is a scared kid and his murder is senseless and disturbing. Of course, the effects are no less shocking when Vincent accidently blows off the head of a black kid who appears to be barely seventeen or eighteen years old. These are disturbing representations of violence, endorsed by a director who appears to have "turned murder into performance art."[33]

Tarantino makes no attempts cinematically to rupture or contest the patterns of violence that his films produce or claim to represent. On the contrary, he empties violence of any critical social consequences, offering viewers only the immediacy of shock, humor, and irony-without-insight as elements of mediation. None of these elements gets beyond the seduction of voyeuristic gazing or enlists audiences' critical engagement. The facile consumption of shocking images and hallucinatory delight that is provoked undercut the possibility of educating audiences to "comment on the image instead of allowing it to pass." There is virtually no space in which the audience can unsettle the "'moment of violence' [to allow it to] resonate meaningfully and demand our critical involvement."[34]

Tarantino employs cruelty, humor, and postmodern parody to parade visually his extensive knowledge of film history and to rewrite the dynamic of

repetition and difference. For example, the male rape scene in *Pulp Fiction* does homage to the classic film *Deliverance* (1972), but in the end Tarantino's use of parody is about repetition, transgression, and softening the face of violence by reducing it to the property of film history.[35] In this case, aesthetics is about reordering the audience's sense of trauma through a formalism that limits any vestige of politics. This is violence with an escape hatch, one that suggests that violence is a "force over which we have no control." The film is based on an aesthetics that resonates with the false assumption that "violence can be distanced from reality through its apparent autonomy of signs."[36] This is what Tarantino suggests when he claims that:

> *Violence in real life is one of the worst aspects of America. But in movies—It's fucking fun! One of the funniest, coolest things for me to watch. I get a kick out of it—all right?*[37]

Tarantino's comments reveal more than a hip aesthetics that neutralizes violence by reducing it to an arid formalism and slapstick humor; they also reveal a cinematic amoralism which separates the representation of violence from real life. His films offer no language for rendering sadistic violence dangerous in its ability to numb us to the senseless brutality that has become a part of everyday life, especially for youth. Tarantino justifies his graphic representations of violence through an aesthetic appeal to realism. This is a realism that is not merely documentary, it is marked by a repertoire of stylistic excesses that rely on sensationalism and elicit visceral responses. Characters take on a frenzied and despairing quality that is as self-indulgent as it is corrupt.

Tarantino argues that his violent depiction and deceleration of pain is about "stopping movie time and playing the violence out in real time. Letting nothing get in the way of it and letting it happen the way real violence does."[38] But "real" violence comes from somewhere; it neither is innocent nor does it emerge outside of existing historical contexts and social relationships. More fundamentally, representations of violence, regardless of how realistic they are, do not rupture or challenge automatically the dominant ideologies that justify or celebrate violence in real life. Whereas symbolic violence offers an ethical language with which to engage acts of inhumanity, an uncritical appeal to realism does not allow audiences to think imaginatively about ways to disrupt what have become

conventional patterns of violence that function as part of a broader discursive arena in which race and violence are being represented by the Right. Tarantino's celebration of realism offers no normative grounds on which to challenge violence or to resist the brutal and oppressive face of power. On the contrary, the aesthetic of realism serves pedagogically to justify abstracting the representation of violence from the ethical responsibility of both filmmakers and audiences to protest brutality for brutality's sake as an established social practice.

Tarantino's view of violence represents more than reactionary politics; it also breeds a dead-end cynicism. His films are peopled with characters who have flimsy histories, go nowhere, and live out their lives without any sense of morality or justice. In Tarantino's celluloid world, the pursuit of happiness or social justice is a bad dream whereas self-promotion and violent action remain two of the few options for exercising human agency. Tarantino acknowledges that his own twenty-something sense of the world was informed less by the social and political events of the '60s and '70s than by French thrillers and Hollywood gangster movies: "The attitude I grew up with was that everything you've heard is lies."[39] In the end, violence for Tarantino submits to the demands of a publicly celebrated, stylized formalism; but the price exacted exceeds instant notoriety. Tarantino ends up with ultraviolent films which serve as a gateway to sadistic humor at everyone's expense, a chance to depict brutality while assuring the audience that its own complicity and involvement, whether in symbolic terms or in real life, can be successfully suspended in the name of clever entertainment.

As I have argued, Tarantino's fame, in part, is due to his willingness to substitute an aesthetic radicalism for a political and moral one. For all of his technical, cinematic virtuosity, he cannot escape the surfacing of his own politics and values in the film's narrative structure, in characterization, and in dialogue. What betrays Tarantino's attempts to render the underbelly of society on its own terms is the overt racism that informs his films, evident on a number of registers. First, there is the racist language that streams forth from his characters in *Reservoir Dogs* and *Pulp Fiction*. Racist slurs and verbal assaults abound in these films, especially in *Pulp Fiction*. There is a disturbing quality to this language, especially in a film that represents a cinematic tradition that Amy Taubin calls a "new acceptable white male art form."[40] Tarantino's use of racist language to authenticate characters aimed largely at white audiences appears to have a jokey quality

Tarantino's interviews and films suggest that use of racist language, especially the endless reference to "nigger" in Pulp Fiction, locates him as a postmodern version of the white beatnik hipster of the fifties with a cool "black" style that allows him to engage in racist transgressions. But while Tarantino may be pushing ideas about racism over the top, he ends up reinforcing nothing less than a not-so-hip racism that allows white boys to laugh when they shout nigger. Tarantino conveniently, or should we say self-indulgently, allows white youth to believe that by reinventing racism they are somehow escaping how it marks them. Gary Indiana captures this sentiment perfectly in his own critical discussion of Pulp Fiction.

> Tarantino flirts with the belief that energetic posturing will make his skin turn black, a delusion shared by white entertainers like Sandra Bernhard and Camille Paglia. In its most exacerbated form, this sentimental tic of the white hipster locates all "authenticity" in the black experience, against which all other experience becomes the material of grotesque irony. To be really, really cool becomes the spiritual equivalent of blackness, and even superior to it: there are plenty of square black people but not one square cool person. For the Tarantino of Pulp Fiction, blackness is a plastic holy grail, a mythic substance with real effects and its own medieval code.[46]

Tarantino's racism reinforces itself through the celebration of a masculinity that asserts its identity through the representation of mindless violence and a portrayal of women who are so one-dimensional that they appear to have been invented in a Beavis and Butt-head script. But in an age when it is clever to be racist and sexist, the combination of slick fun and stylish carnage provides an excuse for Tarantino to erase women from his film, Reservoir Dogs, except through references to their body parts. And when they do appear in his work, they either act violently, as in Uma Thurman's drug snorting in Pulp Fiction, or are violently abused by their pimps, as is the case of Patricia Arquette in True Romance. In the end, Tarantino's use of hyper-real violence is propped up by a "cool" masculinity that simply recycles a patriarchal hatred of women while barely hiding its own homophobic instincts.[47]

Tarantino's mixture of gay bashing, misogyny, and crude racist language in films that are largely white and male does little to boost his alleged moral sensitivity to the everyday implications of racist and sexist

language. Tarantino's racism does not merely reveal itself in the use of racist slurs, it also pervades the one-dimensional representation of blacks in *Reservoir Dogs* and *Pulp Fiction*. Once, at the Sundance Film Festival, Tarantino was told by a fellow filmmaker that "you've given white boys the kind of movies black kids get."[48] Taking this as a compliment, Tarantino nonetheless betrays a profoundly white and suburban sensibility by depicting the two black characters in *Pulp Fiction* as a drug dealer and a gangster hit man. In addition, Tarantino provides a number of subtle provocations in developing these characters. Marsellus, the drug dealer, is married to a white woman. Refusing to rupture the racist obsession with black male sexuality and gangsta drug dealing behavior, Tarantino seems to play into the need to punish his outlaw black character by submitting him to a humiliating and scandalous rape by two hayseed lunatics. This horrendous rape scene was largely ignored in the popular press, except to reference Tarantino's gay bashing rather than his racism. Further, Jules, the main black character in *Pulp Fiction*, is largely defined as an urban sociopath who has a penchant for quoting scripture to those he's about to ice. In a rather scandalous political move, Tarantino appropriates the prophetic language of the black church for criminal and dehumanizing ends, stripping from its tradition a legacy of dignity, compassion, and nonviolence. In the end, when Jules barely misses a rendezvous with death, he decides he has been saved and consequently gives up crime for the pleasures of a more righteous and extended life. Of course, this sudden turn of events has nothing to do with feeling remorse for his victims. The tradition of prophetic language, which has served as a language of resistance and hope in black culture, is reduced in *Pulp Fiction* to a discourse of degeneracy and a signifier for moral bankruptcy.

Given the various film awards that *Pulp Fiction* has won, one wonders why such a racist and violent film has received extensive coverage in the popular press and the highest accolades of the film community. In many ways, Tarantino's film anticipates the Newt Gingrich era with its appeal to nostalgia, hard-edged humor, greed, and an excessive individualism. Well-timed to take advantage of the resurgence of racism which has emerged as a result of the United States' massive shift to the right, Tarantino's film resonates cinematically with a racism that appears to be a defining principle of economic and social policy in the 1990s.

RACE, VIOLENCE, AND CHILDREN'S CULTURE

TOWARD A CULTURAL POLICY OF VIOLENCE IN FILMS

What I have tried to do with Tarantino's recent work is suggest that film occupies an important public space in American culture. As commonplace as this might sound, it should not detract from the importance of recognizing that cinema is a teaching machine. That is, cinematic representations of violence do not merely reflect reality, as many Hollywood producers claim. On the contrary, cinema carries with it a language of ethics and a pedagogy. Producers and directors constantly make normative distinctions about issues regarding whether plot and character will be formulaic and stereotypical or inventive and complex; the degree to which artistic formalism or the use of glossy, color-saturated aesthetics will supersede social and political vision and whether violence and adult situations will provide merely spectacle and diminish the integrity of the plot. This is a far from inclusive list; but it illustrates that films perform a pedagogical function in providing "a certain kind of language for conveying and understanding violence."[49]

At the same time, cinema functions in a broader pedagogical sense in that it is consistently making a claim to particular memories, histories, ways of life, identities, and values that always presuppose some notion of difference, community, and the future. Given that films both reflect and shape public culture, they cannot be defined exclusively through a notion of artistic freedom and autonomy that removes them from any form of critical accountability. This is not to suggest that public sphere of cinema should be subject to ruthless censorship, but at the same time it cannot be regarded as a simple form of entertainment.

Cinematic violence, whether it be ritualistic or hyper-real is not innocent; such violence offers viewers brutal and grotesque images that articulate with broader public discourses regarding how children and adults relate, care, and respond to others. At stake here is not whether cinematic violence directly causes crime or is the determining force in the wider culture of violence. The causes of violence lie in historically rooted, complex economic and social issues that are the heart of American society. To blame Hollywood for the violence in American society would be a subterfuge for addressing the complex causes of violence at work in the larger social order. In a world demeaned by pointless violence, the question that must be raised concerns what responsibilities filmmakers, other cultural workers, and their respective publics have in developing a cultural policy

that addresses the limits and responsibilities of the use of violence in cinema. Such a policy must address how the mass media and the film community can be held responsible for educating children and others about how to discriminate among different forms of violence, how to prevent it in real life when necessary, and how to engage its root social causes in the larger social and cultural landscape. Violence is not merely a function of power; it is also deeply related to how forms of self and social agency are produced within a variety of public spheres. Cinema exercises enormous pedagogical authority and influence. The reach, limits, and possibilities of its influence, especially on young children, can only be addressed through a coordinated effort on the part of cultural workers who inhabit a range of cultural spheres including schools, religious institutions, business corporations, popular culture, local communities, and the home. Such institutions need to articulate their efforts to develop a cultural policy that addresses the ethical responsibilities of a cinematic public sphere, including fundamental questions about the democratization of culture. Such concerns provide a common ground for various organizations and publics to raise questions regarding ownership, power, and control over media culture. They reveal who has access to the means of cultural representation and who does not, and what the possibilities for democracy are when gross financial inequalities and structures of power gain control over the apparatuses that produce popular and media culture.[50]

There appears to be a an enormous deadlock in developing a critical debate over cinematic and media representations of violence. This is evident in the public furor that emerged when Bob Dole, the Senate majority leader, appearing at a fund-raising event in Los Angeles, condemned certain Hollywood filmmakers for debasing United States culture with images of graphic violence and "the mainstreaming of deviancy." Dole specifically condemned films such as *Natural Born Killers* and *True Romance* as "nightmares of depravity" drenched in grotesque violence and sex. Speaking for a Republican party that has increasingly moved to the extreme right, Dole issued a warning to Hollywood: "A line has been crossed—not just of taste, but of human dignity and decency. . . . It is crossed every time sexual violence is given a catchy tune. When teen suicide is set to an appealing beat. When Hollywood's dream factories turn out nightmares of depravity."[51] Dole's remarks were less an insightful indictment of the culture of violence then a shrewd attempt to win the

hearts and minds of Christian conservatives and those in the general public who are fed up with the culture of violence but feel helpless in the face of its looming pervasiveness. While it is commendable that Dole has taken a stand regarding the relationship between Hollywood's representation of violence and its impact in society, he fails to address a number of issues necessary to engage critically the culture of violence in this country. First, political opportunism aside, Dole's remarks do not constitute a thoughtful and sincere analysis of the culture of violence. On the surface, Dole's remarks about the orgy of violence and misogyny flooding American popular culture resonate with a deeply felt anxiety about the alleged innocence of commercial entertainment. But Dole is no spokesperson for carefully criticizing or analyzing the violence in this country. Not only had he not viewed the films he criticized, he argued that Arnold Schwarzenegger's killfest film, True Lies, represented the kind of film that Hollywood should be producing for family entertainment. Dole also refused to criticize the exploitative, bloody films made by Bruce Willis and Sylvester Stallone, both prominent Republicans. Second, Dole's refusal to address the culture of violence in broader terms coupled with his role in actually reproducing such a culture reveal a grave theoretical omission and unfortunate disingenuousness in his criticisms. At a time when "an estimated 100,000 children carry guns to school in the United States [and] gunfire kills on average 15 children a day," Dole drew no connection between the gun culture and the violence in our nation's streets, schools, and homes. But this may be understandable since Dole has received $23,426 in "direct contributions and independent expenditures from the NRA since 1982" and has publicly committed himself to "repealing the ill-conceived gun ban passed as part of President Clinton's crime bill."[52] As Ellen Goodman points out, "anybody who is against violence in the movies and in favor of assault weapons in real life leaves himself open to all sorts of charges, the least of which is hypocrisy."[53]

It is hard to believe that following the Oklahoma City bombing Dole refused to include in his critique of the culture of violence the rise of right-wing militia groups, the hate talk emanating from right-wing talk show hosts such as G. Gordon Liddy, or the gun culture supported by the National Rifle Association, which published a fund-raising letter in which federal law-enforcement agents were referred to as "Jackbooted Thugs." The latter prompted former President George Bush to resign from the NRA

while Dole remained silent on the issue. What is the significance of Bob Dole's attack on Hollywood films he had not viewed, or his refusal to address corporate interests aligned with the Republican party that have a big economic stake in the culture of violence?

It may be that Dole's attack signals less a concern with how the culture of violence is represented in this country than with who is going to control those aspects of the cultural sphere that are influential and at the same time unpredictable, given their allegiance to the often conflicting dictates of the market and artistic expression. Maybe this explains why Dole can criticize the vulgarity of popular culture while at the same time advocating the defunding of PBS, the National Endowment for the Arts, and other government support for the arts. Conservatives want to homogenize culture rather than diversify it. To diversify culture would demand supporting those institutions or public spheres in which critical knowledge, debate, and dialogue occur. Such interaction is necessary for people to make choices about how power works through culture and about what it means to identify with, challenge, and rewrite the representations that circulate in popular and massmediated cultures. This suggests that any debate about the best way to reduce symbolic violence in the culture must be part of a larger discourse about educating people to change the social and economic conditions that produce and sustain such violence. It further suggests addressing how questions of pedagogy and commitment can work to provide a challenge to institutional structures of power that trade in symbolic imagery while refusing to address the limits of the media's potential for error and harm. Social justice is not part of the message that underwrites Dole's concern with media culture and its relationship with the alleged public good. On the contrary, Dole represents an ideological position that advocates abolishing the Department of Education, privatizing public schools, and limiting funding for poor students who want access to higher education. Dole's moral indignation is not merely fueled by political opportunism but also by the imperatives of a political project that engages the cultural public sphere in order to control rather than democratize it.

Unfortunately, Hollywood executives, directors, and celebrities responded to Dole's remarks by primarily focusing on his hypocrisy rather than providing a forum for critically analyzing Hollywood's complicity with and responsibility for addressing the growing culture of violence in the United States. Oliver Stone, the director of *Natural Born Killers*, labeled

Dole's attack "a '90s form of McCarthyism," while actor James Wood compared Dole's actions to the morality crusades that inspired censors of a previous era to attempt to ban *Catcher in the Rye* or *Ulysses*. Such remarks are defensive in the extreme, and exhibit little self-consciousness regarding what Hollywood's role or responsibility might be in shaping popular culture and providing a pedagogical climate in which knowledge, values, desires, and identities are marketed on a daily basis to children and young adults, among others. The relationship between greed and the marketing of violence might inspire Hollywood executives and celebrities to be more attentive to the ravages committed in the name of free markets, or to address their own ethical responsibility as cultural workers who actively circulate ideas and values for popular consumption. Claiming that the film, music, and television industries simply reflect what the public wants represents more than disingenuousness; it also suggests political and ethical cowardice. Neither Dole's one-sided criticism nor Hollywood's defensive posture provides a helpful model for dealing with the culture of violence.

It is hard to imagine how Dole's moralizing and Hollywood's defensiveness address constructively the daily violence that takes place in urban America. While I was writing this chapter in Boston over the hot summer weekend of July 14–15, 1995, the *Boston Globe* reported that eight young people were victims of unrelated shootings in the city: two youths were killed and six others were seriously wounded.[54] All of these youths lived in the poorest sections of Boston. Beneath these senseless acts of violence is a culture of enormous poverty, human indifference, unemployment, economic hardship, and needless human suffering. It seems that Hollywood executives find in these stories material for reflecting reality while disavowing any responsibility for its causes or their own complicity in reproducing it. At the same time, national leadership sinks to an all-time low as social services are cut and the notion of the critical citizen is subordinated to the virtues of creating a society filled with consuming subjects.

In the coming new information age, it is imperative that various cultural workers and educators raise important questions about what kind of teacher we want cinema to be, with special concern for how the representation of violence works to pose a threat "not only to our national health but to our potential for ever becoming a true participatory democracy."[55] To simply blame filmmakers and television executives for causing violence in the United States shifts critical attention away from the poisonous roots of the

ANIMATING

THE DISNEYFICATION OF CHILDREN'S CULTURE

YOUTH

3

Children's culture is a sphere where entertainment, advocacy, and pleasure meet to construct conceptions of what it means to be a child occupying a combination of gender, racial, and class positions in society, positions through which one defines oneself in relation to a myriad of others. As an object of critical analysis, children's culture opens up a space in which children become an important dimension of social theory. While youth culture, especially adolescence, has been a strong component of cultural studies,

children's culture has been largely ignored, especially the world of animated films.[1] An examination of children's culture unsettles the notion that the battles over knowledge, values, power, and what it means to be a citizen are to be located exclusively in the schools or in privileged sites of high culture; moreover, it provides a theoretical referent for "remembering" that the individual and collective identities of children and youth are largely shaped politically and pedagogically in the popular visual culture of video games, television, film, and even in leisure sites such as malls and amusement parks. Lacking an interest in children's culture, cultural critics have not paid enough attention to the diverse spheres in which young children become acculturated.[2] Theoretical indifference has its price politically, since such critics also surrender the responsibility to challenge increasing attempts by corporate moguls and conservative evangelicals to reduce generations of children to either consumers for new commercial markets or Christian soldiers for the evolving Newt Gingrich world order.

Though it appears to be a commonplace assumption, the idea that popular culture provides the basis for persuasive forms of learning for children was impressed upon me with an abrupt urgency during the last few years. As a single father of three nine-year-old boys, I found myself somewhat reluctantly being introduced to the world of Hollywood animation films, and in particular those produced by Disney. Before becoming an observer of this form of children's culture, I accepted the largely unquestioned assumption that animated films stimulate imagination and fantasy, reproduce an aura of innocence and wholesome adventure, and, in general, are "good" for kids. In other words, such films appeared to be vehicles of amusement, a highly regarded and sought-after source of fun and joy for children. However, within a very short period of time, it became clear to me that the relevance of such films exceeded the boundaries of entertainment.[3] Needless to say, the significance of animated films operates on many registers, but one of the most persuasive is the role they play as the new "teaching machines." I soon found that for my children, and I suspect for many others, these films possess at least as much cultural authority and legitimacy for teaching specific roles, values, and ideals as more traditional sites of learning such as the public schools, religious institutions, and the family. Disney films combine an ideology of enchantment and aura of innocence in narrating stories that help children understand who they are, what societies are about, and what it means to construct a world of play and fan-

tasy in an adult environment. The commanding legitimacy and cultural authority of such films, in part, stems from their unique form of representation, but such authority is also produced and secured within the predominance of a broadening media apparatus equipped with dazzling technology, sound effects, and imagery, all packaged as entertainment, spinoff commercial products, and "huggable" stories.

The cultural authority of this postmodern media-scape rests on its power to usurp traditional sites of learning and its ability to expand the power of culture through an endless stream of signifying practices, which prioritize the pleasures of the image over the intellectual demands of critical inquiry. Moreover, it simultaneously reduces the demands of human agency to the ethos of a facile consumerism. This is a media apparatus in which the past is filtered through an appeal to cultural homogeneity and historical purity that erases complex issues, cultural differences, and social struggles. It incessantly works to construct a commercially saturated and politically reactionary rendering of the ideological and political contours of children's culture. In the television and Hollywood versions of children's culture, cartoon characters become prototypes for a marketing and merchandising blitz, and real-life dramas, whether fictionalized or not, become vehicles for pushing the belief that happiness is synonymous with living in the suburbs with an intact white middle-class family.[4]

The significance of animated films as a site of learning is heightened by the widespread recognition that schools and other public sites are increasingly beset by a crisis of vision, purpose, and motivation. The mass media, especially the world of Hollywood films, on the contrary, constructs a dreamlike world of security, coherence, and childhood innocence where kids find a place to situate themselves in their emotional lives. Unlike the often hard-nosed, joyless reality of schooling, children's films provide a high-tech visual space where adventure and pleasure meet in a fantasy world of possibilities and a commercial sphere of consumerism and commodification. The educational relevance of animated films became especially clear to me as my kids experienced the vast entertainment and teaching machine embodied by Disney. Increasingly as I watched a number of Disney films, first in the movie theater and, later, on video, I became aware of how necessary it was to move beyond treating these films as transparent entertainment to questioning the diverse representations and messages that constitute Disney's conservative view of the world.

TRADEMARKING INNOCENCE

I recognized that any attempt to critically take up Disney films rubs against the grain of American popular opinion. After all, "the happiest place on earth" has traditionally gained its popularity in part through a self-proclaimed image of trademark innocence that has protected it from the interrogating gaze of critics. Of course, there is more at work here than a public relations department intent on protecting Disney's claim to fabled goodness and uncompromising morality. There is also the reality of a powerful economic and political empire that in 1994 took in nearly $5 billion at the box office, $3.5 billion from Disney's theme parks, and almost $2 billion from Disney products. Moreover, as this book goes to press, The Walt Disney Company made the biggest deal of the American media industry by investing $19 billion to acquire Capital Cities/ABC.[5] But Disney is more than a corporate giant; it is also a cultural institution that fiercely struggles to protect its mythical status as a purveyor of American innocence and moral virtue.

Quick to mobilize its monolith of legal representatives, public relations spokespersons, and professional cultural critics to safeguard the borders of its "magic kingdom," Disney has aggressively prosecuted violations of its copyrights and has a legendary reputation for bullying authors who use the Disney archives and refuse to allow Disney to approve their prepublished work.[6] For example, in its zeal to protect its image and extend its profits, Disney has gone so far as to threaten legal action against three South Florida day-care centers for using Disney cartoon characters on their exterior walls. In this instance, Disney's role as an aggressive defender of Quayle-esque family values was undermined through its aggressive endorsement of property rights. While Disney's reputation as an undisputed moral authority on United States values has taken a beating in the last few years, the power of Disney's mythological status cannot be underestimated.

Disney's image of itself as an icon of American culture is consistently reinforced through the penetration of the Disney empire into every aspect of social life. Operating as a $22 billion empire, Disney shapes children's experiences through a maze of representations and products found in box office movies, home videos, theme parks, hotels, sports teams, retail stores, classroom instructional films, CDs, television programs, and family restaurants.[7] Through the widespread use of public visual space, Disney inserts itself into a network of power relations that promotes the construction of

a closed and total world of enchantment, allegedly free from the dynamics of ideology, politics, and power.[8] At the same time, Disney goes to great lengths to boost its civic image. Defining itself as a vehicle for education and civic responsibility, Disney has sponsored "Teacher of the Year Awards," provided "Doer and Dreamer" scholarships to students, and, more recently, offered financial aid, internships, and educational programs to disadvantaged urban youth through its ice skating program called "Goals." Intent on defining itself as a purveyor of ideas rather than commodities, Disney is aggressively developing its image as a public service industry. For example, in what can be seen as an extraordinary venture, Disney plans to construct in the next few years a prototype school that one of its brochures proclaims will "serve as a model for education into the next century." The school will be part of a five thousand acre residential development, which according to Disney executives will be designed after "the main streets of small-town America and reminiscent of Norman Rockwell images."[9]

What is interesting here is that Disney no longer simply dispenses the fantasies through which childhood innocence and adventure are produced, experienced, and affirmed. Disney now provides model prototypes for families, schools, and communities. From the seedy urban haunts of New York City to the spatial monuments of consumption-shaping Florida, Disney takes full advantage of refiguring the social and cultural landscape while spreading the ideology of its Disney Imagineers. For instance, not only is Disney taking over large properties on West 42nd Street in New York City in order to produce one musical per year, it has also begun building Celebration, a town covering five thousand acres of property in Florida that is designed to accommodate 20,000 citizens. According to Disney, this is a "typical American small town . . . designed to become an international prototype for communities."[10] What Disney leaves out of its upbeat promotional literature is the rather tenuous notion of democracy that informs its view of municipal government since the model of Celebration is "premised upon citizens not having control over the people who plan for them and administer the policies of the city."[11] But Disney does more than provide prototypes for up-scale communities; it also makes a claim on the future through its nostalgic view of the past and its construction of public memory as a metonym for the magical kingdom. French theorist Jean Baudrillard provides an interesting theoretical twist

on the scope and power of Disney's influence by arguing that Disneyland is more "real" than fantasy because it now provides the image on which America constructs itself. For Baudrillard, Disneyland functions as a "deterrent" designed to "rejuvenate in reverse the fiction of the real."

> Disneyland is there to conceal the fact that it is the "real" country, all of "real" America, which is Disneyland (just as prisons are there to conceal the fact that it is the social in its entirety, in its banal omnipresence, which is carceral). Disneyland is presented as imaginary in order to make us believe that the rest is real, when in fact all of Los Angeles and the America surrounding it are no longer real but of the order of the hyperreal and of simulation.[12]

At the risk of taking Baudrillard too literally, examples of the Disneyfication of America abound. For instance, the Houston airport models its monorail after the one at Disneyland. Small towns throughout America appropriate a piece of nostalgia by imitating the Victorian architecture of Disneyland's Main Street USA. It seems that the real policy makers are not those that reside in Washington, D.C. but those in California calling themselves the Disney Imagineers. The boundaries between entertainment, education, and commercialization collapse through the sheer omnipotence of Disney's reach into diverse spheres of everyday life. The scope of the Disney empire reveals shrewd business practices as well as a sharp eye for providing dreams and products through forms of popular culture in which kids are willing to materially and emotionally invest.

Popular audiences tend to reject any link between ideology and the prolific entertainment world of Disney. And yet Disney's pretense to innocence appears to some critics as little more than a promotional mask that covers over its aggressive marketing techniques and influence in educating children to the virtues of becoming active consumers. Eric Smooden, editor of *Disney Discourse*, a book critical of Disney's role in American culture, argues that "Disney constructs childhood so as to make it entirely compatible with consumerism."[13] Even more disturbing is the widespread belief that Disney's trademarked innocence renders it unaccountable for the diverse ways in which it shapes the sense of reality it provides for children as they take up specific and often sanitized notions of identity, difference, and history in the seemingly apolitical cultural universe of "the Magic Kingdom." For example, Jon Wiener argues that Disneyland's

version of Main Street America harkens back to an "image of small towns characterized by cheerful commerce, with barbershop quartets and ice cream sundaes and glorious parades." For Wiener this view not only fictionalizes and trivializes the history of real Main Streets at the turn of the century, it also represents an appropriation of the past to legitimate a present that portrays a world "without tenements or poverty or urban class conflict. . . . it's a native white Protestant dream of a world without blacks or immigrants."[14]

ANIMATED PEDAGOGY

I want to venture into the contradictory world of Disney through an analysis of its more recent animated films. These films, all produced since 1989, are important because they have received enormous praise from the dominant press and have achieved blockbuster status. For many children they represent their first introduction into the world of Disney. Moreover, the financial success and popularity of these films, surpassing many adult features, do not engender the critical analyses often rendered on adult films. In short, popular audiences are more willing to suspend critical judgement about such children's films.[15] Animated fantasy and entertainment appear to fall outside of the world of values, meaning, and knowledge often associated with more pronounced educational forms such as documentaries, art films, or even wide-circulation adult films. Elizabeth Bell, Lynda Haas, and Laura Sells capture this sentiment:

> Disney audiences . . . legal institutions, film theorists, cultural critics, and loyal audiences all guard the borders of Disney film as "off limits" to the critical enterprise constructing Disney as a metonym for "America"—clean, decent, industrious—"the happiest place on earth."[16]

Given the influence that the Disney ideology has on children, it is imperative for parents, teachers, and other adults to understand how such films attract the attention and shape the values of the children who view and buy them. As a producer of children's culture, Disney should not be given an easy pardon because it is defined as a universal citadel of fun and good cheer. On the contrary, as one of the primary institutions constructing childhood culture in the United States, it warrants healthy suspicion and critical debate. Such a debate should not be limited to the

home, but should be a central feature of the school and any other critical public sites of learning.

In what follows, I will argue that it is important to address Disney's animated films without condemning Disney as an ideological, reactionary corporation deceptively promoting a conservative worldview under the guise of entertainment. It is also important not to simply celebrate Disney as the Hollywood version of Mr. Rogers doing nothing more than providing sources of joy and happiness to children all over the world. Disney does both. The productive side of Disney lies in its ability to address in highly successful pedagogical terms the needs and interests of children. Moreover, its films offer opportunities for children to experience pleasure and to locate themselves in a world that resonates with their desires and interests. Pleasure becomes the defining principle of what Disney produces, and children are the serious subjects and objects of Disney's project. Hence, rather than simply being dismissed, Disney's animated films have to be interrogated as an important site for the production of children's culture. At the same time, Disney's influence and power must be situated within the broader understanding of the company's role as a corporate giant intent on spreading the conservative and commercial values that in fact erode civil society while proclaiming to restructure it.

The role that Disney plays in shaping individual identities and controlling the fields of social meaning through which children negotiate the world is far too complex to be simply set aside as a form of reactionary politics. If educators and other cultural workers are to include the culture of children as an important site of contestation and struggle, then it becomes imperative to analyze how Disney's animated films powerfully influence the way America's cultural landscape is imagined. Disney's scripted view of childhood and society needs to be engaged and challenged as "a historically specific matter of social analysis and intervention" that addresses the meanings its films produce, the roles they legitimate, and the narratives they construct to define American life.[17]

The wide distribution and popular appeal of Disney's animated films provide diverse audiences the opportunity for critical viewing. Critically analyzing how Disney films work to construct meanings, induce pleasures, and reproduce ideologically loaded fantasies is not meant to promote a particular exercise in film criticism. Like any educational institution, Disney's view of the world needs to be taken up in terms of how it narrates children's

culture and how it can be held accountable for what it does as a culturally significant public sphere—a space in which ideas, values, audiences, markets, and opinions serve to create different publics and social formations. Of course, Disney's self-proclaimed innocence, inflexibility in dealing with social criticism, and paranoid attitude towards justifying what it does is now legendary, and suggest all the more reason why Disney should be both challenged and engaged critically. Moreover, as a multi-billion-dollar company, Disney's corporate and cultural influence is too enormous and far reaching to allow it to define itself exclusively within the imaginary discourse of innocence, civic pride, and entertainment.[18]

The question of whether Disney's animated films are good for kids has no easy answers and resists simple analysis within the traditional and allegedly nonideological registers of fun and entertainment. Disney's most recent films, which include *The Little Mermaid* (1989), *Beauty and the Beast* (1991), *Aladdin* (1992), *The Lion King* (1994), and *Pocahontas* (1995), provide ample opportunity to address how Disney constructs a culture of joy and innocence for children out of the intersection of entertainment, advocacy, pleasure, and consumerism. All of these films have been high profile releases catering to massive audiences. Moreover, their commercial success is not limited to box office profits, which totaled over $700 million in 1995.[19] Successfully connecting the rituals of consumption and movie-going, Disney's animated films provide a "marketplace of culture," a launching pad for an endless number of products and merchandise that include videocassettes, soundtrack albums, children's clothing, furniture, stuffed toys, and new rides at the theme parks.[20] For example, in the video market, *Little Mermaid* and *Beauty and the Beast* have combined sales of over thirty-four million videocassettes. Moreover, *Aladdin* has earned "$1 billion from box-office income, video sales and such ancillary baubles as Princess Jasmine dresses and Genie cookie jars."[21] Moreover, produced as a video interactive game, *Aladdin* sold over three million copies in 1993. Similar sales are expected for the video and interactive game versions of the film *The Lion King*, which grossed $253.5 million in profits as of August 24, 1994.[22] In fact, the first few weeks after *The Lion King* videocassette was released, it had sales of over twenty million, and Disney's stock soared by $2.25 a share based on first-week revenues of $350 million. Speaking of one of the most profitable films every made, Jessica J. Reiff, an analyst at Oppenheimer & Company, says "the movie will represent $1 billion in

profits for Disney over two or three years."[23] Similarly, Disney characters such as Mickey Mouse, Snow White, Jasmine, Aladdin, and Pocahontas become prototypes for numerous toys, logos, games, and rides that fill department stores all over the world. Disney theme parks, which made over $3.4 billion in revenues in 1993, produced a sizable portion of their profits through the merchandising of toys based on characters from the animated films. *The Lion King* produced a staggering $1 billion in such merchandising profits in 1994 alone, not to mention the profits made from still other spinoff products from the movie. For example, Disney has shipped over three million copies of the soundtrack from *The Lion King*.[24] Disney's culture of commercialism is big business, and the toys modeled after Disney's animated films provide goods for over three hundred Disney Stores worldwide. As a commentator in *Newsweek* recently pointed out, "The merchandise—Mermaid dolls, Aladdin undies, and collectibles like a sculpture of Bambi's Field Mouse—account for a stunning 20 percent of Disney's operating income."[25]

Disney's biggest promotion campaign to date was put into effect with the summer 1995 release of *Pocahontas*. A record lineup of tie-in merchandise included Pocahontas stuffed animals, sheets, pillowcases, toothbrushes, games, moccasins, and over "40 different picture and activity books."[26] A consortium of corporations spent an estimated $125 million on cross-marketing Pocahontas. Two well-known examples included Burger King, which was converted into an advertisement for the film and gave away an estimated fifty million *Pocahontas* figurines, and the Mattel Corporation, which marketed over fifty different dolls and toys.

But Disney's attempt to turn children into consumers and to construct commodification as a defining principle of children's culture should not suggest a parallel vulgarity in its willingness to experiment aesthetically with popular forms of representation. Disney has shown enormous inventiveness in its attempts to reconstruct the very grounds on which popular culture is defined and shaped. For example, by defining popular culture as a hybridized sphere that combines genres and forms and often collapses the boundary between high and low culture, Disney has pushed against the grain of aesthetic form and cultural legitimacy. For instance, when *Fantasia* appeared in the 1930s it drew the wrath of music critics, who, holding to an elite view of classical music, were outraged that the musical score of the film drew from the canon of high culture. By combining high and

low culture in the form of the animated film, Disney opened up new cultural spaces and possibilities for artists and audiences alike. Moreover, as sites of entertainment, Disney's films "work" because they put both children and adults in touch with joy and adventure. They present themselves as places to experience pleasure, even when we have to buy it.

And yet, Disney's brilliant use of aesthetic forms, musical scores, and inviting characters can only be "read" in light of the broader conceptions of reality and predispositions employed by specific Disney films. These films themselves must be viewed within a wider system of dominant representations about gender roles, race, and agency that are endlessly repeated in the visual worlds of television, Hollywood film, and videocassettes.

All five of the recent films mentioned draw upon the talents of song writers Howard Ashman and/or Alan Menken, whose skillful arrangements provide the emotional glue of the animation experience. The rousing calypso number, "Under the Sea," in The Little Mermaid, and "Be Our Guest," the Busby Berkeley–inspired musical sequence in Beauty and the Beast, are indicative of the musical talent at work in Disney's animated films. Fantasy abounds as Disney's films produce a host of exotic and stereotypical villains, heroes, and heroines. The Beast's enchanted castle in Beauty and the Beast becomes magical as household objects are transformed into dancing teacups, a talking teapot, and dancing silverware. And yet, tied to the magical fantasy and lighthearted musical scores are representations and themes that emulate the repetitive stereotypes that are characteristic of Disney's view of the childhood culture. For example, while Ursula, the large, oozing, black and purple squid in The Little Mermaid gushes with evil and irony, the heroine and mermaid, Ariel, appears as a cross between a typical rebellious teenager and a Southern California fashion model. Disney's representations of evil and good women appear to have been fashioned in the editorial office of Vogue magazine. The wolflike monster in Beauty and the Beast evokes a rare combination of terror and gentleness, while Scar, the suave feline, masterfully embraces a scheming sense of evil and betrayal. The array of animated objects and animals in these films is of the highest artistic standards, but they do not exist in some ideology-free comfort zone. Their characters are tied to larger narratives about freedom, rites of passage, intolerance, choices, greed, and the brutalities of male chauvinism. These are just some of the many themes explored in Disney's animated films. But enchantment comes with a high price if one of its

effects is to seduce its audience into suspending critical judgment on the dominant ideological messages produced by such films. Even though these messages can be read through a variety of significations shaped within different contexts of reception, the dominant assumptions that structure these films carry enormous weight in restricting the number of cultural meanings that can be brought to bear on them, especially when the intended audience is mostly children.

This should not suggest that the role of the critic in dealing with Disney's animated films is to simply assign them a particular ideological reading. On the contrary, the challenge of such films is to analyze the various themes and assumptions that inform them both within and outside of the dominant institutional and ideological formations that attempt to constrain how they might be taken up. This allows educators and others to try to understand how such films can become sites of contestation, translation, and exchange in order to be read differently. But there is more at stake here than recognizing the plurality of readings such films might animate; there is also the political necessity of analyzing how privileged, dominant readings of such texts construct their power-sensitive meanings to generate particular subject positions that define for children specific notions of agency and its possibilities in society.

Contexts mold interpretations; but political, economic, and ideological contexts also produce the texts to be read. Focusing on films must be supplemented with analyzing the institutional practices and social structures that work to shape such texts. This type of analysis does not mean that cultural workers should subscribe to a form of determinism in which cultural texts can be assigned a singular meaning as much as it should suggest pedagogical strategies for understanding how dominant regimes of power work to severely limit the range of views that children might bring to reading Disney's animated films. By making the relationship between power and knowledge visible while simultaneously referencing what is often taken for granted, teachers and critics can use Disney's animated films pedagogically, by assisting students and others to read such films within, against, and outside of the dominant codes that inform them. There is a double pedagogical movement here. First, there is the need to read Disney's films in relation to their articulation with other dominant texts in order to assess the similarities of such texts in legitimating particular ideologies. Second, there is the need on the part of cultural work-

ers to use Disney's thematization of America and America's thematization of Disney as a referent to both make visible and disrupt dominant codings, but to do so in a space that invites dialogue, debate, and alternative readings. That is, pedagogically one major challenge is to assess how dominant significations which are repeated over time in these films and reinforced through other popular cultural texts can be taken up as a referent for engaging how children define themselves within such representations. The task here is to provide readings of such films that serve as a pedagogical referent for engaging them in the context in which they are shaped, understood, or might be seen.[27] But providing a particular ideological reading of these films should not suggest this is the only possible reading. On the contrary, by providing a theoretical referent for engaging Disney films, it becomes possible to explore pedagogically how children, students, and adults both construct and defend the readings they bring to such films. In other words, taking a position on Disney's films should be seen not as a form of political or pedagogical indoctrination. On the contrary, such an approach demonstrates that any reading of these films is ideological in nature and should be engaged in terms of the context that produces a particular reading, its content, and what it suggests about the values and social relations it endorses. Moreover, engaging such films politically and ideologically provides the pedagogical basis for making such films problematic and thus open to dialogue rather than treating them uncritically as mere entertainment.

READING DISNEY

The construction of gender identity for girls and women represents one of the most controversial issues in Disney's animated films.[28] In both The Little Mermaid and The Lion King, the female characters are constructed within narrowly defined gender roles. All of the female characters in these films are ultimately subordinate to males, and define their sense of power and desire almost exclusively in terms of dominant male narratives. For instance, modeled after a slightly anorexic Barbie Doll, Ariel, the woman-mermaid in The Little Mermaid, at first glance appears to be engaged in a struggle against parental control, motivated by the desire to explore the human world and willing to take a risk in defining the subject and object of her desires. But in the end, the struggle to gain independence from her father, Triton, and the sense of desperate striving that motivates her dissolve when Ariel makes

a Mephistophelian pact with the sea witch, Ursula. In this trade, Ariel gives away her voice to gain a pair of legs so that she can pursue the handsome Prince Eric. While children might be delighted by Ariel's teenage rebelliousness, they are strongly positioned to believe in the end that desire, choice, and empowerment are closely linked to catching and loving handsome men. Bonnie Leadbeater and Gloria Lodato Wilson explore succinctly the pedagogical message at work in the film with their comment:

> The 20th-century innocent and appealing video presents a high-spirited role for adolescent girls, but an ultimately subservient role for adult women. Disney's "Little Mermaid" has been granted her wish to be part of the new world of men, but she is still flipping her fins and is not going too far. She stands to explore the world of men. She exhibits her new-found sexual desires. But the sexual ordering of women's roles is unchanged.[29]

Ariel in this film becomes a metaphor for the traditional housewife-in-the-making narrative. When the sea witch Ursula tells Ariel that taking away her voice is not so bad because men don't like women who talk, the message is dramatized as the Prince attempts to bestow the kiss of true love on Ariel even though she has never spoken to him. Within this rigidly defined narrative, womanhood offers Ariel the reward of marrying the right man and renouncing her former life under the sea as a telling cultural model for the universe of female choices and decision making in Disney's worldview. The forging of rigid gender roles in The Little Mermaid does not represent an isolated moment in Disney's filmic universe; on the contrary, the power that informs Disney's reproduction of negative stereotypes about women and girls gains force, in part, through the consistent way in which similar messages are circulated and reproduced, in varying degrees, in all of Disney's animated films.

For example, in Aladdin the issue of agency and power is centered primarily on the role of the young street tramp, Aladdin. Jasmine, the princess he falls in love with, is simply an object of his immediate desire as well as a social stepping stone. Jasmine's life is almost completely defined by men, and, in the end, her happiness is insured by Aladdin, who finally is given permission to marry her.

Disney's gender theme becomes a bit more complicated in Beauty and the Beast and Pocahontas. Belle, the heroine of Beauty and the Beast, is portrayed as

an independent woman stuck in a provincial village in eighteenth-century France. Seen as odd because she always has her nose in a book, she is pursued by Gaston, the ultimate vain, macho male typical of Hollywood films of the 1980s. To Belle's credit she rejects him, but in the end she gives her love to the Beast, who holds her captive in the hopes she will fall in love with him and break the evil spell cast upon him as a young man. Belle not only falls in love with the Beast, she "civilizes" him by instructing him on how to eat properly, control his temper, and dance. Belle becomes a model of etiquette and style as she turns this narcissistic, muscle-bound tyrant into a "new" man, one who is sensitive, caring, and loving. Some critics have labeled Belle a Disney feminist because she rejects and vilifies Gaston, the ultimate macho man. Less obviously, *Beauty and the Beast* also can be read as a rejection of hyper-masculinity and a struggle between the macho sensibilities of Gaston and the reformed sexist, the Beast. In this reading Belle is less the focus of the film than a prop or "mechanism for solving the Beast's dilemma."[30] Whatever subversive qualities Belle personifies in the film, they seem to dissolve when focused on humbling male vanity. In the end, Belle simply becomes another woman whose life is valued for solving a man's problems.

Rather than being portrayed as a young adolescent, Pocahontas is made over historically to resemble a shapely, animated, contemporary, high-fashion supermodel. Represented as a woman who is bright, courageous, literate, and politically progressive, she is a far cry from the traditional negative stereotypes of Native Americans portrayed in Hollywood films. But like many of Disney's female protagonists, Pocahontas's character is drawn primarily in relation to the men that surround her. Initially, her identity is defined in resistance to her father's attempts to marry her off to one of the bravest warriors in the tribe. But her coming-of-age identity crisis is largely defined by her love affair with John Smith, a colonialist who happens to be blond and looks like as if he belongs in a Southern California pin-up magazine of male surfers. Pocahontas's character is drawn primarily through her struggle to save her colonial lover, John Smith, from being executed by her father. Pocahontas exudes a kind of soppy romanticism that not only saves John Smith's life, but convinces the crew of the British ship to turn on its greedy captain and return to England. Of course, this is a Hollywood rewrite of history that bleaches colonialism of its genocidal legacy. No mention is made of the fact that John Smith's countrymen would

ultimately ruin Pocahontas's land, bring disease, murder, and poverty to her people, and eventually destroy their religion, economic livelihood, and way of life. In the Disney version of history, colonialism never happened, and the meeting between the old and new worlds simply becomes fodder for reproducing a "love conquers all" narrative. One wonders how this film would have been taken up in the public mind if it had been a film about a Jewish woman who falls in love with a blond, Aryan Nazi, while ignoring any references to the Holocaust.

The issue of female subordination returns with a vengeance in The Lion King. All of the rulers of the kingdom are men, reinforcing the assumption that independence and leadership are tied to patriarchal entitlement and high social standing. The dependency that the beloved lion king, Mufasa, engenders from the women of Pride Rock is unaltered after his death when the evil Scar assumes control of the kingdom. Lacking any sense of outrage, independence, or resistance, the women felines hang around to do his bidding.

Given Disney's purported obsession with family values, especially as a consuming unit, it is curious as to why there are no strong mothers or fathers in these films.[31] Not only are powerful mothers absent, but with the exception of Pocahontas's father, all of the father figures in these films are portrayed as either weak or stupid. The mermaid only has a domineering father; Jasmine's father is outwitted by his aids; and Belle has an airhead for a father. All the more reason to ponder why Disney cannot conceive of independent and forceful woman outside of the family unit, since that unit is largely portrayed as dysfunctional.

Jack Zipes, a leading theorist on fairy tales, claims that Disney's animated films celebrate a masculine type of power, but more importantly he believes that they reproduce "a type of gender stereotyping . . . that [has] an adverse effect on children in contrast to what parents think. . . . Parents think they're essentially harmless—and they're not harmless."[32] Disney films are seen by enormous numbers of children in both the United States and abroad. As far as the issue of gender is concerned, Disney's view of female agency and empowerment is not simply limited, it borders on being overtly reactionary.

Racial stereotyping is another major issue that surfaces in many of the recent Disney animated films. But the legacy of racism does not begin with the films produced since 1989; on the contrary, there is a long history of racism associated with the studio. This history can be traced back to denigrating images of people of color in films such as Song of the South, released

in 1946, and The Jungle Book, which appeared in 1967.[33] Moreover, racist representations of native Americans as violent "redskins" were featured in Frontierland in the 1950s.[34] The main restaurant in Frontierland featured the real-life figure of a former slave, Aunt Jemima, who would sign autographs for the tourists outside of her "Pancake House." Eventually the exhibits and the Native Americans running them were eliminated by Disney executives because the "Indian" canoe guides wanted to unionize. They were displaced by robotic dancing bears. Complaints from civil rights groups got rid of the degrading Aunt Jemima spectacle.[35]

Recently, the most controversial example of racist stereotyping facing the Disney publicity machine occurred with the release of Aladdin in 1992, although such stereotyping also reappeared in 1994 with the release of The Lion King. Aladdin represents a particularly important example because it was a high profile release, the winner of two Academy Awards, and one of the most successful Disney films ever produced. Playing to massive audiences of children, the film's opening song, "Arabian Nights," begins its depiction of Arab culture with a decidedly racist tone. The lyrics of the offending stanza state: "Oh I come from a land / From a faraway place / Where the caravan camels roam. / Where they cut off your ear / If they don't like your face. / It's barbaric, but hey, it's home." In this characterization, a politics of identity and place associated with Arab culture magnifies popular stereotypes already primed by the media through its portrayal of the Gulf War. Such racist representations are further reproduced in a host of supporting characters who are portrayed as grotesque, violent, and cruel. Yousef Salem, a former spokesperson for the South Bay Islamic Association, characterized the film in the following way:

> All of the bad guys have beards and large, bulbous noses, sinister eyes and heavy accents, and they're wielding swords constantly. Aladdin doesn't have a big nose; he has a small nose. He doesn't have a beard or a turban. He doesn't have an accent. What makes him nice is they've given him this American character.... I have a daughter who says she's ashamed to be call herself an Arab, and it's because of things like this.[36]

Jack Shaheen, a professor of broadcast journalism at Southern Illinois University of Edwardsville, along with radio personality Casey Kasem, mobilized a public relations campaign protesting the anti-Arab themes in

Aladdin. At first the Disney executives ignored the protest, but due to the rising tide of public outrage agreed to change one line of the stanza in the subsequent videocassette and worldwide film release; it is worth noting that Disney did not change the lyrics on its popular CD release of *Aladdin*.[37] It appears that Disney executives were not unaware of the racist implications of the lyrics when they were first proposed. Howard Ashman, who wrote the main title song, submitted an alternative set of lyrics when he delivered the original verse. The alternative set of lyrics, "Where it's flat and immense / And the heat is intense" eventually replaced the original verse, "Where they cut of your ear / If they don't like your face." Though the new lyrics appeared in the videocassette release of *Aladdin*, many Arab groups were disappointed because the verse "It's barbaric, but hey it's home" was not altered. More importantly, the mispronunciation of Arab names in the film, the racial coding of accents, and the use of nonsensical scrawl as a substitute for an actual written Arabic language were not removed.[38]

Racism in Disney's animated films does not simply appear in negative imagery; it is also reproduced through racially coded language and accents. For example, *Aladdin* portrays the "bad" Arabs with thick foreign accents, while the Anglicized Jasmine and Aladdin speak in standard Americanized English. A hint of the racism that informs this depiction is provided by Peter Schneider, president of feature animation at Disney, who points out that Aladdin was modeled after Tom Cruise. Racially coded representations and language are also evident in *The Lion King*. Scar, who is the icon of evil, is portrayed as darker than the good lions. Moreover, racially coded language is evident as all of the members of the royal family speak with posh British accents while Shenzi and Banzai, the despicable hyena storm troopers, speak through the voices of Whoopi Goldberg and Cheech Marin in jive accents that take on the nuances of the discourse of a decidedly urban black and Latino youth. The use of racially coded language is not new in Disney's films and can be found in an early version of *The Three Little Pigs*, *Song of the South*, and *The Jungle Book*.[39] What is astonishing in these films is that they produce a host of representations and codes in which children are taught that cultural differences that do not bear the imprint of white, middle-class ethnicity are deviant, inferior, unintelligent, and a threat to be overcome. The racism in these films is defined by both the presence of racist representations and the absence of complex representations of African-Americans and other people of color.

At the same time, whiteness as a form of racial identity is universalized through the privileged representation of middle-class social relations, values, and linguistic practices. Moreover, the representational rendering of history, progress, and Western culture bears a colonial legacy that seems perfectly captured by Edward Said's notion of orientalism and its dependency on new images of centrality and sanctioned narratives.[40] Cultural differences in Disney's recent films are expressed through a "naturalized" racial hierarchy, one that is antithetical to a viable democratic society. There is nothing innocent in what kids learn about race as portrayed in the "magical world" of Disney. Even in a film such as *Pocahontas*, where cultural differences are portrayed more positively, there is the suggestion in the end that racial identities must remain separate. *Pocahontas* is one of the few love stories in Disney's animated series in which the lovers do not live together happily ever after. It is also one of the few love stories that brings lovers from different races together.

Another central feature common to many of Disney's recently animated films is the celebration of deeply antidemocratic social relations. Nature and the animal kingdom provide the mechanism for presenting and legitimating caste, royalty, and structural inequality as part of the natural order. The seemingly benign presentation of celluloid dramas in which men rule, strict discipline is imposed through social hierarchies, and leadership is a function of one's social status suggests a yearning for a return to a more rigidly stratified society, one modeled after the British monarchy of the eighteenth and nineteenth centuries. Within Disney's animated films, nature provides a metaphor where "harmony is bought at the price of domination. . . . no power or authority is implied except for the natural ordering mechanisms [of nature]."[41] For children, the messages offered in Disney's animated films suggest that social problems such as the history of racism, the genocide of Native Americans, the prevalence of sexism, and crisis of democracy are simply willed through the laws of nature.

CULTURAL PEDAGOGY AND CHILDREN'S CULTURE

Given the corporate reach, cultural influence, and political power that Disney exercises over multiple levels of children's culture, Disney's animated films should be neither ignored nor censored by those who dismiss the conservative ideologies they produce and circulate. I think there are a number of issues to be taken up regarding the forging of a pedagogy and

politics responsive to Disney's shaping of children's culture. In what follows, I want to provide in schematic form some suggestions regarding how cultural workers, educators, and parents might critically engage Disney's influence in shaping the "symbolic environment into which our children are born and in which we all live out our lives."[42]

First, it is crucial that the realm of popular culture that Disney increasingly uses to teach values and sell goods be taken seriously as a site of learning and contestation, especially for children. This means, at the very least, that those cultural texts that dominate children's culture, including Disney's animated films, should be incorporated into schools as serious objects of social knowledge and critical analysis. This would entail a reconsideration of what counts as really useful knowledge in public schools and would offer a new theoretical register for addressing how popular media aimed at shaping children's culture are implicated in a range of power/knowledge relationships.

Second, parents, community groups, educators, and other concerned individuals must be attentive to the multiple and diverse messages in Disney films in order to both criticize them when necessary and, more importantly, to reclaim them for more productive ends. At the very least, we must be attentive to the processes whereby meanings are produced in these films and how they work to secure particular forms of authority and social relations. At stake pedagogically is the issue of paying "close attention to the ways in which [such films] invite (or indeed seek to prevent) particular meanings and pleasures."[43] In fact, Disney's films appear to assign quite unapologetically rigid roles to women and people of color. Similarly, such films generally produce a narrow view of family values coupled with a nostalgic and conservative view of history that should be challenged and transformed. Educators need to take seriously Disney's attempt to shape collective memory, particularly when such attempts are unabashedly defined by one of Disneyland's Imagineers in the following terms: "What we create is a sort of 'Disney realism,' sort of Utopian in nature, where we carefully program out all the negative, unwanted elements and program in the positive elements."[44] Needless to say, Disney's rendering of entertainment and spectacle, whether expressed in Frontierland, Main Street USA, or in its endless video and film productions, does not merely represent an edited, sanitary, and nostalgic view of history, one that is free of poverty, class differences and urban decay. Disney's writing

of public memory also aggressively constructs a monolithic notion of national identity that treats subordinate groups as either exotic or irrelevant to American history while simultaneously marketing cultural differences within "histories that corporations can live with."[45] Disney's version of United States history is neither innocent nor can it be dismissed as simply entertainment.

Disney's celluloid view of children's culture strips the past, present, and future of its diverse narratives and their multiple possibilities. But it is precisely such a rendering that needs to be revealed as an historically specific and politically constructed cultural "landscape of power." Positing and revealing the ideological nature of Disney's world of children's films opens up further opportunities for educators and cultural workers to intervene within such texts to make them mean differently. Rustom Bharacuha puts it well in arguing that "the consumption of . . . images . . . can be subverted through a particular use in which we are compelled to think through images rather than respond to them with a hallucinatory delight."[46] One rendering of the call to "think through images" is for educators and cultural workers to demonstrate pedagogically and politically that history and its rendering of national identity have to be contested and engaged, even when images parade as innocent film entertainment for children. The images that pervade Disney's production of children's culture along with their claim to public memory need to be challenged and rewritten, "moved about in different ways," and read differently as part of the script of democratic empowerment.[47] Issues regarding the construction of gender, race, class, caste, and other aspects of self and collective identity are defining principles of Disney's films for children. It is within the drama of animated storytelling that children are often positioned pedagogically to learn what subject positions are open to them as citizens and what positions aren't. Hence, the struggle over children's culture partly must be seen as the struggle over the related discourses of citizenship, national identity, and democracy itself.

Third, if Disney's films are to be viewed as more than narratives of fantasy and escape, becoming sites of reclamation and imagination, which affirm rather than deny the long-standing relationship between entertainment and pedagogy, cultural workers and educators need to insert the political and pedagogical back into the discourse of entertainment. In part, this points to analyzing how entertainment can be rendered as a subject of intellectual

engagement rather than a series of sights and sounds that wash over us. This suggests a pedagogical approach to popular culture that engages how a politics of the popular works to mobilize desire, stimulate imagination, and produce forms of identification that can become objects of dialogue and critical investigation. At one level, this necessitates addressing the utopian possibilities in which children often find representations of their hopes and dreams. The pedagogical value of such an approach is that it alerts cultural workers to taking the needs, desires, languages, and experience of children seriously. But this is not meant to merely affirm the necessity for relevance in the curriculum as much as it means recognizing the pedagogical importance of what kids bring with them to the classroom (or any other site of learning) to decentering power in the classroom and expanding the possibility for multiple literacies and agency as part of the learning process.

It is imperative that parents, educators, and cultural workers pay attention to how these Disney films and visual media are used and understood differently by diverse groups of kids. Not only does this provide the opportunity for parents and others to talk to children about popular culture, it also creates the basis for better understanding how young people identify with these films, what issues need to be addressed, and how such discussions would open up a language of pleasure and criticism rather than simply foreclose one. This suggests that we develop new ways of critically understanding and reading electronically produced visual media. Teaching and learning the culture of the book is no longer the staple of what it means to be literate.

Children learn from exposure to popular cultural forms, providing a new cultural register to what it means to be literate. Educators and cultural workers must be attentive to the production of popular art forms in the schools. On one level, this suggests a cultural pedagogy that utilizes students' knowledge and experience of popular cultural forms. The point here is that students should not merely analyze the representations of electronically mediated, popular culture, they must also be able to master the skills and technology to produce it. Put another way, students should gain experience in making films, videos, music, and other forms of cultural production. Thus, students gain more power over the conditions for the production of knowledge.

But a cultural pedagogy also involves the struggle for more resources for schools and other sites of learning. Providing the conditions for stu-

dents to become the subjects and not simply the objects of pedagogical work by asserting their roles as cultural producers is crucial if students are to become attentive to the workings of power, solidarity, and difference as part of a more comprehensive project for democratic empowerment.

Fourth, Disney's all-encompassing reach into the spheres of economics, consumption, and culture suggests that we analyze the studio within a broad and complex range of relations of power. Eric Smoodin argues rightly that the American public needs to "gain a new sense of Disney's importance, because of the manner in which his work in film and television is connected to other projects in urban planning, ecological politics, product merchandising, United States domestic and global policy formation, technological innovation, and constructions of national character."[48] This suggests undertaking new analyses of Disney which connect rather than separate the various social and cultural formations in which the company actively engages. Clearly, such a dialectical practice not only provides a more theoretically accurate understanding of the reach and influence of Disney's power, it also contributes to forms of analysis that rupture the notion that Disney is primarily about the pedagogy of entertainment.

Questions of ownership, control, and the possibility of public participation in making decisions about how cultural resources are used, to what extent, and for what effect must become a central issue in addressing the world of Disney and other corporate conglomerates that shape cultural policy. It is imperative that educators and other cultural workers critically examine the control, production, and distribution of Disney's animated films as part of a wider circuit of power. Such an approach provides concerned parents and public citizens with relevant information for understanding and addressing how Disney, Inc., exercises its power and influence within the context of a larger cultural strategy and public policy initiative. In this context, Disney's influence in the shaping of children's culture cannot be reduced to critically interpreting the ideas and values promoted in films and other forms of representation. Any viable analysis of Disney must also confront the institutional and political power Disney exercises through its massive control over diverse sectors of the media industry.

The availability, influence, and cultural power of Disney's children's films demand that they become part of a broader political discourse regarding who makes cultural policy. Such issues could be addressed through public debates about how cultural and economic resources can be distributed to

insure that children are exposed to a variety of alternative narratives and representations about themselves and the larger society. When the issue of children's culture is addressed in the schools, it is assumed that this is a commonplace matter of public policy and intervention, but when it is shaped in the commercial sphere the discourse of public intervention gets lost in abstract appeals to the imperatives of the market and free speech. Free speech is only as good as the democratic framework that makes it possible to extend its benefits to a wider range of individuals, groups, and public spheres. Treating Disney as part of a media sphere that needs to be democratized and held accountable for the ways in which it sells power and manufactures social identities needs to be taken up as part of the discourse of pedagogical analysis and public policy intervention. This type of analysis and intervention is perfectly suited for cultural studies, which can employ an interdisciplinary approach to such an undertaking, one that makes the popular the object of serious analysis, makes the pedagogical a defining principle of such work, and inserts the political into the center of its project.[49]

This suggests that cultural workers need to readdress the varied interrelations that define both a politics of representation and a discourse of political economy as a new form of cultural work that rejects the material/cultural divide. The result would be a renewed understanding of how their modalities mutually inform each other within different contexts and across national boundaries. It is particularly important for cultural workers to understand how Disney films work within a broad network of production and distribution as teaching machines within and across different public cultures and social formations. Within this type of discourse, the messages, forms of emotional investment, and ideologies produced by Disney can be traced through the various circuits of power that both legitimate and insert "the culture of the Magic Kingdom" into multiple and overlapping public spheres. Moreover, such films need to be analyzed not only for what they say, but for how they are used and taken up by adult audiences and groups of children within diverse national and international contexts. That is, cultural workers need to study these films intertextually and from a transnational perspective. Disney does not represent a cultural monolith ignorant of different contexts; on the contrary, its power in part rests with its ability to address different contexts and to be read differently by transnational formations and audiences. Disney engenders what Inderpal Grewa and Caren Kaplan have called "scattered hege-

monies."[50] It is precisely by addressing how these hegemonies operate in particular spaces of power, specific localities, and differentiated transnational locations that progressives will be able to understand more fully the specific agendas and politics at work as Disney is both constructed for and read by different audiences.

I believe that since the power and influence of Disney is so pervasive in American society, parents, educators, and others need to find ways to make Disney accountable for what it produces. The recent defeat of the proposed three thousand acre theme park in Virginia suggests that Disney can be challenged and held accountable for the so-called "Disneyfication" of American culture. In this instance, a coalition of notable historians, community activists, educators, and cultural workers mobilized against the land developers supporting the project, wrote articles against Disney's trivializing of history and its implications for the park, and, in general, aroused public opinion enough to generate an enormous amount of adverse criticism against the Disney project. In this instance, what was initially viewed as merely a project for bringing a Disney version of fun and entertainment to hallowed Civil War grounds in historic Virginia was translated and popularized by oppositional groups as a matter of cultural struggle and public policy. And Disney lost.

What the Virginia cultural civil war suggests is that while it is indisputable that Disney provides both children and adults with the pleasure of being entertained, Disney's public responsibility does not end there. Rather than being viewed as a commercial sphere innocently distributing pleasure to young people, the Disney empire must be seen as a pedagogical and policy-making enterprise actively engaged in the cultural landscaping of national identity and the "schooling" of the minds of young children. This is not to suggest that there is something sinister behind what Disney does as much as point to the need to address the roles of fantasy, desire, and innocence in securing particular ideological interests, legitimating specific social relations, and making a distinct claim on the meaning of public memory. Disney needs to be held accountable not just at the box office but also in political and ethical terms. And if such accountability is to be impressed upon the "magic kingdom" then parents, cultural workers, and others will have to challenge and disrupt both the institutional power and the images, representations, and values offered by Disney's teaching machine. The stakes are too high to ignore such a challenge and struggle, even if it means reading Disney's animated films critically.

PUBLIC

INTELLECTUALS AND

POPULIST

PERSUASIONS

II

PUBLIC

INTELLECTUALS

AND

POSTMODERN

YOUTH

This is a dangerous time for youth in the United States. Within cultural institutions such as television and cinema, violence waged against youth in the streets is increasingly documented and romanticized on the scale of the blockbuster and the spectacle. The print media appears to have shifted its focus from an expressed disdain for the apathy of Generation X (white youth) to the menace of youth as potential muggers, killers, and criminals (black youth). Youth are increasingly narrated through sensational press

stories and statistics highlighting "high rates of teenage pregnancy, sexually transmitted diseases, alcohol and drug consumption, suicide, alcohol- and drug-related deaths, and violent crimes."[1]

Laws have been passed in nearly a thousand cities to either inaugurate or strengthen curfews designed both to keep youth off the streets and to police and criminalize their presence within urban space. In addition to being demonized by certain elements of the media, young people often find themselves inhabiting a postmodern world of cyberspace visuals, digitally induced representations of reality, and a society largely inhabited by malls, fast food restaurants, and a post-Fordist landscape of low-skill jobs. The adult world provides few markers for negotiating this landscape; instead, it offers youth a representation of the past that is thoroughly modernist in orientation, a world in which the culture of print, certainty, and the suburbs provide what appears to be an increasingly irrelevant set of referents for mapping the existing social order. This is most evident as working-class youth and youth of color are increasingly warehoused in modernist educational institutions in which rigid discipline and outdated knowledge are joined with a cultural addiction to excessive individualism, competitiveness, and Victorian moralism. Instead of helping children overcome the despair, hopelessness, and isolation that permeates youth culture, many adults appear to blame youth for the problems they face. One measure of the despair and alienation youth experience can be seen in the streets of our urban centers. The murder rate among young adults eighteen to twenty-four years old increased sixty-five percent from 1985 to 1993. Even more disturbing, as James Alan Fox (the Dean of the College of Criminal Justice at Northeastern University) pointed out recently, is that "murder is now reaching down to a much younger age group—children as young as 14 to 17. Since the mid-1980s, the rate of killing committed by teenagers 14 to 17 has more than doubled, increasing 165 percent from 1985 to 1993. Presently about 4,000 juveniles commit murder annually."[2] Coupled with an increase in poverty among children, a changing world economy that provides fewer jobs for the poor, and a rise in fractured families, one of the most notable features about the crisis of democratic public life in the United States is that youth appear to be one of its main casualties. And, yet, the assault on youth is happening without the benefit of adequate rights, fair representation, or even public outcry.

There is no absence of commentary by conservative public intellectuals on the conditions contributing to the worsening experiences of being

a child in the United States. Public policy issues advocated by conservatives are dominated by contracts with families, steeped in moral righteousness and indifferent to the structural and systemic problems at work in American society. But there is more at work in the New-Right blitzkrieg in Congress and on the airwaves than the call for moral righteousness. There is also the hateful attack on programs that benefit youth, brought about by cuts in government spending and the refusal to invest in education, employment programs for underrepresented youth, and health care reform. Right-wing academics such as Camille Paglia are treated as public intellectuals who provide instant commentary on how to address social issues. In response to whether excessive competition throughout society and increased violence in television shows, computer games, and children's toys help make violence a legitimate option for kids, Paglia offers just the right sound byte: "Human beings are naturally competitive and it's how a species moves forward. . . . I love football, which is a great model for dealing with the workplace. It's about controlled aggression."[3] In this discourse, not untypical among right-wing celebrities, Social Darwinism joins with the culture of competition and violence in sports to provide a pedagogical model for ushering young people into their proper places in the global economy of the 1990s.

Children can't vote, but they can be demonized, deprived of basic rights, spoon-fed an ethos of excessive competitiveness, and forced to put up with a glut of commodified violence in the media. Building more prisons will not solve the problem; neither will reducing student loans, or privatizing public schools. But the conspiracy to ignore the rights of children is nowhere more evident than in the increasingly powerful attempts to decimate the public school system as part of a larger assault on the democratic foundations of political, social, and cultural life. What can academics do in light of such an onslaught against children's culture? What possibilities exist within public spheres such as higher education for progressive educators to assume the role of public intellectuals willing to address those social problems that are destroying hopes of a decent future for the next generations of youth? Higher education cannot absolve its public responsibility to youth or public service, and central to such an obligation is the role that progressive educators might play through their work in the restructuring of democratic public life, especially as it might define and address the crisis of youth as part of the crisis of democracy.

HIGHER EDUCATION AS A PUBLIC SPHERE

As the concept of the public is increasingly attacked by the various factions on the right, a mounting criticism has emerged over the purpose of higher education along with the role that educators might play as critically engaged public intellectuals. This is most evident in the barrage of critiques initiated in the popular press and by right-wing cultural critics against multiculturalism, political correctness, and a variety of other forces that are allegedly undermining the traditional imperative of the university to teach "the best that has been thought and known in the world."[4]

In responding to the assault by neo-conservatives on the university as a critical public culture, left theorists such as Joan Scott have recognized that what is at stake in this battle goes far beyond the specific issues of freedom of speech in the academy, affirmative action, or challenging the canon.[5] More pointedly, the neo-conservative, Reagan-Bush assault waged during the 1980s has attempted to undermine those aspects of public culture which are fostered by and in turn promote critical and oppositional agency. It comes as no surprise that neo-conservatives have chosen higher education as one of the central sites on which to wage such a battle.[6]

Paradoxically, while the university is being attacked for allowing tenured radicals to take over the humanities and undermine the authority of the traditional canon, there is the simultaneous implication that the university should not assume the role of a critical, public sphere actively engaged in addressing either the social problems of the larger society or broader global landscape. On one level, the undermining of the university as a public space can be seen in both the fiscal cuts that have plagued universities across the country and in the increasing belief that issues that are central to public life need not be addressed within the hallowed halls of higher education. Neo-conservative hardliners such as Hilton Kramer go so far as to deny the relevance of both the university as a public sphere and the assumption that academics can operate as public intellectuals. He writes:

> The great mistake is to identify public intellectuals with academics. Most of the serious intellectual discourse for some time has not come out of the academy. The academy is intellectually dead.[7]

Somewhat moderate conservatives and liberals take a more cautious line and argue that universities should simply impart knowledge that is

outside of the political and cultural whirlwinds of the time. The crisis facing the university as a crucial public sphere is also evident in the rhetoric of a currently popular group of diverse conservative, public intellectuals who are located and supported financially in the worlds of government, private foundations, and the popular press. Right-wing ideologues such as Newt Gingrich are now touted as exemplary intellectuals who will apply a get-tough, marketplace approach to running the commanding institutions of civic life.

Debates about education are increasingly addressed within a broader social and policy-making context in which racist discourse, family values, and cultural chauvinism parade as exemplars of freedom of speech. Similarly, democracy is undermined if not overtly derided as the New Right publicly proclaims that they are waging a "counter cultural war" against forms of social dissent inspired by 1960s radicals. Within this formulation, the concept of social indignation becomes the preserve of privileged white men who see themselves as being under assault by the hostile forces of history. Given the current umbrage against almost any notion of the public that speaks to critical intellectual exchange, dialogue, or theoretical difference, it is not surprising that universities, public schools, National Public Radio, and the National Endowment for the Arts are under siege by a Congress whose power now resides in the hands of mostly evangelical Republicans.

The "counter cultural revolution" is not only being waged in Congress. As I point out in the next chapter, media culture, especially talk radio, has become a site for waging the war against progressive social movements and the democratic gains made against poverty, racism, sexism, and the destruction of the environment. Media culture is being increasingly used to unite a variety of conservative politicians, right-wing Christians, and public intellectuals in a common battle against the perils of deconstruction, postmodernism, cultural studies, black studies, gender studies, gay and lesbian studies, poststructuralism, and other alleged theoretical insurgencies. In addition to promoting a resurgent racism, right-wing intellectuals are waging a war against what Newt Gingrich and others label as cultural elites, a code word for anyone who is critical of the status quo. Moreover, the attack on cultural elites appears to be a thinly veiled critique of university academics (as well as public school teachers) who address the pressing social issues of the times.[8]

While the theoretical particulars are different, a similar critique of critical intellectuals in the university has emerged among populist journalists and a number of left theoreticians. The latter is evident in Russell Jacoby's nostalgic lament in *The Last Intellectuals* about the decline of public culture in the United States and the rise of academic intellectuals who allegedly write in arcane languages and largely forsake any viable political intervention into public life.[9] In this view, critical thought nurtured in the halls of higher education through the study of institutions, texts, and various forms of representation offers very little in the way of understanding or promoting concrete struggle over pressing social problems. A very similar critique has emerged in recent years among journalists in the popular media who argue that the university has become a repository of insular elitism marked by linguistic-ideological games far removed from the interests and concerns of everyday life.[10]

While it is true that the university harbors academics whose work often degenerates into an abstract and empty formalism, such a charge too easily slips into an overgeneralized critique that becomes self-serving, binaristic, and anti-intellectual. Refusing to interrogate the partiality of their own cultural authority, the proponents of the popular, everyday experience, and anti-elitism "drown out" any semblance of difference and complexity under a notion of cultural sovereignty that is as problematic as it is arrogant. And yet, this argument has gained substantial currency in the last decade and is indicative of one dimension of the crisis that higher education is facing.[11]

I want to enter this debate regarding critical education in unsettling times by arguing that the university is a major public sphere that not only influences massive numbers of people in terms of what is taught and how they might locate themselves in the context and content of specific knowledge forms but also in terms of the influence that the university has on large numbers of students who impact significantly on a variety of institutions in public life.[12] For example, if cultural critics were more attentive to what is taught in professions such as nursing, social work, and education, it might become more apparent what the importance and impact of such teaching is or might be on the thousands of teachers, health workers, and community people who battle in the health care system, social services, and the public schools. Surely institutions such as the public schools, for instance, can be considered a major public sphere; yet there is hardly a word uttered by radical and conservative critics about the critical relationship between higher education and the public schools. Perhaps the more

important question here is what silences have to endure in the debate on higher education in order for academic intellectuals to be dismissed as irrelevant, even though much of the work that goes on in institutions of higher education directly impacts on thousands of students whose work is significantly related to public issues and the renewal of civil society.

If progressive cultural and educational workers are to resist the conservative assault on critical public spheres, they must be able to defend institutions of higher education as deeply moral and political spaces. They must define themselves as intellectuals who are not merely professional academics acting alone, but as citizens whose collective knowledge and actions presuppose specific visions of public life, community, and moral accountability. Higher education must be defended through intellectual work that self-consciously recalls the tension between the democratic imperatives or possibilities of public institutions and their actual formation in everyday practice.

On one level, the practice of being a public intellectual suggests that academics develop their research programs, pedagogy, and conceptual frameworks in connection to cultural work undertaken in many arenas, including the media, labor organizations, or insurgent social movements. Such relationships should not be uncritical, and the practice also suggests the necessity for public intellectuals to speak to issues from a number of public arenas to a diverse range of audiences. At the same time, such connections and alliances should not suggest that higher education define its public function simply through its association with other public spheres. First and foremost, it must be defended as a vital public sphere in its own right, one that has deeply moral and educative dimensions that impact directly on civic life. This is an important issue, but the more relevant consideration at work in justifying the public nature of the university emerges out of the role higher education plays in educating students as critical agents who are equipped to understand, address, and expand the possibilities for deepening and sustaining democratic public life. As Andrew Ross points out, universities are not filled with students reduced to the passive institutional status of clients, but with actual citizens who constitute a significant public as a group.

> Millions of citizens populate the world of colleges and universities, and thereby constitute a public in its own right. In spite of the powerful, and overly prestigious influence of the private sector within higher education, internal conflicts can be easily defined as issues of public concern.[13]

Viewed as a critical public sphere, the university is defined as a site of contestation and potential instability marked by the democratic possibility for unpredictable collisions, diverse relations of representation, and what Mariam Hansen calls "multiple forms of community and solidarity."[14] In opposition to this view, conservatives posit the university either as a replica of the modernist museum, housing and displaying the privileged artifacts of a Western tradition, or as an adjunct of the marketplace infused with the principles of commerce and competition. By abstracting higher education from a discourse of power, politics, and moral accountability, neo-conservatives such as Roger Kimball, Lynne Cheney, Charles Sykes, William Bennett, Chester Finn, Jr., and others have been able to argue forcefully against the university as a critical, public sphere actively engaged in addressing either the social problems of the larger society or broader global landscape. Lost in this discourse are the moral and political referents for accentuating the relationship between the university and the larger society through the imperatives of public service rather than the dynamics of professionalism, competition, and social mobility.

As a critical public space whose moral and educative dimensions impact directly on the renewal of everyday life, the university becomes indispensable for rendering students accountable to their obligations as critical citizens who address what role knowledge and authority might play in the reconstruction of democracy itself. In this instance, knowledge and power intersect with ethical discourses attentive to the ravages of racism, corporate greed, sexism, and other injustices, not as the privileged preserve of identity politics but as a site of resistance to the ever-growing threat to democratic public life. Defending higher education as a site of learning and public strategy of engagement is a necessary condition for academics to redefine their role as public intellectuals who can move within and between various sites of learning actively engaged in the production of knowledge, values, and social identities.

As an active site for the production of critical thinking, collective work, and social struggle, higher education must be defended as a public resource vital to the moral life of the nation and open to working people and communities that are often viewed as marginal to such institutions with their resources, knowledge, and skills. At issue here is redefining the knowledge, skills, research, and social relations constructed in the university as part of a broader reconstruction of a tradition that links critical thought to collec-

tive action, knowledge and power to a profound impatience with the status quo, and human agency to diverse and multiple ethics of social responsibility. In part, this suggests inserting the concept of the political as a defining principle of university life. But the political in this sense rejects the language of normalization and universalization for the discourse of contingency and the constitutive role of difference and conflict. For it is precisely through the revival of the political that democracy is bolstered— through competing conceptions of the common good, a range of possible identities to define what it means to be a citizen, and a reassertion of the important relationship between ethics and public life. Within this pedagogy of citizenship, morality and politics are not passive, and citizenship becomes a form of identification that necessitates critical dialogue, struggle, and forms of identification with a notion of the public where "relations of domination exist and must be challenged if the principles of liberty and equality" are to become central to democratic public life.[15]

THE PEDAGOGY OF POLITICAL EDUCATION

The criticism expressed toward the role of teachers as public intellectuals has a long tradition in the United States.[16] In its contemporary form, it is a critique that cuts across ideological lines. For example, neo-conservatives argue that university teachers who address public issues from the perspective of a committed position or pedagogy violate the spirit of academic professionalism. They are painted as ideologues left over from the 1960s who represent a dangerous threat to the freedom and autonomy of the university. This is implicit in Irving Kristol's charge that the greatest threat to conservative hegemony comes from the cultural left, which consists of teachers and others "from the so-called helping professions."[17] This being the case, there is a deep suspicion of any attempt to open up the possibility for educators to address important social problems and to connect them to their teaching.

Attempting to license and regulate pedagogical practice, conservatives argue that universities are apolitical institutions whose primary goal is to create a select strata of technical experts and cultural specialists to run the commanding institutions of the state, to prepare students for the workplace, and to reproduce the alleged common values that define the "American" way of life.[18] In this perspective, politics as an oppositional practice is canceled out through an appeal to cultural and technical management, and critical pedagogy is displaced by the imperatives of "objectivity"

and "appropriate academic standards." Ironically, there is also an attempt on the part of populist conservatives to "expose" university professors who don't work at elite research universities for not fulfilling their teaching duties because of the time they spend on research. The cure here is worse than the disease since what is at stake are not the interests of the students but the attempt to deskill university professors by subjecting them to the dictates of political hacks who run state legislatures.

At the same time, many liberals have argued that while university academics should address public issues they should do so from the perspective of a particular teaching methodology or pedagogy rather than from a particular political project. This is evident in Gerald Graff's call for university educators to teach the conflicts. Graff's position is that academics who teach about oppression from a particular theoretical standpoint presuppose some prior agreement among students that particular forms of domination actually exist before being critically interrogated. And for those "radical" educators who address issues of human suffering and other social problems, Graff believes that they end up speaking to the already converted. Lacking a political project, Graff's view of the role of university intellectuals runs the risk of reducing academics to technicians engaged in formalistic, pedagogical rituals devoid of any pressing commitment that might help students identify, engage, and transform relations of power that generate the material conditions of racism, sexism, poverty, and other oppressive conditions.[19]

Graff's position represents more than a cheap theoretical assertion; it is based on a confusion between political education and politicizing education. Political education, which is central to critical pedagogy, refers to teaching "students how to think in ways that cultivate the capacity for judgment essential for the exercise of power and responsibility by a democratic citizenry. . . . A political, as distinct from a politicizing education would encourage students to become better citizens to challenge those with political and cultural power as well as to honor the critical traditions within the dominant culture that make such a critique possible and intelligible."[20]

A political education means decentering power in the classroom and other pedagogical sites so the dynamics of those institutional and cultural inequalities that marginalize some groups, repress particular types of knowledge, and suppress critical dialogue can be addressed. On the other hand, politicizing education is a form of pedagogical terrorism in which the issue of what is taught, by whom, and under what conditions is deter-

mined by a doctrinaire political agenda that refuses to examine its own values, beliefs, and ideological construction. While refusing to recognize the social and historical character of its own claims to history, knowledge, and values, a politicizing education silences in the name of a specious universalism and denounces all transformative practices through an appeal to a timeless notion of truth and beauty. Ironically, the latter virtues seem much more endemic to right-wing educational agendas, given their emphasis on pedagogy as an unproblematic vehicle for conveying truth and on knowledge as something to be handed down rather than critically engaged. For those who practice a politicizing education, democracy and citizenship become dangerous in that the precondition for their realization demands critical inquiry, risk-taking, and the responsibility to resist and say no in the face of dominant forms of power.

I want to argue further that public intellectuals must address combining the mutually interdependent roles of educators and citizens. This implies finding ways to connect the practice of classroom teaching to the operation of power in the larger society. I think Edward Said is correct in arguing that the public intellectual must function within institutions, in part, as an exile, as someone whose "place it is publicly to raise embarrassing questions, to confront orthodoxy and dogma, to be someone who cannot easily be co-opted by governments or corporations."[21] In this perspective, it becomes the responsibility of the educator as public intellectual to link the diverse experiences that constitute the production of knowledge, identities, and social values in the university to the quality of moral and political life in the wider society. Vaclav Havel argues that intellectuals have a responsibility to engage in practical politics, to see "things in more global terms . . . build people-to-people solidarity. . . foster tolerance, struggle against evil and violence, promote human rights, and argue for their indivisibility."[22] Feeling an increased sense of responsibility for humanity does not mean that intellectuals can or should explain the problems of the world in terms that purport to be absolute or all encompassing. Nor should they limit their responsibility to the university or the media. On the contrary, public intellectuals need to approach social issues with humility, mindful of the multiple connections and issues that tie humanity together; but they need to do so by moving within and across diverse sites of learning as part of an engaged and practical politics that recognizes the importance of "asking questions, making distinctions,

restoring to memory all those things that tend to be overlooked or walked past in the rush to collective judgment and action."[23]

Public intellectuals need to challenge forms of disciplinary knowledge, specialization, and social relations that either produce or legitimate material and symbolic violence, while simultaneously being deeply critical of their own authority and how it structures classroom relations and cultural practices. Pedagogically, this suggests that the authority that educators legitimate and exercise in the classroom becomes both an object of self-critique and a critical referent for expressing a more "fundamental dispute with authority itself."[24] One qualification needs to be made here. While Said appears to suggest that the public intellectual stands alone in his or her opposition, I want to argue that intellectual work cannot be detached from collective action. Public intellectuals do not act merely on the basis of academic merit or integrity but within and across broader political, cultural, and social formations that both support their work and allow them to engage in collective struggles with others.[25]

Critical educational work must do more than open up the space for critical exchange, it must also provide conditions for the production of "fugitive" knowledge to enable students to move beyond symbolic resistance to specific acts of resistance and social engagement within different spheres of public life.[26] As public intellectuals, university teachers need to provide the opportunities for students to learn that the relationship between knowledge and power can be emancipatory, that their histories and experiences matter, and that what they say and do can count as part of a wider struggle to unlearn dominating privileges, productively reconstruct their relations with others, and transform, when necessary, the world around them. As I repeatedly stress in this book, educational work needs to be relocated in the intersection of schooling and everyday life. The curriculum needs to be organized around knowledge that relates to the communities, cultures, and traditions of students, which in turn provide them opportunities to critically appropriate a sense of history, identity, and place. This is a call for transgressing the often rigid division between academic culture and popular/oppositional culture. Recognizing the university as a critical public sphere means expanding pedagogical practice as a form of cultural politics by making all knowledge subject to serious analysis and interrogation, and in doing so making visible the operations of power that connect such knowledge to specific views of authority and cultural practice.

But critical pedagogical practices must do more than make learning context specific, they must also challenge the content of the established canon as well as point to the need to expand the range of cultural texts that inform what counts as "really useful knowledge." As public intellectuals, university teachers need to understand and use those electronically mediated knowledge forms that constitute the terrain of popular culture. I refer to the world of media texts—videos, films, music, and other mechanisms of popular culture—constituted outside of the technology of print and the book. Put another way, the content of the curriculum needs to affirm and critically enrich the meaning, language, and knowledge forms that students actually use to negotiate and inform their lives. This suggests that academics can in part exercise their role as public intellectuals by giving students the opportunity to understand how power is organized through an extensive number of "popular" cultural spheres that range from malls, movie theaters, and amusement parks to high-tech media conglomerates that circulate signs and meanings through newspapers, magazines, advertisements, electronic programming, films, and television programs.

While it is central for university teachers to expand the relevance of the curriculum to include the richness and diversity of the students they actually teach, they also need to correspondingly decenter the curriculum. That is, students should be actively involved with issues of governance, "including setting learning goals, selecting courses, and having their own, autonomous organizations, including a free press."[27] Not only does the redistribution of power among teachers, students, and administrators provide the conditions for students to become agents in their learning process, it also provides the basis for collective learning, civic action, and ethical responsibility. Moreover, such agency emerges through a pedagogy of lived experience and struggle rather than as the empty, formalistic mastery of an academic subject.

In an age of shifting demographics, large-scale immigration, and multiracial communities, university teachers must make a firm commitment to cultural difference as central to the relationship of schooling and citizenship. In the first instance, this means dismantling and deconstructing the legacy of nativism and racial chauvinism that has defined the rhetoric of school reform for the last decade.[28] In specific terms, it means fighting against the resurgence of legislation to make English the official language, federal spending cuts that deny school lunches to poor children, and laws

aimed at dismantling bilingual programs. Beginning with the Reagan and Bush eras and extending into the current, overcharged racial backlash being inaugurated under Newt Gingrich and his fellow conservatives in government, the United States is witnessing a full-fledged attack on the rights of minorities, civil rights legislation, affirmative action, and the legitimation of curriculum reforms pandering to Eurocentric interests. University educators can affirm their commitment to democratic public life and cultural difference by struggling in and outside of their classrooms in solidarity with others to reverse these policies in order to make schools more attentive to the cultural resources that students bring with them to all levels of schooling. At one level, this means working to develop legislation that protects the civil rights of all groups. Equally important is the need for university teachers to take the lead in encouraging programs that open school curricula to the narratives of cultural difference, without falling into the trap of merely orientalizing the experience of Otherness.

At stake here is the development of an educational policy that asserts university education as part of a broader ethical and political discourse, one that both challenges and transforms those curricula reforms of the last decade that are profoundly racist in context and content. Within the current historical conjuncture there is a need for ongoing institutional struggles in which transformative academic, interdisciplinary programs are not constructed on the margins of academic power, but attempt to play a central role in defining the department or college curriculum so that such programs are open to a wide variety of students and play a major role in shaping academic policy, particularly around issues that directly impact on minority students.

In part, such an antiracist struggle suggests changing the terms of the debate regarding the relationship between schooling and national identity, resisting an assimilationist ethic and the profoundly Eurocentric fantasies of a common culture, and struggling to link national identity to diverse traditions and histories that expand the basis of democratic life. All of the considerations I have mentioned point to the necessity for a political language that articulates some common ground among those working for progressive change in the classroom, workplace, neighborhoods, community social services, media, state legislatures, and a number of other politically influential public sites. Central to such a task is a political project that provides a shared pedagogical discourse enabling educators to work within

as well as across those primary sites active in the writing of "patriotic" youth culture. Lauren Berlant points to such a project in analyzing how the production of modern citizenship takes place through the narrative structures of print, radio, television, mostly coded in a right-wing cultural agenda. For Berlant, the genres of patriotism produced in the media and other cultural sites mobilize forms of collective identification in which "national knowledge itself becomes a modality of national amnesia. . . . a consciousness of the nation with no imagination of agency—apart perhaps from voting, here coded as a form of consumption."[29]

Berlant's analysis posits the need for cultural workers to address media culture, especially popular culture, as an influential pedagogical sphere; it is also a call to construct alternative pedagogical practices that encourage academics and others to work together to provide ideologies, methods, and representational strategies to challenge the conservative models of patriotism often produced within media culture. This is a task not merely for public intellectuals in the public schools and universities, but for all progressive, cultural workers. While there is no easy answer for addressing the major social problems of the time, there are small steps that can be taken for educators to cross academic and theoretical borders and to grasp more clearly what it might mean to assume the role of a public intellectual. I want to cross such a border and, once again, draw sparingly from the many traditions that make up the field of cultural studies. I believe that such a theoretical excavation might prove helpful for educators to engage many of the premises that inform cultural studies. Once engaged, educators can address how relevant they may be for redefining the university as a critical public space.

CULTURAL STUDIES AND PUBLIC LIFE

Within the last five years, cultural studies has become something of a boom industry in the United States. Book stores are scurrying to set up cultural studies displays that house the growing collection of texts that are now being published under its theoretical banner. Within universities and colleges, cultural studies programs are appearing with growing frequency in both traditional disciplinary departments and in new interdisciplinary units. Large crowds are attending cultural studies symposiums at academic conferences. Moreover, as the site of cultural studies has migrated from England to Australia, Canada, Africa, Latin America, and the United States, it has become one of the few fields that appears to have traveled

across multiple borders and spaces, loosely uniting a diverse number of intellectuals who are challenging conventional understandings of the relationship among culture, power, and politics. Far from residing in the margins of a specialized discourse, cultural studies has more recently attracted the interests of both the popular media and established press.

The growing attraction of cultural studies for educators rests on a number of assumptions. Cultural studies has prompted a new attentiveness to theoretical and cultural practices that link criticism to discursive and institutional forms of power within a variety of contexts that both challenge and reinvent the range of possible critical public spheres. For example, the language of disturbance, unsettlement, and disorientation informs much of the work done by cultural studies theorists on the complex relationship between colonialism and national identity as it is constructed and deconstructed within the shifting and often illusory borders of the nation-state and emerging postnational formations.[30]

Hesitant to focus on the singularity of class, race, or gender as a determinant force in shaping historical and social formations, cultural studies has begun to produce theoretical work on the multiple forms of oppression, subject positions, and social relations that inhabit any claim to politics and strategies of social change. In part, this can be seen in the renewed theoretical interests and critical sensibility developed by cultural studies toward the spheres of popular culture and everyday life.[31] This suggests pedagogically using both traditional and nontraditional media to analyze, study, and engage the dynamics of power within local, national, and global cultural formations; it also suggests combining media and developing intertextual genres that speak to new audiences while simultaneously creating new public strategies of engagement.[32]

Cultural studies has also been instrumental in developing a form of spatial praxis, a politics of space interrogated as a site of resistance and inclusion where "radical subjectivities can multiply, connect and combine in polycentric communities of identity and resistance."[33] Central to this discourse is the refusal to subordinate analyses of the specificity of place, location, and space to the primacy of time and history. Echoing Michel Foucault, many cultural studies theorists believe that "our experience of the world is less that of a long life developing through time than that of a network that connects points and intersects with its own skein."[34] Rather than cancel out history, the politics of space provides a

broader register for engaging the interrelated dynamics of temporality and simultaneity.

In some quarters, cultural studies has rightly challenged a politics of representation that focuses almost exclusively on the culture of the book and more specifically on those books legitimated as artifacts of high culture. Cultural texts are increasingly selected from a wide range of aural, visual, and printed signifiers; moreover, such texts are often taken up as part of a broader attempt to analyze how individual and social identities are mobilized, produced, and transformed within circuits of power informed through the interrelated social relations of race, gender, class, ethnicity, and other cultural formations. Recasting theoretically and politically how identities are shaped and transformed at the intersections of the local and global, on the multiple sites of popular culture, and in the changing landscape of work and leisure has resulted in new considerations of the ways in which dominant intellectual and institutional forces police, contain, and address meaning. Developing a new attentiveness to how culture mobilizes power, many proponents of cultural studies have expanded textuality as a medium of analysis to the broader study of structures, institutions, and relations of power.[35]

But cultural studies is not without its critics.[36] Given the attention that cultural studies has received in the popular press, many critics have dismissed it as simply another academic fashion. More serious criticism has focused on its Eurocentric tendencies, its narrow academic presence, and what some have called its political fuzziness. I believe that in spite of its popularity and the danger of commodification and appropriation that haunts its growing influence and appeal, cultural studies is a field that holds enormous promise for educators who are willing to address some of the fundamental dilemmas of our times. But the promise of cultural studies will in part depend not only on the relevance of the challenges, contexts, and problems it addresses but also on the willingness of its practitioners to enter into its interdisciplinary discourses less as a journey into sacred theoretical ground than as ongoing critical interrogation of its own formation and practice as a political and ethical project. In what follows, I want to argue that cultural studies has helped make visible three crucial issues that need to be further developed by educators and others in order to face the challenge of an increasingly conservative and reactionary political and social order, particularly in the United States.

CULTURAL STUDIES AND THE EDUCATION OF CITIZENS

First, while cultural studies has multiple languages, histories, and founding moments, its underlying commitment to political work needs to be expanded as part of a wider project for social reconstruction and progressive change. As cultural studies has moved from its earlier emphasis on adult literacy, class analysis, and youth subcultures to its later concern with feminism, race, popular culture, and identity politics, it has failed to unite its different historical undertakings under a comprehensive democratic politics and shared notion of public struggle and social justice. While issues of racism, class, gender, textuality, national identity, colonialism, subjectivity, and media culture must remain central elements in any cultural studies discourse, educators must place the issue of radical democracy at the center of the multiple strands and projects that constitute cultural studies. Radical democracy in this context serves as a critical referent for analyzing how the conditions of democratic life have been eroded through a market culture and bureaucratic state in which access to power and pleasure is limited to few groups wielding massive amounts of economic and political power while being relatively unaccountable to those groups below them.

But radical democracy is more than a discourse of criticism, it also represents a form of political identity and an important signifier of moral pluralism, indeterminacy, and possibility that signals a horizon of collective struggle and hope. Such hope is rooted in a "democracy to come,"[37] a democracy that can never be reached but is constantly struggled over as part of an ongoing attempt to expand the bonds of meaningful citizenship, boundaries of diverse communities, relations of social justice, and the economic, political, and social conditions necessary for "ensuring that ordinary people live lives of dignity."[38]

Cultural studies has contributed greatly to a deeper understanding of how politics and power work through institutions, language, representations, culture, and across diverse economies of desire, time, and space. But in enabling this vast reconceptualization of power, politics, and struggle, cultural studies has not adequately articulated a clear sense of what these sites have in common. By addressing radical democracy as a political, social, and ethical referent for rethinking how citizens, especially youth, can be educated to deal with a world of different, multiple, and fractured public cultures, educators confront the need for constructing a new ethical and political language to map the problems and challenges of a newly

constituted global public. It is within this postmodern politics of difference and the increasingly dominant influence of globalization that educators can work to appropriate and revitalize cultural studies pedagogically and politically. They can do this by making it more attentive to restoring critical languages through which ethics, agency, power, and social responsibility can be discussed as part of a struggle to revitalize democratic public life. The struggle will take place within the borders of nation-states and those newly emerging postnational social formations at work in major urban crossroads throughout the world.

Hence, educators must rework the discourse(s) of cultural studies to provide some common ground in which traditional modernist orderings of difference and politics around the binaries of capital/labor, self/other, subject/object, colonizer/colonized, white/black, man/woman, majority/minority, and heterosexual/homosexual can be reconstituted through more complex representations of identification, belonging, and community. Educators can interrogate the field of cultural studies to develop new theoretical frameworks for challenging the way we think about the dynamics and effects of cultural and institutional power in order to face the current crisis of vision, agency, and meaning by engaging the complexity of the space of representation, struggle, and power. This suggests, once again, a discourse of ruptures, shifts, flows, and unsettlement, one that functions less as a politics of transgression than as part of a concerted effort to construct a broader vision of political commitment, democratic struggle, and institutional change.

Critically committed educational work can further expand its own theoretical horizons by addressing the issue of radical democracy as part of a wider discourse of rights and economic equality, history, and the politics of space. In this context, an educational discourse for unsettling times offers the possibility for rewriting the language of cultural studies in order to extend the democratic principles of justice, liberty, and equality to the widest possible set of social relations, public spheres, and institutional practices that constitute everyday life. Under the always contested project of radical democracy, educators can use the more radical assumptions of cultural studies to develop pedagogical practices that affirm the importance of the particular and contingent while acknowledging the centrality of the shared political values and ends of a substantive democracy.

Second, by emphasizing transdisciplinary and transcultural scholarship, cultural studies redefines the relationship among knowledge, authority,

and pedagogy so as to challenge the largely Eurocentric disciplinary struc-
ture of the academy that often depoliticizes and vocationalizes educational
inquiry in order to mask its fundamentally exclusionary nature. Cultural
studies also echoes Walter Benjamin's call for intellectuals to assume
responsibility with regard to the task of translating theory back into a con-
structive practice that transforms the everyday terrain of cultural and polit-
ical power. Unlike traditional vanguardist or elitist notions of the
intellectual, cultural studies increasingly advocates that the vocation of
intellectuals be rooted in pedagogical and political work tempered by
humility, a moral focus on suffering, and the need to produce alternative
visions and policies that go beyond a language of critique.[39] On one level
this means that cultural studies is important because it takes on the task
of establishing institutional spaces and practices that might produce pub-
lic intellectuals. But the fight to provide the institutional and social space
for public intellectuals to speak and act with conviction must be matched
by a cautious pedagogical regard for striking a critical balance between
producing rigorous intellectual work, on the one hand, and exercising
authority that is firm rather than rigid, self-critical and concretely utopian
rather than repressive and doctrinaire, on the other. Rather than denounc-
ing authority, those who engage in education and cultural work must use
it critically to organize and analyze their own cultural work in order to be
attentive to the politics of their own location institutionally but also to
avoid committing pedagogical terrorism with their students. By allowing
their own forms of authority to be held up to critical scrutiny, authority
itself becomes an object of social analysis and can then be viewed as cen-
tral to the conditions necessary for the ownership and production of
knowledge. The importance of such an issue is captured in Fabienne
Worth's criticism of some recent feminist work in education in which

> pedagogy becomes an excruciating exercise in "guilt and me too-ism", . . . requir-
> ing that students constantly put their identities on trial and that teachers
> renounce all authority. [Such a project] suffers from crossing the line between
> subjective disidentification and the loss of subject position. Yet such a line needs
> to be maintained if students are going to remain free to engage in intellectual
> arguments from all their various positions, including those of mainstream white
> viewers—which are particularly in need of articulation.[40]

Worth's insistence that intellectuals cannot retreat from the politics of authority and the role it plays in providing students with a space for critically negotiating their own identities challenges many of the traditional notions of what it means to be a public intellectual. This means moving beyond the idea of the cultural worker who speaks as the "universal intellectual" as well as the specific intellectual who speaks exclusively within the often essentializing claims of an exclusively based experiential politics.[41] If the universal intellectual speaks for everyone, and the specific intellectual is wedded to serving the narrow interests of specific cultural and social groups, the public intellectual travels within and across communities of difference, working in collaboration with diverse groups and occupying many locales of resistance while simultaneously defying the specialized, parochial knowledge of the individual specialist, sage, or master ideologue. By connecting the role of the intellectual to the formation of democratic public cultures, educators can work to provide ethical and political referents for cultural workers who inhabit sites as diverse as the arts, religious institutions, schools, media, the workplace, and other spheres. As public intellectuals, cultural workers can articulate and negotiate their differences as part of a broader struggle to secure social justice, economic equality, and human rights within and across regional, national, and global spheres. In this case, critical education can engage cultural studies as part of an ongoing attempt to construct pedagogical practices and social formations in which students and others develop relations in which they can work collectively and find ways to make knowledge relevant to broad-based democratic change in an effort to transform the undemocratic institutional conditions that produce human suffering.

Third, cultural studies has played an important role in providing theoretical frameworks for analyzing how power works through the popular and everyday to produce knowledge, social identities, and maps of desire. Crucial here is the ongoing pedagogical work of understanding how social practices which deploy images, sounds, and other representations are redefining the production of knowledge, reason, and new forms of global culture. While cultural studies has been enormously successful in making the objects of everyday life legitimate sources of social analysis, educators need to extend its insights in order to face the task of interrogating how technology and science are combining to produce new information systems that transcend high/low culture dichotomies. Virtual reality systems

and the new digital technologies that are revolutionizing media culture will increasingly come under the influence of an instrumental rationality that relegates their use to the forces of the market and passive consumption. Popular culture must be addressed not merely for the opportunities it provides to revolutionize how people learn to become cultural producers, but also for the role it will play in guaranteeing human rights and social justice, as well as the role it plays in developing oppressive aspects of popular culture. This suggests the need for a new debate around reason, Enlightenment rationality, technology, and political/cultural work.

Cultural studies is uniquely suited to developing a language for rethinking the complex dynamics of cultural and material power within an expanded notion of the public, solidarity, and democratic struggle. What cultural studies offers diverse educators and cultural workers is a conception of the political, the role of the intellectual, and a notion of the public that is open yet committed, respects specificity without erasing global considerations, and provides new spaces for collaborative work engaged in productive social change. The time has come for educators to further develop these insights to and work toward constructing a political project in which power, history, and human agency can play an active role in constructing the multiple and shifting political relations and cultural practices necessary for connecting the construction of academics and other cultural workers as public intellectuals to the revitalization of democratic public life. Critical educators need to register their own encounters with difference as a form of border crossing understood not as an obstacle or exclusion but as a site of movement and transit across pluralized, democratic geographies of space, time, desire, and hope. The theoretical and political fault lines of cultural studies offer educators and other cultural workers opportunities and challenges to appropriate and transform those aspects of cultural studies that can be used to expand the critical pedagogical practices in which educators engage and the possibilities for developing new sites and spaces for inserting the political back into pedagogical work.

CONCLUSION

In conclusion I want to affirm my call for educators to become public intellectuals and provocateurs. This suggests that academics can "take a stand" while simultaneously refusing either cynical relativism or doctrinaire politics. It is precisely within the interrelated dynamics of a discourse of

commitment, self-critique, and indeterminacy that a border pedagogy can offer educators, students, and others the possibility for embracing higher education as a crucial public sphere while simultaneously guarding against the paralyzing orthodoxies that close down rather than expand democratic public life, especially for youth in the United States. In part, this means that as public intellectuals, university educators must bring to bear in their class-rooms and other pedagogical sites the courage, analytical tools, moral vision, time, and dedication that is necessary to return universities to their most important task: creating a public sphere of youth who are able to exercise power over their own lives and especially over the conditions of knowledge acquisition. With one eye on specificity, educators can engage the institutional constraints and power mechanisms that they need to transform in order to take up their role as public intellectuals in the classroom; at the same time, they need to focus on those borderlands and public sites that link the university to public schools, workplaces, churches, talk radio, the print media, libraries, the arts, children's culture, and other sites where pedagogy becomes the condition for fashioning the social identities and values of youth and other segments of the American public. Public intellectuals come in many forms and are shaped in numerous sites. Inner city youth, for instance, have produced their own public intellectuals as can be seen in the emergence of a host of creative black rap artists, young filmmakers, and even talk radio hosts. Academics do not have a monopoly on what it means to be a public intellectual, and such a recognition warrants crossing borders into other public spheres to learn how different youth cultures produce and identify with a range of values and assumptions that position them along the wide range of social formations at work in the United States today.

As a progressive concept, the category of public intellectual suggests linking knowledge to power, and authority to moral responsibility as part of a broader effort to improve the health, education, quality of life, and possibilities for youth at a time in history when youth are the first to be abandoned as the social welfare system is dismantled by a Republican-led Congress. Public intellectuals need to establish the priority of ethics and social justice over the logic of the market and the language of excessive individualism. As the notion of the public cracks under the assault of right-wing budget-cutting ideologues, it appears all the more imperative for public intellectuals to focus their work on the importance of youth as part of a broader concern with the construction of critical citizens and

TALKING

HEADS

AND

MICROPHONE POLITICS AND THE
NEW PUBLIC INTELLECTUALS

RADIO

PEDAGOGY

5

The United States appears, for many of us, to be going through one of the most startling and potentially dangerous historical junctures since the tumultuous "Red Scare" of the 1920s. The signs are evident at all levels of society. At the local level, fear and racial hatred appear to be inspiring a major backlash against the gains of the civil rights movement as affirmative action is openly attacked and anti-immigration sentiment and legislation sweep the nation. At the state level, financial cutbacks and the restructuring of

the labor force have weakened unions and vastly undercut social services for the most vulnerable, including women with infants, children of the poor, and older citizens who rely on Medicare and other such benefits. Across the nation, we are witnessing increased violence by anti-abortion groups, right-wing hate groups, and a growing number of right-wing militia. The recent Oklahoma City bombing and sabotaging of an Amtrak train in Arizona provide tragic examples of how the culture of violence prompts an indiscriminate rage against innocent children and adults. The rapid spread of a politics of rage and maliciousness throughout society includes well-organized attempts by conservatives to limit the civil rights of women as well as encouraging the increasing acts of violence against gays, lesbians, and racial minorities. Concomitant with race and gender discrimination is an increase in cultural censorship in the arts coupled with an attack on those public arenas instrumental in fighting AIDS, poverty, and the destruction of the environment.

What is significant and emblematic about the rise of a conservative public sphere and the emergence a new breed of aggressive, right-wing politicians is the new twist such events give to the meaning of the phrase "public intellectual." Newt Gingrich is typical in this regard. Not only has he exploited his role as an adjunct professor (teaching a history class that is made widely available through cable TV), he also circulates his ideas and knowledge through the media, publishing industry, and in the hallowed halls of Congress.[1] In one sense, Gingrich is a right-wing border crosser, moving in and out of diverse public spheres and in doing so reinforcing the idea of teaching as a political pedagogy. He plays the role of the intellectual as a "revolutionary" advocate of a conservative version of patriotism, citizenship, and civic life. But there is more at work here than the formalistic rewriting of what it means to be a public intellectual or to speak from newly invigorated pedagogical sites such as talk radio. Right-wing attacks on civil rights legislation, welfare reform, and policies designed to benefit the poor are serious enough, but what progressives have missed is that such attacks are part of a broader assault on all critical public spheres in which democracy can be enacted.

This is evident in Gingrich's "Contract with America," which is really a contract on America. It's about the death of democratic vision, a willfully innocent, anti-intellectual individualism reminiscent of the film character Forrest Gump, and the cult of Christian capitalism. Moral authority

in the new conservative view of the world appears to derive its claim to public memory from the index of free market culture and a nostalgic rendering of the traditional values expressed in one of Gingrich's favorite films, *Boys Town* (1930). Underpinning the right-wing claim to public memory is the marriage of a sentimental return to the archaic traditions of a "golden age" when blacks and women knew their place, and the culture of racism was buttressed by an appeal to a Eugenicist discourse parading under the mantle of scientific empiricism. In this scenario Patrick Buchanan joins Charles Murray, Richard Herrnstein, and others who justify economic, political, and social inequality "by attributing it to innate, and therefore supposedly ineradicable, differences in intelligence."[2]

Politics and the media have come together as a result of new satellite technology, wireless phone networks, and extensive mailing lists. While politics has been a staple of radio since the 1920s, it is only within the last decade that the technological conditions have existed that allow audiences to call in and voice their opinions on nationally broadcast talk shows to millions of other listeners.[3] Popular talk show hosts can mobilize thousands of listeners on short notice. New technological innovations not only provide the illusion of democracy by allowing listeners to voice their approval or dissent via cable phone lines, they have also set the stage for the meteoric rise of talk radio hosts. As the new public intellectuals, talk show hosts unapologetically urge their audiences to adopt specific ideological positions.

Radio has become a new public sphere, but not one marked simply by audience interaction. The rise of talk radio also signals the emergence of a new type of public intellectual and pedagogy in America. In fact, the crisis of meaning and politics facing the United States is strikingly evident in the rhetoric of a currently popular group of conservative, public intellectuals who are located and supported financially in the worlds of government, private foundations, and the popular media, especially talk radio. Right-wing firebrands such as Rush Limbaugh, James Dobson, Patrick Buchanan, Michael Reagan, and Howard Stern are now touted as public intellectuals who will apply an aggressive, populist, no-nonsense approach to running the commanding institutions of civic life. Instead of fueling progressive social movements, growing numbers of Americans appear to be using the airwaves to vent their anger and rage against the government on largely conservative talk radio shows.

POSTMODERN RADIO POLITICS

What counts as a source of education for many Americans appears to reside in the spawning of local and national talk radio shows. Talk radio fully arrived as a political force in 1989 when a number of conservative radio hosts spread the word to their listeners that Congress was about to vote their members a fifty percent pay raise. Just before the bill was to be voted on, thousands of letters and phone calls were sent to Capitol Hill protesting the pay hike. Within days the pay raise was dead and talk radio emerged as a potent force in shaping public protest around single issue politics. Talk radio took the country by storm in 1992 and put the new, Democratic president immediately on the defensive with the American public. President Clinton felt the sting of talk show democracy twice in his first month in office. Radio hosts at that time played a major role in mobilizing public opinion against the nomination of Zoe Baird for Attorney General; they urged listeners to protest her hiring of an undocumented alien and her failure to pay the employee's Social Security taxes. Eventually the nomination was withdrawn.[4] In addition, call-in talk radio shows mobilized enormous resistance to Clinton's proposal to lift the ban on gays in the military. As a result, Clinton eventually backed away from the original recommendation.

The impact of right-wing talk radio on the 1994 elections is readily acknowledged by winning conservative Republicans who "gratefully dubbed Limbaugh their 'Majority Maker.'"[5] In fact, America's turn to the right can be seen in the rise of talk radio shows from two hundred a decade ago to over twelve hundred in the 1990s. Moreover, many of the shows are conservative and evangelical in political orientation, with "Christian radio . . . now the third most common format on the dial, behind country and adult contemporary."[6] Equally significant is the fact that as many as "44 percent of Americans regard talk radio as their prime source of political information."[7] The king of the medium is Rush Limbaugh.[8] His talk radio show is "estimated to reach an audience of 20 million people a week on 660 stations, all tuning in to a daily monologue of Clinton-bashing and welfare-trashing, punctuated by Limbaugh's much-imitated riff, the angry cry of the put-upon white male."[9] In this case, talk radio becomes an important educational, public sphere and provides the conditions for a resurgent conservatism that wages an aggressive attack on any viable notion of critical educational work.[10]

Talk radio unites a variety of right-wing, public intellectuals in a common battle against the perils of left-wing idealism, liberalism, and any forward-looking optimism that makes social justice and cultural diversity central to its vision. But talk radio also provides the script through which white suburban conservatives, the religious right, militia groups, and the servants of American oligarchy (white, conservative, middle-class men) define themselves as under assault from either various internal enemies spawned in the counter-culture of the 1960s or from the growing menace of an increasingly powerful federal government. Defining themselves as "outsiders," these talk show hosts are enormously skillful at mobilizing racial fears, class resentment, and mass alienation, while simultaneously "manipulating anger and turning righteous resentment into fearful hatred of the oppressed."[11]

As conservatives' weapon of choice, talk radio provides a powerful educational outlet for filling the void in moral leadership and making a claim on public memory. Lewis Lapham has captured some of the defining elements in the conservative version of history and its underlying attempt at demonizing the recent past in order to appeal to an earlier age of sweetness and harmony:

> Once upon a time, before the awful misfortunes of the 1960s, America was a theme park constructed by nonunion labor along the lines of the Garden of Eden. But then something terrible happened, and a plague of guitarists descended upon the land. Spawned by the sexual confusions of the amoral news media, spores of Marxist ideology blew around in the wind, multiplied the powers of government, and impregnated the English monster of deconstruction that devoured the arts of learning. Pretty soon the trout began to die in Wyoming, and the next thing that anybody knew the nation's elementary schools had been debased, too many favors were being granted to women and blacks, federal bureaucrats were smothering capitalist entrepreneurs with pillows of government regulation, prime-time television was broadcasting continuous footage from Sodom and Gomorrah and the noble edifice of Western civilization had collapsed into the rubble of feminist prose.[12]

TALK RADIO AND THE POLITICS OF HATE AND RACISM

This fictive narrative illustrates inventively how the right wing suffers from a massive dose of historical amnesia; it also buttresses a claim to narrating a version of the present that is as reactionary as it is mean-spirited.

Polls and surveys indicate that the politics of harshness is in, while any show of compassion is out. This is clear in the reception that right-wing public intellectuals are getting to their incitement of violence, to race baiting, and to policy recommendations that, if they had been raised fifteen to twenty years ago, would have been met with massive public resistance. For instance, G. Gordon Liddy, who has a syndicated radio program, advised listeners after the Oklahoma City bombing that if they had to defend their homes from Federal agents, to aim at the agents' "heads because they wear protective vests, . . . and if that does not work then shoot to the groin area."[13] Liddy was condemned by President Clinton and others for his comments, and some radio stations terminated his nationally syndicated program. But the National Association of Radio Talk Show Hosts legitimated Liddy's actions by selecting him for its 1995 Freedom of Speech Award. While such a gesture may ostensibly signal resistance to an alleged infringement on the right of free speech, it also poses the issue of what the limits of free speech are in a democratic society. The double standard at work in a racist culture regarding representations of violence can be see in the treatment accorded the black rapper Ice-T. When he released his speed-metal album *Body Count*, it contained a song titled "Cop Killer" and contained lyrics that advocated killing cops (though as an act of self-defense). There was a massive public protest to censure the lyrics and to ban the album from being sold on the market. And yet when a white man, G. Gordon Liddy, used the same violent language, he received a Freedom of Speech Award. One wonders where the white guardians of free speech were when a prominent black musician was being censored for inflammatory speech. The racial undertones of the divergent responses to the use of violent language is too obvious to comment upon in any great detail.

In many ways talk radio has become the vehicle of public choice for bringing the hateful language of racism, homophobia, and the armed militia movement into the mainstream. As a defining principle of the new pedagogy of hate, right-wing stations have become a hot item across America. One notable example is in the recent firing of all the liberal talk show hosts at San Francisco radio station KSFO. In place of its formerly liberal programs, KSFO served up an "all-male, all conservative roster of Limbaugh-wannabes" under the banner of "Hot Talk Radio" and re-christened itself "the station for Right-Thinking People."[14] True to form, KSFO

York City host Bob Grant refers to African-Americans as "savages," Haitian refugees as "swine," and as a public policy recommendation frequently promotes the "Bob Grant Mandatory Sterilization Program."[21] Airing blatant racism has paid off for Grant by boosting his show's program ratings and drawing praise for it from the WABC station manager. After Bruce Bradley of television station KETC (Channel 9) in St. Louis claimed that "young black males are destroying the city of St. Louis, and . . . the suburban schools" he was fired by KETC general manager Michael Hardgrove for making racist remarks on the air.[22] Unfortunately, when Bradley made similar remarks on his WIBV talk radio show, he was praised by his station manager, who cited a ninety-five percent positive station response from audience surveys. Cathy Hughes, host and owner of a daily talk show on radio station WOL in Washington, D.C., roused the anger of a number of listeners on January 26, 1995, by complaining that "Hispanics had taken over parts of her city."[23]

While radio has been a medium for transmitting prejudice since the early part of the century, when "Father" Charles Coughlin made anti-Semitic remarks about Jewish bankers in the United States, the traffic in racist and hate discourse aimed at subordinate groups seems to have become more accepted since it has been appropriated by such nationally prominent talk show hosts as Rush Limbaugh and Howard Stern. Limbaugh, in particular, appears to have become a model for prejudicial attacks against gays, blacks, women, and feminists. Combining hate speech with humor provides Limbaugh with the opportunity to use entertainment as a way of both legitimating and displacing what in a less "humorous" format would be perceived as not simply a harmless political joke but as an act of overt racism and prejudice. Limbaugh's racism and sexism offers both young adults between the ages of eighteen and thirty-four and white suburbanites the scapegoats they need to believe that it's the "feminazis" and welfare minorities that are taking away their jobs. These are the people preventing them from reaching the highway of financial success.[24] Limbaugh's radio pedagogy is not based on the humorless, virulent posture characteristic of the once-popular talk show host Morton Downey Jr. On the contrary, Limbaugh is the "angry white guy with a sense of humor," or what Stephen Talbot calls a "funny conservative."[25] Maybe it is the Beavis and Butt-head quality that makes Limbaugh so acceptable to a national audience. But whatever it is, Limbaugh knows

how to use humor, popular culture, a highly skilled delivery, and a well-paced format to engage his audience.

As a vehicle for right-wing Christian evangelicals, talk radio reproduces a politics without shame. And its growing number of conservative hosts and listeners are becoming an important sphere for shaping policy in American politics. In addition to pressing a long list of demands such as restricting abortions, slashing welfare programs favored by liberals, and expanding the intrusion of religion into a variety of public spheres including public schools, right-wing talk radio hosts such as James Dobson and Marlin Maddoux have helped defeat federal legislation outlawing home schooling (a practice favored by the Christian right). Under the leadership of Pat Robertson and Ralph Reed, the Christian Coalition spent nearly one million dollars on radio commercials urging powerful lawmakers to back the balanced budget amendment. Evangelical Christians constitute over one-third of the Republican Party, and a significant number of the newly elected seventy-three Republicans in the House and the eleven in the Senate "owe a debt to the religious right."[26] Ralph Reed, the executive director of the Christian Coalition, which includes 1.6 million members, is using the airwaves to drum up support for the coalition's *Contract with the American Family*, which advocates a constitutional amendment to allow prayer at public events, legislation to use taxpayer's money to send children to private schools, and the elimination of all federal funding for the National Endowment for the Arts and Humanities, the Corporation for Public Broadcasting, and the Legal Services Corporation.[27] Reed is being courted by many prominent Republicans, including majority house leader, Newt Gingrich.

What the right wing means by family values can be seen in the recent suggestion by Newt Gingrich that it might be appropriate to turn the children of the poor (read black) over to orphanages. As absurd as such a suggestion might have sounded a decade ago, the culture of hate talk actually makes such proposals appear viable today. How else can one explain why Gingrich's proposal was greeted in the popular press as a serious policy suggestion. While the political shift to the right cannot be blamed on talk radio, it is clear that such radio has produced a new public space in which politics, voter resentment, and pedagogy intersect to mobilize large segments of the American public.

TALK RADIO AS A NEW PUBLIC SPHERE

While talk radio may have fueled the resurgence of conservative and right-wing causes over the last few years, its value as a site of learning is not limited to right-wing demagogues.[28] Talk radio signals a shift in the way in which people listen and respond to the media. When Ross Perot claimed he would use "electronic town halls" to engage the public in policy making, he pointed to the possibility of "providing a new way for people to learn about and participate in the political process."[29] While it is clear that many people who listen to talk radio never call in to voice their opinions, there is a rhetorical rawness in the unfiltered and untempered speech that gives talk radio a populist stamp of authenticity. Moreover, it is an accessible wireless phone technology whose immediacy and pleasures can easily be used while walking, washing dishes, relaxing on a park bench, riding in an automobile, or working in the shop. Coupled with the ubiquity of car, airplane, public, and home phones, listeners can easily respond directly to issues that engage them. Talk radio is also a medium that is cheaply produced and is especially appealing to those segments of the population that are not print oriented.

In many ways, the technology of radio seems perfectly matched for a generation of youth who are more favorably oriented to a visual and aural culture than to the culture of the book. In a society in which entertainment is associated with high-speed graphics, humor, and sound bites, youth appear to be a prime market for talk radio. Hence, it is not surprising that a number of radio stations are attempting to develop a youth market by combining hip hop culture and popular music with a talk show format. It comes as no surprise to conservatives that Rush Limbaugh has a substantial following among young audiences. Limbaugh's elitism, celebration of popular culture, and his self-defined status as an outlaw or member of a group of besieged white men has struck a positive chord with a number of young people in the United States. Robert LaFranco, writing in *Forbes Magazine*, points out that "Limbaugh made politics approachable and amusing for young people whereas most of the media played politics straight. . . . Limbaugh proved that political talk need not be dull and predictable."[30] Of course, what LaFranco misses is that entertaining talk is not neutral, and while Limbaugh has attracted a large youth audience because of his biting humor, he also uses his mix of politics and wit to scapegoat blacks, women, environmentalists, and gays. What Limbaugh makes clear is that

youth are marked by multiple and contradictory ideologies and identify with a range of political positions, some of which cannot be romanticized because they are taken up within the site of popular culture. The crucial issue for progressives is this: How does talk radio in its appeal to certain youth cultures address the pleasures, desires, and identifications that give meaning to a particular type of politics?[31]

Talk radio's popularity is also based on its growing reputation as the "bad boy" of the communication industry. Given the unrehearsed nature of talk, it is less controlled and more open to speaking the unspeakable. Moreover, the often spontaneous nature of its content, along with its appeal to audiences willing to believe that they have been excluded from mainstream media, gives talk radio an outlaw status and popularity with often marginalized segments of the American public.

While talk radio offers its listeners the opportunity to participate in the "electronic town hall," most talk shows offer the illusion rather than the substance of democratic participation. Kathleen Hall Jamieson, dean of the Annenberg School for Communication at the University of Pennsylvania, argues that most talk programs are not ideologically diverse and tend to speak to the already converted.[32] Moreover, participants who call in to such shows are sometimes either screened out if they raise issues challenging the talk radio host or have simply called in to register their approval at what is being said. Rush Limbaugh has repeatedly acknowledged that his callers are carefully screened and has legitimated the head-nodding response of his callers by popularizing his followers as Dittoheads. Limbaugh claims his callers are carefully selected in order to "make me look good."[33] As disconcerting as some of these discriminatory tactics are to journalists, liberals, and more traditional media advocates, the fact remains that people who are increasingly getting their information about the world from talk radio believe that it is a democratic medium.[34] Balance in talk radio may not be as important an issue as some critics claim. Balance has never been characteristic of the dominant media. Left and critical theorists have rarely been allowed to voice their opinions on national television shows or in the major print media. As a result of satellite technology, moderately priced telephone communication costs, and the ubiquity of private, public, and cellular telephones, radio listeners can more readily respond to talk show hosts and other callers from all parts of the nation. At issue is not merely a question of

public access to talk show hosts, but the significance of radio as a site of learning, engagement, and resistance for the disaffected, and its broader potential as a critical, democratic, public sphere.[35] It is important to note that the charge made by critics such as Jamieson, that Limbaugh and other opinionated talk show hosts speak only to the converted, not only flattens out the complexity and contradictions that mark Limbaugh's audience, it also offers no understanding of either the pedagogical strategies used by such hosts or of the range of factors that attract diverse populations to their shows. Jamieson offers up the traditional charge that populist media is simply a drug and in doing so fails to critically engage the complexities at work in the production, circulation, and mediation of knowledge and desire.[36]

CULTURAL WORK AND RADIO PEDAGOGY

Progressives need to respond to the challenge posed by the rise of conservative public intellectuals in a number of ways. First, public intellectuals must reject forms of cultural authority that legitimate and locate cultural workers as marginal figures, professionals, or academics acting alone. Cultural workers need to generate an alternative conceptual space as border crossers, whose collective knowledge and actions presuppose fashioning democratic visions and forms of moral accountability in concert with others in a variety of public spheres. If progressives are to rupture the binarism that separates entertainment from what is considered critically engaged practice, we will have to address how mass-mediated cultural forms function as teaching machines, pedagogical apparatuses that in their attempts to amuse and entertain simultaneously inform and impart knowledge and values about identities, social relationships, and what it means to desire. By linking pleasure and understanding, desire and knowledge, it becomes possible for cultural workers to raise policy issues regarding who controls popular cultural apparatuses, in whose interests, and to what effects. At the same time, issues of power and control must be attentive to culturally specific practices regarding how social identities and desires are mobilized within and through particular cultural apparatuses. What pedagogical practices are at work in popular forms such as talk radio that shape how people come to desire, identify with particular communities, take up particular ideologies, define themselves in particular ways, and learn to resist or accommodate particular relations of power? What do popular cultural forms such as radio,

cinema, schools, churches, performance art, and talk radio have in common pedagogically, and what is it that we can learn from looking at them historically, relationally, and institutionally in terms of their similarities and not simply their differences? And what might it mean to interrogate what effects they have in terms of broader considerations and transformative practices that enable rather than close down forms of democratic life?

At the very least, progressives need a more expansive notion of education and pedagogy as a form of cultural work that takes place across multiple sites of learning, including schools. This suggests that progressives must redefine not only what constitutes the intertextual, hybridized, and interdisciplinary space of pedagogy, but also how such practices in a media-saturated culture can be used to negotiate and transform the tension between the democratic imperatives of public life and the everyday practices of diverse popular cultural apparatuses, including talk radio. While it is now commonplace to recognize that knowledge and power come together to shape experience and presuppose different versions of the past, present, and future in a variety of locations, there have been few attempts to understand how diverse cultural workers who inhabit these varied sites of learning might relate to each other around the interrelated considerations of pedagogy and democracy. The workplace, day-care center, local church, youth centers, hospitals, movie studios, and TV programs are not empty cultural spaces defined only in abstract economic or sociological terms, but pedagogical sites in which cultural workers engage in social practices that produce, circulate, and distribute knowledge. For progressives, the important issue here might be: How can we come to understand these different sites through the transformative learning practices used by different cultural workers? How might we formulate through a common political and pedagogical project the current assault on public life as part of a larger struggle to extend the principles and practices of democracy for future generations who inhabit this country?

Talk radio has become an important public sphere within the broader arena of mass-mediated culture. The importance of talk radio pedagogically and politically rests, in part, with its ability to frame debates, mobilize desire, and to make a claim on public memory. The power of talk radio to attract a wide audience of young people and others in the United States suggests something about its pedagogical value in mobilizing individual and collective desires across a wide spectrum of resentment, anger, hunger

for knowledge, and need to assert some control over public life. Richard Turner recently wrote that many of the people listening to Rush Limbaugh are not simply "dittoheads in lockstep with his politics. Many are reacting against generations of bland TV commentators afraid to hazard an opinion."[37] This suggests that progressives need to develop cultural and pedagogical practices that combine critical commentary with Mort Sahl–like irony and humor; that is, we need to find ways as cultural workers to redefine the relationship among entertainment, pleasure, and critical discourse in order to include in our pedagogical approaches styles and forms of engagement that move beyond the didacticism and alleged neutrality reminiscent of stodgy forms of academic and cultural professionalism. Progressives need to use the electronic media as a site of learning in which they can combine entertainment and serious commentary with a broader project rooted in alternative, democratic projects. Put more theoretically, we need to take the affective investments seriously that allow people to experience a range of emotions when finding themselves in the thrall of the media, especially of talk radio. This is not a case for taking issues less seriously, but for engaging our audiences and publics through a variety of discourses, formats, and styles.

Next, if cultural and educational workers are to resist the conservative assault on those structures of civic life that require public discourse and enable critical learning across a spectrum of sites, they must, as I have argued, recognize that what counts as critical education in this country is not limited to the traditional sphere of schooling, the up-scale space of the museum, or other more privileged spheres of high culture. In fact, it might be argued that the most important sites of learning today encompass both television and radio airwaves. This suggests a fundamental redefinition in the role of public intellectuals and in the range of locations from which they address their work, especially as regards the diverse arenas in which popular culture is produced, circulated, and received. The very definition of what it means to be a critical public intellectual must be linked to the imperatives of working educationally and politically to extend the possibilities of democratic public life. This is an eminently pedagogical task, one that must address not merely what it means to reach diverse audiences but also to engage audiences that have in the past been routinely dismissed as too lowbrow to be taken seriously. In part, cultural workers need to develop what Robert Stam and Ella Shohat call a relational pedagogy, that is, a pedagogy that

"would shuttle between [and within] dominant and resistant [popular cultural forms] . . . so as to enable a contrapuntal reading of a shared, conflictual history."[38] In this context, cultural workers would specify the leaky and contradictory nature of dominant power, the spaces of resistance within dominant forms, and the possibility for alternative readings and "highjackings" of sites such as talk radio.

Then, progressives need to combine the languages of critique, meaning, and motivation with a discourse of possibility. Conservatives have been successful in gaining public attention not only because they translate complex problems into simple solutions, but also because disaffected segments of the American public feel empowered by conservative attempts to build a sense of community through an appeal to the concrete fears, needs, and desires of their listeners (although such a mobilization is at the same time based on the swindle of fulfillment). The pedagogy of talk radio employs a cultural populism rooted in "plain" talk, engages national and local issues that often are not covered in the mainstream media, and offers both extended dialogue and fast-paced, witty improvisations. Wrapped in an anti-intellectual ferocity, conservative talk show hosts refuse the discourse of the objective, distanced professional "voice." Instead, they fill the airwaves with impassioned speech, provide moral anchors in an unraveling world, and assert their ideological position in an up-front manner.

Progressive cultural workers need to be critically attentive to these pedagogical practices. At one level, this suggests that taking a stand and being committed to a position provides a referent for engaging people in a dialogue about crucial social issues while simultaneously registering the importance of conviction and passion in taking up particular positions. This is not a call for pedagogical demagoguery as much as it is a refusal to speak as if one occupies a "view from nowhere." Implicit in such a pedagogical stance is the willingness to forge knowledge and commitment and to develop a politics of one's own location that prioritizes justice over balance, an engaged and self-critical stand over the posture of weak relativism, and a defense of cultural authority in the name of broadening the conditions for active, critical citizenship. Cultural workers must address issues and speak from places in which people reflect daily on their lives. The challenge, then, is to move beyond a pedagogical appeal to either relevance or practicality. Instead, it is crucial for progressive cultural workers to arouse the language of desire and hope through a commitment to values and social

practices rooted in moral compassion and a respect for social justice. Pedagogy is about more than providing correct knowledge, it is also about developing practices "by which subjectivities may be lived and analyzed as part of a transformative, emancipatory praxis. . . . [Pedagogy is also about] mobilizing desire in liberatory directions."[39] Appeals to democracy, community, social service, self-determination, solidarity, economic justice, equity, and a future without racism, child abuse, poverty, sexism, and environmental violence offer, in part, the possibility of moving beyond the divisiveness and mean-spiritedness of the moment in order to imagine new forms of community. The moral and educative dimensions of these forms will impact directly on the renewal of democratic, public life.

Unfortunately, the debate about public intellectuals in the United States has become one either of fashion or of limited social analysis. What is largely unexamined by progressives is that the concept of the public intellectual is not a privileged preserve of the left or the naming of instant celebreties. To ignore that Rush Limbaugh, Pat Buchanan, Newt Gingrich, and others are public intellectuals who cannot be simply dismissed as racist or authoritarian is to relinquish the necessity to examine the resources and pedagogical conditions at work in the creation of broad-based conservative, public spheres, including talk radio, television talk shows, telecommunication revivalist conferences, etc.

The shortcomings of focusing mainly on left scholars as public intellectuals has been exemplified recently in accounts by members of the liberal media who have rediscovered the public intellectual in the ranks of African-American academics, a number of whom have become fashion hits with the publishing industry. In no small measure, these writers heap generous attention on the "new public intellectuals" because of their racial identities and intellectual work rather than for the role they play in mobilizing a large constituency in order to shape public policy in a time of moral and political crisis.[40] For example, Michael Bérubé lauds a number of mostly African-American male academics precisely because they speak to an audience outside of the university, and rightly so.[41] What he does not do adequately is to link their work as public intellectuals to those sites of learning where most of the action is, or to where most of the public is tuning in to get their information or to register their concerns. Why is it that Rush Limbaugh attracts an audience that numbers in the millions while Cornel West is merely an academic celebrity mostly addressing a very limited number of

people? Within the limited ranks of left intellectuals, black public intellectuals may be reaching out to more people than those who inhabit the university, but they are not mobilizing anywhere near the numbers of people that right-wing public intellectuals are reaching. In part, this may be because media such as talk radio are seen as occupying the lower reaches of popular culture and thus disdained by many academic intellectuals. Or it may be that progressives are so concerned about balance that they fail to provide the combination of focus and ideological fervor that comes with taking a stand. Put another way, "if conservatives dominate [popular media such as] talk radio it may be because liberals are programmatically inclined to pretend to respect opposing points of view."[42]

On the other hand, neo-conservative Robert S. Boynton fears that as black intellectuals go public and address more popular issues in a less scholarly language, they will compromise their intellectual integrity.[43] While Bérubé provides a corrective to the Eurocentric notion that whiteness and intellectual production go hand in hand, Boynton simply makes an indirect case for linking scholarly work to high culture. Bérubé does not go far enough and Boynton simply misses or misrepresents the point.

Because black intellectuals combine scholarly discourse with analyses of popular culture does not necessarily mean that the left has either found a paradigmatic postmodern model of the public intellectual or compromised the university as a site of scholarship. In fact, the crucial concern about being a progressive public intellectual in this country should focus on both the political relevance of scholarly ideas and how successfully they are taken up within specific pedagogical spheres that mobilize the desires and needs of varied audiences. Public intellectuals are not isolated, romantic figures howling in the wind; at their best, they provide ideas, ideals, and legitimation for working with a vast array of publics, political communities, and cultural workers who both represent and are moved by their ideological positions and sense of commitment. Put simply, they generate ideas and build organizational structures for change in a variety of cultural spheres.[44] This is precisely what the conservative public intellectuals have demonstrated, especially Rush Limbaugh, who blends right-wing ideology and pop culture, as Jon Wiener points out, "in a way that can only be called brilliant."[45] Power is about more than the politics of representation, and the public is increasingly getting educated about politics from places of learning like talk radio. These places of learning offer

a combination of entertainment, ideology, and commentary largely ignored by progressives in their analysis of public intellectuals.

What appears to be grossly excluded in this debate is the role that the right wing has played in developing a model of the populist public intellectual outside of the hallowed halls of academe—in locales of learning that are often dismissed because they are crudely popular or ignored because they are not considered to be spheres worthy of serious pedagogical analysis.[46] While progressives such as former presidential candidate Gary Hart and former New York Governor Mario Cuomo have signed on in attempts to become known as the left's alternatives to Rush Limbaugh, there are more substantial challengers on the left to Limbaugh's dominance. Jim Hightower, former agriculture commissioner of Texas, until recently fired by ABC, ran a three-hour program called *Hightower Radio*, broadcast on 150 ABC network stations. Hightower's show combined country music with biting satire and political commentary. A master of the radio format, Hightower also combined anger, popular culture, and humor in just the right combinations to entertain and educate at the same time. On one show he pointed out that Elvis would have been 60 on that particular day and then played Elvis's version of "Money Honey." Using the song as a backdrop, Hightower then made his point: "the song is for both political parties. . . . Problem is, we have one party in Washington—the money party." Rupturing the standard right-wing attack on welfare, Hightower then stressed another populist theme: "Always follow the money: there's no reform until there is lobbying reform and campaign reform. Corporate welfare is five times bigger than people's welfare. And keep your eye on the Newt—he's a slimy little lizard."[47] But Hightower was more than a left populist with a sharp wit and political jab; he was also skillful at winning commercial sponsors, and has proven that left public intellectuals can drum up corporate financial support. This is no small matter if gaining national markets is to be a crucial part of the strategy for gaining access to and using radio as a viable, progressive, public sphere. The Disney/ABC merger brought an end to Hightower's radio show less because of the show's success than because of monopoly intolerance for dissenting views.

Another substantial left intellectual who has generated widespread popularity on the talk show circuit is Tom Leykis, who has one of the fastest growing shows in America. An unabashed and unapologetic progressive,

he supports the interests of labor and is pro-choice. He also argues for the legal and civil rights of homosexuals, and supports drug legalization. Unlike most of his conservative counterparts, he is against capital punishment. Capitalizing on radio's populist image, Leykis combines critical analysis, knowledge, political commitment, and humor, but in doing so he offers no solace for liberals who take a middle-of-the-road position. His up-front, pedagogical style can be glimpsed in his forthright attack on liberals, who he claims "are lazy, mealy-mouthed wimps who think we need to hear more than one opinion on everything. Liberals don't kick ass. And if they don't kick ass, their ass is gonna get kicked. And that is what has happened to liberalism."[48] Leykis's rhetoric may be overstated, but his point is well taken. Public intellectuals have to take a stand without standing still, be willing to begin with an issue and defend it without being closed to critical dialogue. Leykis is now heard on 134 radio stations, and when he was pitted against Rush Limbaugh in prime time on a Boston radio station he beat Limbaugh's ratings. Leykis has succeeded because he knows how to pace his monologues, connect isolated events to larger public issues, and address his audience through the skillful use of anecdotes, humor, and satire. But most important, Leykis is a public intellectual who employs a pedagogy rooted in a democratic project, one that reinvents populist discourse and critical analysis in order to address an audience without treating them as if they were simply anti-intellectual fools incapable of engaging real issues critically.

The pedagogical value of talk radio as a medium for addressing issues of race and youth can be found on a number of community-based radio programs. One important example is Carl Boyd's *Generation Rap*, aired every Saturday on KPRS-FM in Kansas City. Boyd, a former teacher, educational consultant, and singer, uses his program to get teenagers to talk about drugs, crime, violence, education, and a range of important social issues. One recent program focused on teen violence and mediated a conflict between high school rivals who settled their dispute on the air. Explaining the pedagogical principles underlying his program, Boyd combines a sense of hope with the need to listen to young people and engage them in serious dialogue. He points out that "people are calling them [teenagers] the lost generation. I consider them the 'tossed' generation. . . . Why not respond to them differently, talk to them, listen to them and reward them for good things? If we are going to stereotype them, why not stereotype

them positively."[49] Although Boyd's program and others such as Black Liberation Radio in Springfield, Illinois, and WLIB in Harlem are both critical of mainstream knowledge and offer counter-discourses for addressing issues of racial injustice, such stations reach relatively small audiences. At the same time, they provide models of how critical pedagogical practices can be used in popular cultural spheres such as talk radio.[50]

Boyd, Leykis, Limbaugh, and others have found in talk radio a new medium for shaping public memory, cultural identity, and the meaning of empowerment. What progressives need to recognize is the importance of this work in pedagogical and political terms. They need to redefine its relevance for forming new alliances, expanding our understanding of how power works through popular culture, and rethinking the meaning and mechanisms of how diverse groups of people learn within multiple locations. Progressives need to stake out new critical spaces for fighting the ravages of racism, corporate greed, sexism, and other injustices. In part, this means rejecting the long-standing assumption among progressives that identity politics is the privileged marker determining who speaks where and under what circumstances. The issue of opening up new borders and popular spaces in which multiple, critical pedagogies can flourish cannot be tied to the narrow dictates of identity politics.

Similarly, public intellectuals cannot be located exclusively within the privileged domains of high culture. This suggests defending the intersection between cultural politics and the work of public intellectuals within expanded pedagogical sites as part of a public strategy of engagement. Such a strategy would engage critically the taken-for-granted assumptions that inform dominant cultural life, struggle to create new alternative democratic projects and aesthetic sensibilities, and work to bring diverse cultural workers together within shared structures of power. At stake here is redefining the politics of transformative teaching through a broader notion of the public intellectual, a notion of one who can move within and between various sites of learning while actively addressing what it means to engage both individually and collectively in the production of knowledge, values, and social identities.

As the sites of learning have expanded in this country, so has the idea of what it means to be a public intellectual. The highbrow journal and the academy are no longer the privileged spaces that define who counts as an intellectual. The electronic media, with their ever-expanding modes of

information, have become one of the primary spaces in which knowledge, authority, and power are used to shape identities, beliefs, and public memory. These sites must be defended, not in terms of the logic of the capitalist market, but as political and pedagogical spheres vital to the moral life of the nation. Democracy and politics must be rethought through an expanded notion of the meaning and practice of cultural workers as public intellectuals. All around us, especially in electronic media, practices of oppression exist and must be challenged and transformed if the principles of liberty and equality are to become central to democratic public life. The recent focus on the role of talk radio in creating and trading in the discourse of hate and anger was brought home in a flood of critical analysis about the medium that followed the Oklahoma city bombing and the O.J. Simpson verdict. This analysis pointed up the degree to which talk radio contributed to a political culture of hate that triggered such violence and racism.

Talk radio as a political and pedagogical medium cannot be dismissed simply because it is catering to audiences such as right-wing militia groups or because it is spewing forth a torrent of racism.[51] On the contrary, it presents a challenge for all of us who believe that transformative teaching and learning are central to the democratic functioning of public life in the broadest possible terms. Progressive cultural workers need to expand the politics and meaning of education to talk radio shows, the factory, the family, youth organizations, organized religion, the art world, the media, and all those other locations where ideas circulate and identities are produced. This is the challenge we face in an age in which talk radio has become one of the defining educational resources of the times.

THE WAY

THINGS

OUGHT NOT TO BE:

RACE AND

NATIONAL IDENTITY

LICENSING BIGOTRY

WITHOUT

BEING

POLITICALLY CORRECT

6

The power and influence of the political correctness campaign launched by right-wing conservatives in the late 1980s can, in part, be gauged by the degree to which PC bashing has united diverse public spheres that often ignore each other. The academy, popular media, religious institutions, and the world of fashion have all taken part. The attack on political correctness has managed to bind together a powerful range of right-wing parties actively engaged in a concerted attack on higher education, critical

academics, the cultural elite, and other public sites that breed the alleged tyranny. What is at stake in this campaign is both a claim to historical truth and the attempt to shape public memory. Of course, cultural memories that attempt to write history from a single perspective often hide more than they reveal. Such narratives exhibit a mythic quality because the past is linked to a notion of authenticity and purity, "a never-never land of pure wish fulfillment, in which the problems of the present are symbolically resolved in a past that not only did not, but could not exist."[1] History becomes an act of impossible recovery in this narrative and tends to sound more like a fairy tale than a serious engagement with the past.

Right-wing conservatives aggressively attempt to look inside of American society for signs of moral weakness, political insubordination, and cultural decay. Working-class and poor youth appear to be one of the major casualties of this attack on public life. Inner-city schools are threatened with funding cuts, and school lunches for the children of the poor are labeled as a financial burden for the federal government at the same time that conservatives call for the building of more prisons. Children become citizens without rights as conservatives attempt to remove public schooling from the relations of equity, justice, and freedom that connect them with the institutions and problems of modern, democratic society.[2]

Public criticisms of education at all levels are not new and have a long historical legacy. In the past, schools have been repeatedly criticized for failing to educate skilled workers, develop adequate academic standards, or adequately prepare students to enable the United States to compete internationally in the global marketplace. What is new is not only the mean-spiritedness that underlies funding cuts in social service programs for the public schools, but also the level of protest against schools for allegedly failing to transmit the universal values of Western culture, shore up traditional family values, and reproduce the assimilative imperatives of a "common national culture."[3] Within the last few years, there has been a growing concern on the part of the popular press, politicians, and conservative and liberal groups over public and higher education increasingly "opening their doors to minority students, expanding curricula, questioning canons, breaking down monolithic disciplinary structures and searching for new teaching methodologies."[4]

For many conservatives, public schooling and higher education have fallen prey to an adversarial culture that is touted as being at odds with traditional

conceptions of citizenship, national identity, and history. Invoking the language of patriotism, conservatives argue that schools are increasingly undermining the very foundation of what it means to be American. Within this discourse, the enemies of the state first appeared in the university and public schools as deconstructionists and multiculturalists. But more recently, according to conservative journalist Richard Bernstein, the influence of the political correctness movement has penetrated into

> the elite institutions, in the universities, the press, the liberal churches, the foundations, the schools, and show business, on PBS, and "Murphy Brown," at Harvard and Dallas Baptist University, on editorial boards and op-ed pages, at the Ford Foundation and the Rockefeller Brothers Fund, the National Education Association, the American Society of Newspaper Editors, the National Council of Churches, and the Pew Charitable Trusts.[5]

In spite of its widespread popular attention and its list of growing enemies, the conservative attack on "political correctness" might appear to some as simply faddish or an invention of media hype with little relevance to serious educational issues.[6] In opposition to this view, I believe that the anti–political correctness movement represents a serious attack on children's culture, and demonstrates both the resurgence of a racist discourse and the effects of rising fundamentalism in American society. Pedagogically, the anti–political correctness movement wages war against critical thought, the relevance of raising controversial social issues in the classroom, and the necessity for educating youth in the imperatives of civic courage and social responsibility. In large part, the anti-PC movement sacrifices the "disturbing" nature of a critical education by pitting the First Amendment rights of individuals to free speech against the crucial concern for understanding how classroom language can be oppressive, intolerant, and carry a legacy of ignorance and hatred. For many right-wing conservatives, the willingness of teachers and students to embrace social and political discourses unjustifiably means holding people responsible for what they say and don't say, how they act and don't act. In this case, the conservative attack against political correctness represents a thinly veiled attempt to reduce classroom language to a disciplinary practice that is "ruthless in its policing duties [and] has no desire or purpose other than maintaining the free range of its own narcotic narcissism, its own exclusivity and dominance."[7] By

LICENSING BIGOTRY WITHOUT BEING POLITICALLY CORRECT

undercutting the conditions needed for teachers to make critical inquiry a primary part of what it means to teach young people to live in and struggle for a radical democracy, the anti–political correctness movement infantilizes youth as purposely as it attempts to remove the possibility for recognizing critical citizenship as an urgent pedagogical task. Issues of equity, access, economic justice, the pluralization of cultural identities, and the positing of a common moral language and a set of shared values (one that defends democracy against inequality, racism, and oppressive social relationship) have come under attack by PC bashers. Moreover, the increasingly right-wing terms in which this debate is being structured have dire consequences for defining the purpose and content of teaching.

The debate over political correctness has been largely waged through the media and the popular press, and students and teachers rarely have access to the full range of issues associated with the debate. If educators and students are to make sense of the debate's implications for analyzing the relationships between knowledge and authority, between teaching and student learning, it will be necessary to analyze what is often left out of the discussion. This means having access to arguments that inform this debate from a critical, progressive perspective. More specifically, it means providing educators and students with at least two critical modes of inquiry. First, educators and students need a critical perspective on the anti–political correctness view of teaching, knowledge, and standards. Second, they need access to elements of a critical pedagogy that challenges and poses alternatives to the ideological and pedagogical assumptions that inform the attack on academics, whose classroom practices are often summarily dismissed as merely a species of political correctness.

THE TYRANNY OF THE POLITICALLY CORRECT?

On May 4, 1990, President Bush, while delivering a commencement address at the University of Michigan at Ann Arbor, spoke to the issue of political correctness. He argued that while political correctness arises "from the laudable desire to sweep away the debris of racism and sexism and hatred" it has led to intolerance and has declared "certain topics off-limits." Provided with a presidential imprimatur, "political correctness" erupted in cover stories in such major popular magazines as *Newsweek*, *The Atlantic Monthly*, and *New York*. Sustained accounts of this new movement were given full-scale editorial and journalistic treatment in *Time*, the *New York Times*, and

the *Wall Street Journal*. At the heart of this coverage and popular fanfare is the general argument that

> the academy is under siege by leftists, multiculturalists, deconstructionists, and other radicals who are politicizing the university and threatening to undermine the very foundations of the Western intellectual traditions. . . . Armed with affirmative action admissions and hiring, as well as new French literary theories, the politically correct hope to transform the university into a den of multiculturalism—silencing everyone who would dare to dissent by calling them "sexist," "racist" or anti-deconstructionist.[8]

For conservatives such as Patrick Buchanan, Irving Kristol, and more recently Rush Limbaugh, the assault on political correctness indicates an important political transition necessitated by the break up of the Soviet Union and the "winning" of the Cold War by the United States. No longer unified in their fight against the external threat of communism, conservatives now use the tyranny of the politically correct as an ideological rallying cry to ward off the cultural peril posed by the "enemy within." Patrick Buchanan puts it well with the exhortation that:

> Political leaders in Washington believe that the battle against communism is being fought in the jungles of Asia and Central America, while failing to realize the war is also raging on the battlefield of [the humanities curriculum in schools and universities] and in the arts within our own borders. . . . The hour is late; America needs a cultural revolution in the '90s as sweeping as its political revolution in the '80s."[9]

As the battle lines of higher and public education are redrawn around American culture and national identity, right-wing conservatives have pointed to the political danger posed by the civil rights community and the adoption of multicultural curricula in many public schools. In its more alarmist forms, the right labels the struggles of subordinated ethnic groups as the most dangerous threat to American society. For example, nationally syndicated columnist Charles Krauthammer claims that such groups are "wards of the left" who are launching "an all-out assault . . . on America's cultural past" and on "common citizenship." He goes on to claim that "America will survive both Saddam and the snail darter. But the setting of one ethnic group against another, the fracturing not just of American soci-

ety but of the American idea, poses a threat that no outside agent in this post-Soviet world can match."[10] Across the country, talk radio hosts rail against multiculturalism, affirmative action, and the threat that immigrants pose to the economic security and the alleged cultural purity of the United States. Anti–PC advocates such as KSFO radio talk show host Spencer Hughes are characteristic of a new breed of right-wing public intellectual using radio airwaves to spew racist intolerance. Hughes has assaulted immigrant children by telling his audience that illegal immigrants are "cramming our classrooms [and] should be kicked into the gutter."[11]

In this perspective, the Communist danger is replaced by the domestic danger of the Rainbow Coalition in the political sphere and what Dinesh D'Souza calls the surge of the "victim's revolution on campus."[12] Behind this discourse of racial and political panic is the additional claim by the right that a generation of young "radical" academics have emerged who challenge the racial and gender admissions polices of the universities while simultaneously highlighting exclusions and biases built into the academic canon. In fact, the call for constituting higher education according to principles that constitute a radical democracy has vitalized a generation of academics who came of age in the 1960s.[13] Appropriating the principles of freedom, equality, and justice, progressives have increasingly struggled to reclaim higher education as a public sphere in which education provides the basis for an expanded notion of insurgent citizenship marked by real debate, the decentralization of authority, and the extension of democratic rights to the widest possible number of individuals and social groups.

Within a contentious climate that the popular press has labeled as "the culture wars," the issue of how authority is constituted and secured in the university has been called into question by feminists, gays and lesbians, multiculturalists, and other dissident groups. These groups have challenged the exclusionary politics of the canon and the invocation of higher education as a privileged cultural site where resident intellectuals act as "free floating" guardians of high culture.[14] Consequently, higher education, and in a lesser sense public education, have experienced a crisis over the relationship between authority and knowledge, on the one hand, and the purpose of schooling and the responsibility of intellectuals on the other.

Right-wing conservatives have responded to such criticism as both a species of anti-Americanism and a threat to Western civilization itself. UCLA public policy professor James Q. Wilson captures this sentiment when he says,

"The university has always had leftists, but never before like the ones we have now. . . . These new leftists rebel against reason, not just against institutions."[15]

For progressives such a claim exemplifies less the perils of political correctness than a right-wing version of academic correctness. For example, *The Chronicle of Higher Education* reports yearly that left-wing academics make up about four percent of college faculties and that most faculty define themselves as either liberals or conservatives. Similarly, Rosa Ehrenreich refutes the charge that radicals have taken over higher education with this comment:

> *A national survey of college administrators released last summer found that "political correctness" is not the campus issue it has been portrayed to be by pundits and politicians of the political right. During the 1990–91 academic year, according to the survey's findings, faculty members complained of pressure from students and fellow professors to alter the political and cultural content of their courses at only 5 percent of all colleges. So much for the influence of radicals, tenured or otherwise.*[16]

But neither the empirical evidence nor the charges of gross exaggeration lodged by many progressives have deterred either conservatives or liberals from strongly arguing that "political correctness" poses a serious threat to Western culture and its educational institutions. What is often left out of this debate are the implications the anti–political correctness movement has for constructing youth as a historical and social category and, more specifically, what its implications are for those educators who either teach youth directly or teach those educators who do work at various levels of public schooling.

THE POLITICS OF STANDARDS

Speaking at a recent symposium on "political correctness," Stephen Balch, President of the National Association of Scholars, argued that "the debate about political correctness . . . is actually a debate not about politics but about appropriate intellectual standards and appropriate academic ethics. . . . What is at issue here is to convey a sufficient knowledge base because without knowledge we can't think."[17] For Balch, as for many other conservatives waging a battle against political correctness, the issue of standards has become one of the key concerns facing public and higher education in the 1990s. Three major considerations frame this issue.

First, a resolute defense of the traditional curriculum serves to guard against the contamination by "other" knowledge that threatens the canon. In

this perspective, the knowledge that shapes the canon of higher education and the curriculum of the public school is defended largely through rhetorical and poetic appeals to the timeless values of reason, truth, and beauty. Second, an insistence on "excellence" removed from the issues of equity and power points to the purity and alleged objectivity of academic pursuits. Here, excellence is legitimated on the assumption that knowledge accumulated through the selective process of a tradition represents the best that can be offered through the evolution of Western culture within the intellectual grasp of an elite few. Third, the defining principle of traditional pedagogical practice is the transmission of bodies of knowledge from one generation to the next. The emphasis, crucially, is on processing received knowledge rather than on transforming it in the interest of social growth or change.

According to conservatives such as Balch, the integrity of the university and public schooling is at risk because academic standards have been compromised through such programs as affirmative action, open admissions, and the inclusion of writers and cultural texts into the curriculum that undermine the tradition of the "great books" as well as standards of discipline and rigor. The call to standards as a rallying cry for conservatives gained enormous popularity in Allan Bloom's book, *The Closing of the American Mind*.[18] Issuing both a manifesto and a call to action, Bloom boldly displayed his contempt for any curricula reform that challenged his own version of classical education. As Aronowitz and I have written elsewhere:

> He bitterly castigates the handful of "first-class" private universities for pandering to women, people of color, and radicals who want to study Marx, Nietzsche, and Heidegger rather than Plato and Hegel; or Richard Wright and Zora Neale Hurston rather than Charles Dickens; and whose critical sensibility is formed by their own time rather than by the Greek city-state.... Bloom goes so far as to claim that, however democratic, the recent efforts to open the doors of the universities to many who were formerly excluded through affirmative action and open admissions, are futile gestures because blacks and other people of color are so overwhelmed by economic and social problems that they could not possibly master a rigorous curriculum.[19]

Standards in this discourse are pitted against the threat posed by subordinate groups such as Afro-Americans, feminists, Latinos, gays and lesbians, and others who take issue with the content and form of the traditional

curriculum. Conservatives such as Dinesh D'Souza, Roger Kimball, and John Searle scorn the attempts of such groups to contest the claims to historical certainty and authority made on behalf of the traditional curriculum.[20] Believing that the traditional curriculum should only change "in response to advances in knowledge and intellectual skills, and not at the behest of political imperatives or in response to every shift of intellectual fashion,"[21] conservatives routinely dismiss as political cant critical inquiries regarding the relationship between institutional interests, power, and what counts as "literature," "history," and "knowledge" in the curriculum. For example, the claim by subordinate groups that the act of knowing is integrally related to the power of self-definition and, in part, legitimates the call for schools to include knowledge rooted in the narratives of the oppressed and the popular in the classroom is seen by conservatives not only as a call to politicize the curriculum but as a corrosive social force that promotes national disunity and cultural decay.

But there is more at stake for conservatives than protecting the content of traditional education. There is also the threat of standards being "lowered" by admitting students formerly excluded from higher education. For instance, Jeffrey Hart, a major spokesperson against political correctness, has argued that "a broadening of the student body has led to a corruption of the curriculum."[22] In this view, ideological differences are not the only threat posed by political correctness. Cultural, racial, gender, and class differences are also marked, by virtue of their very presence, as forms of subversion and a threat to middle-class, white cultural capital. Possession of such capital characterizes those who wield the power to secure the authority of the canon and enforce its claims to history, teaching, and learning. Christopher Newfield expands on this sentiment by arguing that challenges to the canon in the form of new courses are dismissed by conservatives

> not because of their particular content or methodology but because they presume the importance of the lives of their students. The predetermined truth the Right wishes to associate with political correctness is . . . a routine component of its own definition of legitimate classroom topics, since they seek to exclude the supplements or challenges to the truth that arise from students' active participation.[23]

Adopting a generally defensive posture, conservatives respond to critiques of the canon with a crusade to safeguard the traditional curriculum from

what they view as a hostile appropriation. In an effort to protect the canon from being watered down, conservatives often cite attempts at various colleges to replace Shakespeare and Rabelais with contemporary novelists such as James Baldwin and Toni Morrison. Standards in this case, at least for the Right, appear at odds with the democratization of power relations in either universities or public schools. They are also at odds with the call by progressives for groups formerly excluded from dominant educational institutions to make "their own decisions about how knowledge is to be structured and used."[24]

Paradoxically, the conservative position on academic "standards" generally ignores the economic effects of the bottom line crisis on universities, and, hence, offers meager acknowledgement, not to mention resistance, to the severe budget cuts in higher education (and public education) that have resulted in the elimination of entire academic departments, the raising of tuition, the firing of both nontenured and tenured faculty, and the downsizing of university services. The result has been a growing demoralization among faculty forced to teach larger classes and assume greater workloads as well as a disillusioned working-class student body of whites and minorities forced to pay higher tuition and bear the burden of reduced financial aid. In addition, such cuts open up the university to funding by private foundations and corporations who will support "only those programs deemed economically correct."[25] It is precisely the refusal to deal with such issues and their effects upon teaching and learning that betrays conservatives' obsession with the lowering of standards.

ACADEMIC FREEDOM AND THE ISSUE OF POLITICS

The dispute over standards is only one of the major considerations that defines the issues in the political correctness debate. Even more controversial than the issue of academic standards is the widespread perception that the public schools and universities are being increasingly politicized and that one casualty of this process is academic freedom.

According to anti–politically correct conservatives, the politicization of the discourse of schooling and higher education is evident on a number of fronts. First, it can be seen in the efforts of radical intellectuals to use the public space of the university to address issues of race, class, and gender. By challenging the university as a font of neutral scholarship, it is alleged that radical educators have compromised the integrity and moral purpose of the

educational process. Rather than being linked to the search for truth and pure knowledge, the university, in this perspective, becomes merely a breeding ground for social transformation or what John Taylor calls "the new fundamentalism."[26] One response to the perils of political correctness that exemplifies this position can be seen in Boston University President John Silber's report of April 15, 1993, to the board of trustees. Silber proclaims:

> This University has remained unapologetically dedicated to the search for truth and highly resistant to political correctness.... [W]e have resisted the fad toward critical legal studies.... In the English Department and the departments of literature, we have not allowed the structuralists or the deconstructionists to take over. We have refused to take on dance therapy.... We have resisted revisionist history.... In the Philosophy Department we have resisted the Frankfurt School of Critical Theory.... We have resisted the official dogmas of radical feminism. We have done the same thing with regard to gay and lesbian liberation, and animal liberation.... [W]e have resisted the fad of Afro-centrism. We have not fallen into the clutch of multi-culturalists.[27]

For conservative fellow travelers such as Jeff Jacoby, who confuse ideological rigidity with courage, Silber exhibits a strain of mental toughness in resisting alleged "ideological fads and epistemopathologies that are poisoning the wells of academe."[28] Hollywood machismo and academic intolerance come together in this instance in defending what Silber argues is the "recognition that Western culture, so called, is in fact a universal culture."[29] Eliding the relationship between Western culture and the history of colonialism is one thing, but even more egregious is the refusal on the part of Silber and others to distinguish criticisms of ethnocentrism from wholesale condemnations of Western culture. Moreover, contrary to Silber's apologists, the defensive quality of his engagement with political correctness suggests a dangerous ideological orthodoxy at work in Silber's pursuit of the truth. Ironically, Silber's statements suggest that the threat to academic freedom comes less from left-wing professors than it does from administrative demagogues who are willing to police and censor knowledge that does not silence itself before the legitimating imperatives of the traditional academic canon.

Many conservatives believe that radical academics have no grounds for distinguishing between the literary and the nonliterary since they vacate

the grounds of universal truth by arguing that knowledge is mediated historically, linguistically, and socially. Nor can they distinguish works that embody high aesthetic qualities and noble ideals from those everyday cultural texts that pass the political litmus test regarding race, class, and gender. William Kerrigan echoes this sentiment in arguing that those critics who claim that the dominant curriculum is racist or exclusionary can be dismissed as simply "liberal educators who have become pathologically sensitive to complaints of ethnocentrism." Paradoxically, he reinforces such a charge by declaring that "Black and Hispanic students must be taught in the language of the British and American intelligentsia, since integration will never succeed on any other level."[30]

Finally, one of the most visible rallying cries against political correctness comes from conservatives who link the expression of progressive ideas about gender, race, and power to forms of censorship. Citing excessive strains of anti–civil libertarianism among specific antiracist and antisexist groups, some conservatives argue that the discourse as well as the practices of such groups stifle traditional convictions and silence mainstream faculty and students. The result is an alleged marriage between intimidation and intellectual conformity. Camille Paglia, the author of *Sexual Personae*, goes so far as to claim that politically correct faculty and students in the university bear strong resemblance to "Moonies" and "the Hitler Youth."[31] Robert Rozenzweig, President of the Association of American Colleges, argues that the language of social criticism, whether it be antiracist, antisexist, or antihomophobic, closes down debate by simply "bludgeoning the opposition into submission."[32] These charges betray more than an exaggerated fear. They also suggest an act of bad faith on the part of conservatives who raise the specter of fascism against progressive faculty and students and at the same time remain indifferent to the alarming increase in hate crimes on American campuses against women, gays, and people of color. Within this critique, conservatives mobilize populist fears of violence while keeping the social order off the agenda for either criticism or change.

Moreover, evidence of the assault on free speech can also be found, according to anti–politically correct educators, in the emergence of hate-speech codes at American universities. Some conservatives claim that these rules are a threat to free speech. In this scenario, students who engage in hostile racial slander, for example, should be immune from disciplinary action under First Amendment rights. Racism in this case is seen as less

corrosive to democracy than the protection of the right of its advocates to translate their prejudices into speech acts.

Even more pernicious are the arguments made by conservatives regarding academic freedom and its relationship to particular teaching practices. Many liberals and conservatives argue that any form of pedagogy that takes as its goal the progressive transformation of either the classroom or society at large by definition engages in a form of pedagogical terrorism. Teachers who take a position of advocacy, who link knowledge to democratic commitment or incorporate social issues into their classrooms, are criticized for indoctrinating their students. Teachers who model leadership and civic courage in this view simply silence students who are allegedly refused the right to express opinions at odds with those of the teacher. However, it is precisely teachers with progressive visions who recognize the necessity of struggle and debate in the classroom as opposed to those who advocate the transmission of orthodox world views. Conversely, conservatives reject the notion that teaching is a political and cultural practice that encourages critical debate and radical disagreement. In its place they advocate the promotion of pedagogical practices free of controversy and the clash of opinions.

In the final section, I will analyze the potential for redefining the purpose of education, the roles of and interaction between teachers and students, and pedagogy itself as part of a wider effort to expand, deepen, and reconstruct the possibility for democratic public life, especially as it affects diverse sections of youth.

POLITICS AND EDUCATION

I will begin by examining an assumption at odds with the anti–politically correct conservatives, one that has a long tradition in the United States. The assumption being examined claims that the meaning and purpose of schooling is imminently political. This suggests that schools cannot be understood outside of the meditations of history, power, and struggle. Schools are both sense-making and power-bearing institutions that are actively involved in the "struggle to control and contribute to the social circulation and uses of meanings, knowledges, pleasures, and values."[33]

Central to any notion of education is the relationship between authority and teaching, on the one hand, and knowledge and power on the other. Authority is both a condition and effect of teaching. Teaching itself is

premised on making choices about the production and use of knowledge as well as helping students understand the linkages that mutually inform the relationship between schooling and the larger society. School as a site and teaching as a practice must always be seen as deeply moral and political. Schools like all social sites produce and organize knowledge through processes of inclusion and exclusion. Such processes do not exist outside of history nor are they untouched by the operations of power. Neither the curriculum nor the canon can be understood as expressions of the disinterested search for truth and knowledge. Such knowledges more often than not express an ongoing process of negotiation and struggle among different groups over the relationship between knowledge and power on the one hand and the construction of individual and social identities on the other.

What counts as legitimate knowledge, culture, history, and speech can, in part, be understood by interrogating the conditions of exclusion and inclusion in the production, distribution, circulation, and use of power and authority in the classroom. The conservative view of knowledge as neutral and pedagogy as a transparent vehicle of truth overlooks important political issues regarding how canons are historically produced, whose interests they serve as well as those they do not serve, and how they are sustained within specific forms of institutional power. Toni Morrison, the Nobel Prize-winning novelist, illuminates the political nature of the relationship between knowledge and power by arguing that:

> Canon building is Empire building. Canon defense is national defense. Canon debate, whatever the terrain, nature and range (of criticism, of history, of the history of knowledge, of the definition of language, the universality of aesthetic principles, the sociology of art, the humanistic imagination), is the clash of cultures. And all of the interests are vested. [34]

Morrison suggests that both knowledge and its dissemination are filtered through the normative lens of history and tradition. Since histories are constructed and struggled over rather then merely received and passed on to future generations, it is imperative that teachers articulate a moral vision and social ethics that provide a referent for justifying how, what, and why they teach. After all, if education presupposes a vision of the future and always produces selective narratives and stories, it is crucial for teachers both to clarify and make themselves accountable for how their

pedagogical practices contribute to the social consciousness, hopes, and dreams of their students. Or, to put it another way, how their pedagogies contribute to the construction of youth as a social formation in the process of becoming active and critical citizens.

For the anti–politically correct conservatives, tradition dictates what is taught in schools. But tradition in these terms is tied to the obligations of reverence rather than to what might be called the imperatives of respect. Reverence suggests treating tradition as an object, a series of artifacts that are unproblematically collected, displayed, and transmitted—simply passed on to students in conveyer belt fashion. Conversely, respect situates tradition not as a fixed object of austere contemplation but as diverse cultural texts that need to be historically situated and open to debate. Such respect is central to helping students understand the limits and strengths of tradition as part of a wider attempt for them to narrate themselves as critical agents, capable of making history rather than simply being carried away by it.

Some conservatives would argue that such an approach to tradition vacates the terrain of values; on the contrary, it makes the very category of value problematic and in doing so enhances its potential for critical exchange. A critical attentiveness to the values that inform teacher work, the ways in which knowledge is constructed, and the structuring of teacher-student relationships is a precondition for making explicit and, when necessary, changing those values that inform commonsense assumptions that structure oppressive conditions for students. Symbolic and material violence, whether expressed in the form of racially inspired tracking, sexist curricula, institutional inequality, authoritarian teaching, or academic insensitivity to the demands of Afro-Americans, women, the poor, and others cannot be challenged and transformed unless teachers become aware of how the values that sustain such practices are reproduced in the histories, institutional practices, and narratives that shape their own locations as teachers and the pedagogical practices they employ. The issue for teachers is not to abandon judgments in the name of a false neutrality that suggests they simply be priests of an unproblematic truth; on the contrary, teachers and other cultural workers need to try to understand how the values that inform their work are historically conditioned and institutionally produced. They also need to understand that such values may be pedagogically used to inform both their own sense of agency and its

possibilities for releasing the spirit of meaning, motivation, and hope that affirms and critically engages students as shapers of public life.

I want to argue that the anti–political correctness argument against politics, with its claim to disinterested teaching and scholarship, is really a prescription for deskilling teachers and masking how the dynamics of power work in the culture, in pedagogy, and in the institutional organization of schools. The conservative ploy of labeling critical educators as "the new fundamentalists" or "cultural barbarians" may provide a rhetorical strategy for making headlines in the popular press or fodder for hate commentaries on talk radio, but it offers no language for understanding how power has worked historically to silence, disable, and marginalize working-class youth and youth of color in society through the process of schooling. Removed from the context of history, theory, politics, and power, the discourse of anti–political correctness offers limited insights into a view of educational leadership that would provide a moral focus on suffering or on how youth are contained and defamed with material and representational structures of power. It offers no language for discriminating between the pedagogical and ethical imperative of challenging racism, discrimination, and social injustice and the unacceptable behavior of teachers who in their excessive zeal commit pedagogical violence by preventing students from engaging in critical and open dialogue. Moreover, the claim that social criticism promotes censorship confuses acts of state censorship with the inability of many conservatives to actually engage in critical inquiries into how power works in public schools and higher education. Anti–civil libertarian behavior is unacceptable, whether its source is a public school teacher, college professor, or an anti-abortion activist. But social criticism is not a liability in a vibrant democracy; in fact, it is both a political and pedagogical necessity if such a democracy is to become part of a dynamic tradition rather than a historical relic.

I don't want to suggest that teachers should tolerate expressions of anti–civil libertarian behavior that close down debate and silence others, but it is no secret that America has a long legacy of witch hunts, show trials, and an appalling absence of public debate about crucial political issues. My point is that institutional authorities, the United States government, and industry have never passionately defended the right to dissent from established and consensual policies. Therefore, the call for free speech cannot be dismissed as a convenient trope of conservative discourse parading

under the banner of the anti–political correctness campaign. What teachers need to address is the contradiction between the call for the defense of free speech and the simultaneous refusal to address the central and most urgent social problems of our time. The real crisis in schools and youth culture may not be about censorship, freedom of speech, or other alleged evils of political correctness, but whether students are learning how to think critically, engage larger social issues, take risks, and develop a sense of social responsibility and civic courage.

Finally, I want to argue in opposition to anti–politically correct advocates that teachers cannot abstract the issue of standards and excellence from a concern with equity and social justice. These should be mutually informing categories because the discourse of standards represents part of the truth about ourselves as a nation in that it has often been evoked in order to legitimate elitism, racism, and privileges for the few, as well as to shut down the possibilities for public schools and the academy to educate students for critical citizenship and the promises of a democratic society. Equally important, when standards are removed from their ethical and political referents, they mystify how educational practices shape what is legitimated or excluded as knowledge and truth. Teachers need to assert their vocation as a political enterprise, without necessitating that they politicize their students.

This is not an argument for indoctrination. On the contrary, it is a discourse that challenges the very nature of indoctrination by raising questions such as, Whose authority is secured through the form and content of specific canons? What does it mean to organize the curriculum in ways that decenter its authority and power relations? What social relations have to come into play to give university teachers and students control over the conditions for producing knowledge? If educators are to take the precepts of radical democracy seriously in their pedagogy, they need to address what it means to decenter the curriculum.

As I have mentioned throughout this book, students should be actively involved with issues of governance, "including setting learning goals, selecting courses, and having their own, autonomous organizations, including a free press."[35] Not only does the distribution of power among teachers, students, and administrators provide the conditions for students to become agents in their learning process, it also provides the basis for taking seriously the imperatives of citizenship for a radical democracy.

Through student-centered investigations of social problems such as toxic waste dumping, homelessness, poverty, the high incidence of certain diseases, and other issues that bear upon their experiences, students can develop community-based curricula and initiate projects that link civic action to academic learning and ethical responsibility. Not only does such agency emerge through a pedagogy of lived experience and struggle rather than as the empty, formalistic, mastery of an academic subject, but it also develops within a larger social and historical vision through which the student can both understand and challenge the imperatives of schooling.

The distinction I am making here refutes the liberal and conservative criticism that, since critical pedagogy attempts to both politicize teaching and teach politics, it represents a species of indoctrination. Asserting that all teaching is profoundly political and that critical educators should operate out of a project of social transformation should not mean that as educators we refuse either to examine critically the basis of the classroom authority we exercise or make such authority an object of student analysis. Nor does the assertion that as educators we should use authority in the interest of social transformation suggest that we underestimate the pain and resistance involved in learning. (This is especially true regarding the fear of theory that students often exhibit in making themselves accountable for their own arguments or in their reluctance to engage specific socio-political discourses.[36]) There is no excuse for an oppressive pedagogy, but at the same time, it is politically and ethically irresponsible to suggest that, because radical pedagogy defines itself as a political practice, it represents a species of tunnel vision. It is argued that radical pedagogy "is for those who have already decided to be radicals, and that the others will pretty much stay out of it, as presumably they will want to anyway."[37] This position is too simplistic. It wrongly suggests that any pedagogy informed by a political project is by nature oppressive. In opposition to this view, I want to reassert the importance of what I have referred to previously as the distinction between political and politicizing education.

Political education, which is central to critical pedagogy, advocates being attentive to the historical and ideological formations that shape the politics of one location as a teacher and cultural worker. Rather than abstracting politics from education, political education exercises a critical self-consciousness regarding how power operates within the classroom to produce knowledge, arrange teacher-student relations, and challenge

oppressive structures of power. Political education embraces the inescapable political nature of education while always being suspicious of any politics that is dogmatic, doctrinaire, or closed to critical examination.

For teachers and other cultural workers to acknowledge how educational practices are shot through with political considerations necessitates avoiding the pitfalls of the politicization of the classroom. The latter approach exercises authority in a domineering fashion and in doing so often silences students who speak critically. Politicizing education offers no safe spaces for students to narrate themselves and more often than not exclusively legitimates the monocultural voice of the middle-class teacher. Premised on appeals to categories such as beauty, truth, and certainty coupled with a pedagogy of transmission, politicizing education, regardless of the ideological credentials of those who practice it, reproduces the cultural politics of the status quo and is inimical to a progressive, transformative pedagogy. Most importantly, politicizing education bankrupts any notion of critical citizenship and represents the advance guard of the anti–politically correct advocates. Pedagogy within this discourse infantilizes youth. It substitutes training for learning and docile bodies for students who might act as border crossers and agents of civic courage.

In short, the battle against political correctness is less a corrective to bad educational and pedagogical practices than a prescription for removing debate, cultural differences, and diverse theoretical orientations from the sphere of schooling. The anti–political correctness movement has become a media event for a resurgent conservatism and a rationale for removing the language of social justice from public discourse. The call to free speech becomes synonymous with the reduction of public life to the laws of the free market. Free speech in this case is emptied of both critical content and social responsibility and serves to legitimate an indifference to the suffering, exploitation, and hardships of others. Behind the ideological battle against political correctness lurks the attempt on the part of conservatives to undermine the conditions that encourage educators and students to become critical public intellectuals actively engaged in the process of linking their own self-formation and teaching, along with the purpose of schooling itself, to the struggle for radical democracy and social justice.

Commitment is not the disease of oppressive partisanship, it is the basis for making teachers and youth aware of what it means to be the active

subjects of history rather than the guardians of an unproblematic and nostalgic view of the past. The current debate about political correctness in the United States does more than misrepresent the alleged tyranny of a handful of progressive educators; it also reveals the fear that radical democracy inspires in the orthodox guardians of traditional culture. Such fears make visible the limits of the political vocabulary of the new conservative majority fashioned in the image of Newt Gingrich, Rush Limbaugh, and the Christian Coalition. Beneath the political discourse of contempt aimed at all shades of progressives, conservatives want to administer rigid pedagogy, political conformity, and strict moral regulation to those unwashed others who might otherwise embrace the frustrations and modest hopes that cultural, political, and economic democracy demand. If democracy is to become more than a formality or a rhetorical gesture cheaply dispensed through the dominant media, it must once again become a site of economic and social struggle and insurgent risk taking.[38] As a performative act rooted in imaginative practices and modest hopes, democracy produces uncertainty, dissension, and critical debate; this suggests the creation of public spheres where values are both learned and debated, dialogue is invoked to affirm differences, and taking a stand becomes an essential element of leadership rather than a prescription for demagoguery. Democracy is unsettling, yet calls for hard ethical evaluations. Catherine Stimpson is right in suggesting that "being a cultural democratic can be exhausting and irritating," but she also recognizes that such hope and anguish strengthen and expand our moral, cognitive, and cultural capacities as educators while simultaneously encouraging us to act in order to expand democratic public life as the deepest expression of individual and collective freedom.[39] Maybe the lesson here is that in a democracy that matters, youth are not feared, education becomes a vehicle of critical learning, the economy is not left to the whims of the market and its greed, and social justice is invoked to eliminate bigotry rather than sanction it by labeling its opponents as politically correct.

THE MILK

AIN'T

7

NATIONAL IDENTITY AND MULTICULTURALISM

CLEAN

G lobal changes have provided the conditions for
the emergence of new theoretical discourses that pose a powerful
challenge to modern assumptions regarding the unity of nationalism
and culture, the state and the nation, and national identity and the
universal imperatives of a common culture. The historic and spatial
shifts that have, in part, produced new forms of theorizing about
globalization, the politics of diaspora, immigration, identity politics,
multiculturalism, and postcolonialism are as profound intellectually

as they are disruptive politically. Judith Squires captures the scope of these changes, while expressing some reservations about what they have come to mean as they are rapidly absorbed into new theoretical discourses.

> The global economy is a given in our life now: transnational corporations cross borders to maximize productivity and transnational intellectuals cross academic boundaries to maximize knowledge. The academic discipline, along with the national state, is subject to powerful forces of change. And, as we might acknowledge the failings of the old model of state sovereignty and hegemonic nationalism but nonetheless remain deeply skeptical about the gains to be had from the free movement of international capital around the globe in pursuit of profit, so we must be attuned to the benefits of jettisoning the status of empirical area studies, the constricting patriarchal academic canons and oppressive hierarchical department structures, but also the pitfalls.[1]

The pitfalls to which Squires refers are the lack of specificity and theoretical blurriness that sometimes accompany the scholarly rush to take up issues of the politics of globalization, diaspora, multiculturalism, and postcolonialism.[2] I am particularly concerned here with a position that does not attempt to differentiate among radical, liberal, and conservative forms of multiculturalism. Within the politics of the nation-state, such generalizations often recycle or reproduce colonialist discourse. What must be resisted is the assumption that the politics of national identity is necessarily complicitous with a reactionary discourse of nationalism and has been superseded by theories which locate identity politics squarely within the discourses of postnational, diasporic globalism, or what Arjun Appadurai calls the "search for nonterritorial principles of solidarity."[3]

This is not to suggest that diverse nationalisms can be addressed outside of their transnational links, or that the mechanisms of a dominant and oppressive politics of assimilation can be abstracted from the pain, anguish, and suffering experienced by those diasporic groups who define themselves through "nonnational identities and aspirations."[4] What I am resisting is the claim that nationalism can only be associated with ethnic conflict, that nationalism is witnessing its death knell, or that the relationship between nationalism and national identity can only be framed within a transnational discourse. The importance of such arguments must be acknowledged; at the same time it is vital to recognize in the context

of the current conservative ideological offensive in the United States that it is crucial for critical educators and others to "locate our theorizing in the grounded sites of cultural and political resistance" within the United States, on the one hand, and to guard against the tendency to "overgeneralize the global current of so-called nomadic, fragmented and deterritorialized subjectivity."[5]

I want to argue that nationalism is crucial to understanding the debates over identity and multiculturalism in the United States, and that as important as the discourse of globalization might be, it cannot be used to overlook how national identity reasserts itself within new discourses and sites of learning.[6] More specifically, I want to contend that, rather than dismissing the politics of identity as another essentialist discourse, progressives need to address how the politics of identity and difference are being constructed around new right-wing discourses and policies. Central to the construction of a right-wing nationalism is a project of defining national identity through an appeal to a common culture that displaces any notion of national identity based upon a pluralized notion of culture (with its multiple literacies, identities, and histories) and erases histories of oppression and struggle for the working class and minorities. Stuart Hall is right in arguing that the 1990s is witnessing the return of recharged nationalism in big and small societies that serves to restore national culture as the primordial source of national identity.[7] But this should not suggest that the relationship between nationalism and culture manifests itself exclusively in terms of oppression or domination or that any attempt to develop an insurgent multiculturalism through an appeal to radical democracy necessarily assumes or leaves intact the boundary of the nation as an unproblematic historical, political, and spatial formation. At stake here is the need to both acknowledge the existence of the nation-state and nationalism as primary forces in shaping collective identities and simultaneously addressing how the relationship between national identity and culture can be understood as part of a broader struggle around developing national and postnational forms of democracy.

The relationship between culture and nationalism always bears the traces of those historical, ethical, and political forces that constitute the often shifting and contradictory elements of national identity. To the degree that the culture of nationalism is rigidly exclusive and defines its membership in terms of narrowly based common culture, nationalism

tends to be xenophobic, authoritarian, and expansionist; hence, the most commonly cited example of nationalism is one steeped in the practices of ethnic cleansing, genocide, or imperialist aggression. On the other hand, nationalism moves closer toward being liberal and democratic to the degree that national identity is inclusive and respectful of diversity and difference. And yet, a civic nationalism that makes a claim to respecting cultural differences does not guarantee that the state will not engage in coercive assimilationist policies. In other words, democratic forms of nationalism cannot be defended simply through a formal appeal to abstract, democratic principles. How nationalism and the nation-state embrace democracy must be determined, in part, through the access diverse cultural groups have to shared structures of power that organize commanding legal, economic, political, and cultural institutions on the local, state, and national levels.[8]

Cultural differences and national identity stand in a complex relationship to each other and point to progressive as well as totalitarian elements of nationalism that provide testimony to its problematic character and effects. On the negative side, recent history bears witness to the Second World War, a period steeped in forms of national identity that mobilized racial hatred and supported right-wing, antidemocratic governments in Germany, Italy, and Japan. Following 1945, one of the most flagrant legacies of such a poisonous nationalism is evident in the longstanding apartheid regime that, until recently, dominated South African politics. Also notable is the continuing attempt on the part of Turkey to deny the Kurds any status as a national group.

Representations of national identity constructed through an appeal to racial purity, militarism, anti-Semitism, and religious orthodoxy have once again surfaced aggressively in Western Europe and can be seen in the rise of neo-Nazi youth movements in Germany, the neo-Fascist political parties that won the recent election in Italy, and the ethnic cleansing that has driven Serbian nationalism in the former Republic of Yugoslavia. This highly selective list merely illustrates how national identity can be fashioned around appeals to a monolithic cultural identity that affirms intolerance, bigotry, and an indifference to the precepts of democratic pluralism. Needless to say, these forms of demagogic nationalism emerge from a diverse set of conditions and circumstances, the roots of which lie in a complex history of racial conflict, the unstable economic conditions

that have gripped Europe, and the dismantling of the Soviet Union and its empire. As a social construction, nationalism does not rest upon a particular politics, but takes its form within rather than outside of specific, historical, social, and cultural contexts.

The more positive face of nationalism has emerged in a number of countries through a legacy of democratic struggles and can be seen not only in various anticolonialist struggles in Asia and Africa, but also in diverse attempts on the part of nation-states to mobilize popular sentiment in the interest of expanding human rights and fighting against the encroachments of undemocratic social forces. While many of these movements of national struggle are far from unproblematic, particularly during periods in which they assume state control, they do provide credibility to the emancipatory power of nationalism as a defining principle in world politics.[9] Equally important is the need to develop a politics of difference and multiculturalism that combines the most progressive elements of nationalism with a notion of border crossing, diasporic politics, and postnationalism that recognizes the transits, flows, and social formations being produced on a global scale. It is precisely in the interaction of the national and global that a borderline space exists for generating new forms of transnational literacy, social relations, and cultural identities that expand the meaning of democracy and citizenship beyond national borders.

MYTHIC NATIONAL IDENTITY

For many Americans, questions of national identity seem to elude the complex legacy of nationalism and take on a mythic quality. Informed by the powerful appeal to assimilation and the legitimating discourse of patriotism, national identity often operates within an ideological register untroubled by the historical and emerging legacies of totalitarianism. Rather than being viewed cautiously as a potential vehicle for undermining democracy, national identity in the United States has been defined more positively in commonsensical terms as deeply connected to the mythic march of progress and prosperity at home and the noble effort to export democracy abroad. Hence, national identity has all too often been forged within popular memory as a discourse that too neatly links nation, culture, and citizenship in a seamless and unproblematic unity. Invoking claims to the past in which the politics of remembering and forgetting work powerfully to legitimate a notion of national belonging that "constructs the nation as

THE MILK AIN'T CLEAN

an ethnically homogeneous object,"[10] national identity is rewritten and purged of its seamy side. Within this narrative, national identity is structured through a notion of citizenship and patriotism that subordinates ethnic, racial, and cultural differences to the assimilating logic of a common culture, or, more brutally, the "melting pot." Behind the social imaginary that informs this idea of national identity is a narrowly defined conception of history that provides a defense of the narratives of imperial power and dominant culture and legitimates an intensely narrow and bigoted image of what it means to be an American.

In an era of recharged nationalist discourse in the United States, the populist invocation of national identity suggests that social criticism itself is antithetical to both the construction of national identity and the precepts of patriotism. Of course, national identity, like nationalism itself, is a social construction that is built upon a series of inclusions and exclusions regarding history, citizenship, and national belonging. As the social historian Benedict Anderson has pointed out, the nation is an "imagined political community" that can only be understood within the intersecting dynamics of history, language, ideology, and power. In other words, nationalism and national identity are neither necessarily reactionary nor necessarily progressive politically; thus, they give rise to communities which, as Anderson points out, are "to be distinguished, not by their falsity/genuineness, but by the style in which they are imagined."[11]

The insight that national identity must be addressed according to the ways in which it is imagined signals for me the importance of pedagogical practices to current controversies around questions of identity which characterize much political debate in the United States. It is the pedagogical processes at work in framing the current debates on national identity that interest me most. More specifically, the questions I want to raise are: What forms of address, images, texts, and performances are being produced and used in popular discourses to construct what it means to be an American, and what are the implications of these dominant representations for extending or undermining a substantive plural democracy?

The current debate over national identity represents, in part, a conservative backlash fueled by the assumption that "those common values and consensual freedoms that have defined the 'American' way of life, circa Norman Rockwell"[12] are now under attack by racial, sexual, and political minorities. Moreover, the current conservatism produces a new nationalism

rooted in an imaginary construction of national identity that is dangerous to any viable notion of democracy. This is not meant to suggest that the discourse of national unity voiced through an appeal to shared language of difference (not the assimilationist language of a common culture) should be summarily dismissed as Eurocentric, racist, or patriarchal. National identity steeped in a shared vision of social justice and a respect for cultural differences is to be applauded. At the same time, the healing grace of a national identity based on a respect for "lived cultures in the plural"[13] should not be confused with a politically reactionary notion of national identity whose primary purpose is to restrict the terms of citizenship and community to a discourse of monoculturalism and nativism. National identity in the service of a common culture recognizes cultural differences only to flatten them out in the conservative discourse of assimilation and the liberal appeal to tolerance.[14] However, the linkage between national identity and nationalism is not bound by any particular politics, and nationalism is not, by definition, intrinsically oppressive. Hence, it is both important and necessary as part of a progressive politics of national identity to provide a theoretical space to address the potential of both a pedagogy and politics that can pluralize cultural differences within democratic relations of power as part of an effort to develop an emancipatory politics of national identity and nationalism. This is especially important at a time in the United States when the discourse of nationalism and national identity has taken a decidedly reactionary political turn.

The appropriation of national identity as a vehicle to foster racism, nativism, and political censorship is not unique to the 1990s, but has a long history in the United States. However, the conditions, contexts, and content through which the discourse of national identity is being produced and linked to virulent forms of nationalism are new. For example, media culture, with its new cable technologies coupled with the proliferation of radio and television talk channels, has created a public sphere that vastly expands the intrusion into daily life of mainstream discourses that greatly restrict the possibility for real debate, exchange, and diversity of opinions. These electronic media, largely driven by corporate conglomerates, have no precedent in American life in terms of their power both to disseminate information and to shape how national identity is configured, comprehended, and experienced as part of everyday life. In addition, popular culture has become a powerful site for defining

nationalism and national identity against diversity and cultural differences, the latter rendered synonymous with disruption, disunity, and separatism. In this populist discourse, there is a theoretical slippage which equates national identity with a common identity and the assertion of cultural pluralism with an assault on the very character of what it means to be an American. At issue here is a politics of forgetting that erases how disparate social identities have been produced, legitimated, and marginalized within different relations of power. But there is more at stake than the erasure of social memory; there is also the emergence of a racially saturated discourse that mobilizes national identity as the defining principle for a national community that is under siege. Similarly, the new nationalism in foreign policy employs the chauvinistic bravado of the marketplace with its call for the United States to be number one in the world while simultaneously stigmatizing internal social criticism as unpatriotic and a threat to American culture and civility.

MEDIA CULTURE AND THE POPULIST CONSTRUCTION OF NATIONALIST IDENTITY

I want to examine briefly some populist examples of the new nationalism that speak from different places in the cultural apparatuses that shape public opinion. In different ways, these populist voices advocate a pedagogy and politics of national identity that serve to reproduce some reactionary elements of the new nationalism. For example, expressions of the new nationalism can be found in several sites: in the backlash against multiculturalism in the public schools and universities; in the rise of the English Only movement; in the notion of the state as a "stern parent" willing to inflict harsh measures on welfare mothers; and in educational reforms demanding a national curriculum. Ideological signposts pointing to the new nationalism can be found in analogies invoking the imagery of battle, invasion, and war, which increasingly shape the debates over immigration in the United States, as in the passing of anti-immigration legislation such as California's Proposition 187. Crime is represented in the dominant, white, media as a black issue, implying that race can only be understood through a reductionist correlation of culture and identity. Representations of black men appear ad nauseam on the covers of magazines such as *Newsweek*, *The New York Times Magazine*, and *Time* whenever a signifier is needed to mobilize and draw upon the general public's fear of crime and urban decay. Recent

Hollywood films abound with racist representations that link criminality to skin color. Some of the most popular examples include *Pulp Fiction* (1994) and *Just Cause* (1995).[15] All of these examples underscore how nationalism is currently being shaped to defend a beleaguered notion of national identity read as white, heterosexual, middle class, and allegedly threatened by contamination from cultural, linguistic, racial, and sexual differences.

The power of the new nationalism and its centrality to American political life can also be seen in its growth and popularity in a number of popular and public spaces. One example can be found in the written and television commentaries of Republican presidential hopeful Patrick Buchanan on shows such as CNN's *Crossfire*. Buchanan represents a new version of the public intellectual speaking from such critical public sites as the news media, especially from the growing number of news programs found on cable television, which are largely dominated by right-wing commentary. For Buchanan, the new nationalism is defined through a bellicose nativism that views cultural differences as a threat to national unity. Buchanan argues that the reality of cultural difference, with its plurality of languages, experiences, and histories, poses a serious threat to both national unity and what he defends as Judeo-Christian values. According to Buchanan, calls for expanding the existing potential of political representation and self-determination are fine insofar as they enable white Americans to "take back" their country. In this reactionary discourse, difference becomes a signifier for racial exclusivity, segregation, or, in Buchanan's language, "self determination." For Buchanan, public life in the United States has deteriorated since 1965 because "a flood tide of immigration has rolled in from the Third World, legal and illegal, as our institutions of assimilation . . . disintegrated." Ushering in the discourse of nativism, Buchanan asks: "Who speaks for the Euro-Americans? Is it not time to take America back?"[16] Similarly, populist right-wing conservative Rush Limbaugh, who describes himself as the "Doctor of Democracy," rails against the poor and disadvantaged minorities because they do not act like "real" Americans who "rely upon their own resources, skills, talents, and hard work."[17] Limbaugh has become the populist equivalent of Beavis and Butt-head. Combining humor, unrestrained narcissism, and outright buffoonery with a virulent and mean-spirited attack on progressive causes, Limbaugh accentuates the current appeal of the talk show as part of a broader reactionary, conservative offensive through popular

media. Perhaps one of the more interesting insights to be understood by progressives about Limbaugh is that he exemplifies the way in which right-wing conservatives no longer limit their political agenda to the traditional channels of policy, news, and information; they have now extended their influence to the more populist cultural realms of radio and television talk shows, the world of stand-up comics, and other texts of media culture.

Rush Limbaugh, Howard Stern, Andrew Dice Clay, and other popular figures represent a marriage of media culture and the lure of extremist attacks, in what appears to be a legitimation of a new form of public pathology dressed up as entertainment.[18] Limbaugh echoes the increasingly popular assumption that an "ethnic upsurge" threatens both the American model of assimilation and the unity of America as a single culture. Extending rather than challenging the ideological assumptions that buttress the old racism and Social Darwinism, Limbaugh and others echo a call for cultural unity less as an overt marker for racial superiority than as a discourse for privileging a white "minority." Within this populist discourse, racism is couched in the critique of the welfare state but serves primarily as a signifier for cultural containment, homogeneity, and social and structural inequality. Just as Charles Murray and Richard Herrnstein warn in *The Bell Curve* against the effects of immigration on the gene pool of white, middle-class Americans, and the religious right calls for a "holy war" to be waged in the schools to preserve the identity of the United States as a "Christian" nation, right-wing populist commentators add a twist to the new nationalism and its racial coding by appealing to a nostalgic, romanticized view of history as the "good old days" in which white men ruled, blacks knew their place in the social and political hierarchy, and women attended to domestic work. The appeal is no longer simply to racial supremacy but also to cultural uniformity parading as the politics of nationalism, national identity, and patriotism. These attacks on multiculturalism organize themselves around a view of nationalism that stigmatizes any disagreement by simply labeling critics as "America-bashers."

In the world of TV spectacles and mass entertainment, the Buchanans and Limbaughs represent the shock troops of the new nationalism. On the academic front, a more "refined" version of the new nationalism has been advanced. Two examples will suffice, though they are hardly inclusive. In the first instance, public intellectuals writing in conservative

periodicals such as *The New Republic*, *The New Criterion*, and *The American Spectator* have increasingly argued for the new nationalism in terms that both dismiss multiculturalism and reproduce the discourse of assimilation and common culture. Rather than analyzing multiculturalism as a complex, legitimate, and necessary "on-going negotiation among minorities against assimilation,"[19] the new nationalists see in the engagements of cultural difference less a productive tension than a debilitating divisiveness. John B. Judis and Michael Lind echo this sentiment in their own call for a new nationalism.

> There is a constructive and inclusive current of American nationalism that runs from Alexander Hamilton through Abraham Lincoln and Theodore Roosevelt. It emphasizes not the exclusion of foreigners, but rather the unification of Americans of different regions, races and ethnic groups around a common national identity. It stands opposed not only to nativism, but also to today's multiculturalism and economic or strategic globalism.[20]

Nationalism in this discourse becomes the marker of certainty; it both affirms monoculturalism and restores the racially coded image of "Americaness" as a beleaguered national identity.[21] The new nationalism also pits national identity against the possibility of different groups to articulate and affirm their histories, languages, cultural identities, and traditions through the shifting and complex relations in which people imagine and construct national and postnational social formations. This is evident in the attack being waged by the Right and the Republican Congress on affirmative action, quotas, immigration, bilingualism, and multiculturalism in the public schools. But the new nationalism is not confined to right-wing conservatives and evangelical Christians.

A more moderate version of the new nationalism can be found in the writing of liberals such as Richard Rorty, a prominent liberal philosopher from the University of Virginia. While Buchanan, Limbaugh, and their followers might be dismissed as simply populist demagogues, public intellectuals such as Rorty command enormous respect from the academic community and the established press. Moreover, such intellectuals travel between academic and popular public spheres with enough influence to bring professional legitimacy to the new nationalism as it is taken up in television and talk radio programs, the electronic media, and in the major

newspapers and magazines in the United States. Hence, it is all the more important that arguments that reinforce the logic of the new nationalism and parade under the banner of a "tough" or "patriotic" liberalism be critically engaged, especially by individuals who find in such arguments a semblance of reason and restraint.

RICHARD RORTY, LIBERALISM, AND THE PROBLEM OF NATIONAL IDENTITY

Writing in the Op-Ed section of the *New York Times*, Richard Rorty has argued under the headline "The Unpatriotic Academy" that left-wing academics who support multiculturalism are "unpatriotic." For Rorty, the litmus test for patriotism is not to be found in social criticism that holds a country up to its professed ideals, but in a refusal on the part of "this left . . . to rejoice in the country it inhabits. It repudiates the idea of a national identity, and the emotion of national pride." Speaking for an unspecified group of "patriotic" Americans, Rorty, in this instance, insists that "we take pride in being citizens of a self-invented, self-reforming, enduring constitutional democracy."[22] One wonders: for whom do intellectuals such as Rorty speak? Have they appointed themselves as spokespersons for all Americans who disassociate themselves from the Left? And does this generalization further suggest that one gives up respect and love of one's country if one engages in criticism that can be conveniently labeled as left wing? Does a public assertion of patriotism, as ritualistically invoked by all manner of demagogues, suggests that such rhetoric provides a certified stamp of legitimacy regarding one's own politics?

Of course, Rush Limbaugh and Patrick Buchanan consistently engage in the rhetoric of love for their country while simultaneously baiting gays, blacks, feminists, and others. Moreover, one must consider the implications of Rorty's attack on the left social critics in view of the ways in which the United States engaged in red-baiting during the 1920s and the McCarthy witch hunts of the 1950s. Is he suggesting that left-wing theorists (as if they were a homogeneous group) should be policed and punished for their lack of patriotism? There is a recklessness in Rorty's charges that places him squarely in the camp of those who would punish dissenters rather than support free speech, especially if it is speech that one disagrees with. Maybe Rorty was simply being rambunctious in his use of the term "unpatriotic," but given the way in which the term has been

used historically in this country to squelch social criticism, such a lapse of historical memory seems unlikely. So what is the point?

Rorty seems to be caught between liberal guilt and the appeal of a rabid conservatism that equates cultural differences with a threat to national unity, a threat that has to be overcome. Having posited such an equation, Rorty then takes the extraordinary step of identifying all those academics who support some version of multiculturalism as posing a threat to the social order. For Rorty, there is no contradiction in feeling one's heart swell with patriotism and "national hope" and feeling "shame at the greed, the intolerance and the indifference to suffering that is widespread in the United States."[23] In this theoretical sweep, multiculturalism is not addressed in its complexity as a range of theoretical positions that run the ideological gamut from calls for separatism to new forms of cultural democracy. Multiculturalism for Rorty is simply a position that exists under some absolute sign. In this reductionistic perspective, there are no theoretical differences between multicultural positions espoused by academic leftists such as Hazel Carby, Guillermo Gomez-Pena, June Jordan, and bell hooks, on the one hand, and liberals such as James Banks, Gregory Jay, or Stanley Fish, on the other. But there is more at stake here than Rorty's suspect appeal to patriotism. Social criticism is not the enemy of patriotism, it is the bedrock of a shared national tradition that allows many voices to engage in a dialogue about the dynamics of cultural and political power. In fact, national identity must be understood within a broader concern for the expansion and deepening of democratic public life itself.

I believe that Rorty's notion of national identity closes down, rather than expands, the principles that inform a multicultural and multiracial democracy. However, Rorty is important in terms of exemplifying the limits of the reigning political philosophy of liberalism. Rorty's gesture towards tolerance "presupposes that its object is morally repugnant, that it really needs to be reformed, that is, altered."[24] As David Theo Goldberg points out:

> Liberals are moved to overcome the racial differences they tolerate and have been so instrumental in fabricating by diluting them, by bleaching them out through assimilation or integration. The liberal would assume away the difference in otherness maintaining thereby the dominant of a presumed sameness, the universally imposed similarity in identity.[25]

National identity cannot be constructed around the suppression of dissent. Nor should it be used in the service of a new fundamentalism by appealing to a notion of patriotism that equates left-wing social criticism with treason, and less critical forms of discourse with a love of nationalism or national identity. It is precisely this type of binarism that has been used, all too frequently throughout the twentieth century, to develop national communities that make a virtue of intolerance and exclusion. Moreover, this kind of logic prevents individuals and social groups from understanding and critically engaging national identity not as a cultural monument but as a living set of relations that must be constantly engaged and struggled over.

Rorty's facile equating of national identity with the love of one's country, on the one hand, and the dismissal of forms of left social criticism that advocate multiculturalism, on the other, is simply an expression of the new nationalism, one which views cultural differences and the emergence of multiple cultures as a sign of fragmentation and a departure from, rather than an advance toward, democracy. Rorty's mistake is that he assumes that national identity is to be founded on a single culture, language, and history when in fact it can't. National identity is always a shifting, unsettled complex of historical struggles and experiences that are cross-fertilized, produced, and translated through a variety of cultures. As such, it is always open to interpretation and struggle. As Stuart Hall points out, national identity "is a matter of 'becoming' as well of 'being'. . . . [It] is never complete, always in process. . . . [It] is not eternally fixed in some essentialized past [but] subject to the continuous 'play' of history, culture, and power."[26]

The discourse of multiculturalism represents, in part, the emergence of new voices that have generally been excluded from the histories that have defined our national identity. Far from being a threat to social order, multiculturalism in its various forms has challenged notions of national identity that equate cultural differences with deviance and disruption. Refusing a notion of national identity constructed on the suppression of cultural differences and social dissent, multiculturalism, especially its more critical and insurgent versions, explores how dominant views of national identity have been developed around cultural differences. Such differences are constructed within hierarchical relations of power that authorize who can or cannot speak legitimately as an American. Maybe it is the insertion of politics and power back into the discourse on difference that threatens Rorty so much that he responds to it by labeling it as unpatriotic.

Pitting national identity against cultural difference not only appeals to an oppressive politics of common culture, but reinforces a political moralism that polices "the boundaries of identity, encouraging uniformity and ensuring intellectual inertia."[27] National identity based on a unified cultural community suggests a dangerous relationship between the ideas of race, intolerance, and the cultural membership of nationhood. Not only does such a position downplay the politics of culture at work in nationalism, but it erases an oppressive history forged in an appeal to a common culture and a reactionary notion of national identity. As Will Kymlicka points out, liberals and conservatives often overlook the fact that the American government "forcibly incorporated Indian tribes, native Hawaiians, and Puerto Ricans into the American state, and then attempted to coercively assimilate each group into the common American culture. It banned the speaking of Indian languages in school and forced Puerto Rican and Hawaiian schools to use English rather than Spanish or Hawaiian."[28]

What is problematic about Rorty's position is not simply that he views multiculturalism as a threat to a totalizing notion of national identity. More important is his theoretical indifference to counter-narratives of difference, diaspora, and cultural identity that explore how diverse groups are constructed within an insurgent multiculturalism that engages the issue both of what holds us together as a nation and of what constitutes our differences from each other. Viewing cultural differences only as a problem, Rorty reveals a disturbing lacuna in his notion of national identity; it is a view that offers little defense against the forces of ethnic absolutism and cultural racism that are so quick to seize upon national identity as a legitimating discourse for racial violence. There is an alarming defensiveness in Rorty's view of national identity, one which reinforces rather than challenges a discourse of national community rooted in claims to cultural and racist supremacy.

PEDAGOGY, NATIONAL IDENTITY, AND THE POLITICS OF DIFFERENCE

Critical educators need a notion of national identity that addresses its political, cultural, and pedagogical components. In the first instance, national identity must be addressed as part of a broader consideration linking nationalism and postnational social formations to a theory of democracy. That is, the relationship between nationalism and democracy must address not only the crucial issue of whether legal rights are provided for all groups

irrespective of their cultural identity, but also how structures of power work to ensure that diverse cultural communities have the economic, political, and social resources to exercise "both the capacity for collective voice and the possibility of differentiated, directly interpersonal relations."[29] Rather than waging war against the pluralization of cultural identities and the crucial spheres in which they are nurtured and engaged, educators must address critically how national identity is constructed in the media, through the politics of state apparatuses and through the mobilization of material resources and power outside of the reach of the state.[30] As part of a broader politics of representation, this suggests the need for progressive cultural workers to provide the pedagogical conditions and sites "open to competing conceptualizations, diverse identities, and a rich public discourse" necessary to expand the conditions for democracy to flourish on both a national and global level.[31]

Second, national identity must be inclusive and informed by a democratic pluralization of cultural identities. If the tendency towards a universalizing, assimilative impulse is to be resisted, educators must ensure that students engage varied notions of an imagined community by critically addressing rather than excluding cultural differences. While the approach towards such a pedagogy is culturally inclusive and suggests expanding the varied texts that define what counts as knowledge in public schools and institutions of higher education in the United States, there is also the need to create institutionalized spaces obligated to transdisciplinarity and multicultural studies. But such pedagogical spaces must be firmly committed to more than a politics of inclusive representation or simply aimed at helping students to understand and celebrate cultural difference (e.g., Martin Luther King Jr. Day). The politics of cultural difference must be a politics of more than texts, it must also understand, negotiate, and challenge differences as they are defined and sustained within oppressive networks of power. Critically negotiating the relationship between national identity and cultural differences, as Homi Bhabha has pointed out, is a negating activity that should be valued for **making** a difference in the world rather than merely reflecting it.[32]

What educators need is a pedagogy that redefines national identity not through a primordial notion of ethnicity or a monolithic conception of culture, but as part of a postmodern politics of cultural difference in which identities are constantly being negotiated and reinvented within complex

and contradictory notions of national belonging. A collective dialogue over nationalism, national identity, and cultural differences is not going to be established by simply labeling certain forms of social criticism as unpatriotic or national identity as a shared tradition that exists outside of the struggles over representation, democracy, and social justice. If American society is to move away from its increasing defensiveness about cultural differences, it will have to advocate a view of national identity that regards bigotry and intolerance as the enemy of democracy and regards cultural differences as one of its strengths. However, even where such differences are acknowledged and affirmed, it is important to recognize that they cannot be understood exclusively within the language of culture and identity, but rather as a part of an ethical discourse that contributes to a viable notion of democratic public life. Among other things, this suggests a need for a pedagogy and language through which values and social responsibility can be discussed not simply as a matter of individual choice or reduced to complacent relativism, but as a social discourse and pedagogical practice grounded in public struggles. David Theo Goldberg is right in arguing that educators need a "robustly nuanced conception of relativism underpinning the multicultural project, [one that] will enable distinctions to be drawn between more or less accurate truth claims and more or less justifiable values (in contrast to absolute claims to the truth or the good)."[33] The issue here is not merely the importance of moral pragmatism in developing a pedagogy that addresses national identity as a site of resistance and reinvention. Equally important is the political and pedagogical imperative of developing a postmodern notion of democracy in which students and others will be attentive to negotiating and constructing the social, political, and cultural conditions for diverse cultural identities to flourish within an increasingly multicentric, international, and transnational world.

In short, if national identity is not to be used in the service of demagogues, it must be addressed pedagogically and politically in order to unravel how cultural differences have been constructed within the unequal distribution of resources, and how such differences need to be understood around issues of power and struggle. National identity must be taken up in ways that challenge economic and cultural inequality while providing for young people a notion of national and global identity that fights against bigotry and for democracy.

NOTES

NOTES

INTRODUCTION:
THE KIDS AREN'T ALRIGHT:
YOUTH, PEDAGOGY, AND
CULTURAL STUDIES

1. Shoshana Felman and Dori Laub, *Testimony: Crisis of Witnessing in Literature, Psychoanalysis and History* (New York: Routledge, 1992), p. 53.

2. George Lipsitz, "We Know What Time It Is: Race, Class and Youth Culture in the Nineties," in Andrew Ross and Tricia Rose, Eds., *Microphone Fiends: Youth Music & Youth Culture* (New York: Routledge, 1994) p. 17.

3. George Lipsitz is instructive on this issue. He notes that:

Nationwide, the number of children living in poverty increased by 2.2 million between 1979 and 1989. Child poverty among European-Americans increased from 11.8 percent to 14.8 percent, among Latinos from 28 percent to 32 percent, and among blacks from 43.7 percent to 51.2 percent.... Despite endless rhetoric about "family values" and "protecting our children," the wealthiest and most powerful forces in our society have demonstrated by their actions that they feel that young people do not matter, that they can be our nation's lowest proirity. From tax cuts that ignore pressing needs and impose huge debts on the adults of tomorrow in order to subsidize the greed of today's adult property owners, to systematic disinvestment in schools, the environment and industrial infrastructure, the resources of the young are being cannibalized to pay for the irresponsible whims and reprehensible avarice of a small group of wealthy adults.

George Lipsitz, op. cit, Microphone Fiends, p. 18.

Conservatives demonize youth as they pass legislation that undermines their life chances in society. For instance, the 1994 Republican-controlled Congress calls for legislation that cuts $7 billion from the U.S. Department of Housing and Urban Development, 17 percent of $1.1 billion for Title I programs for the most disadvantaged learners, and $266 million or 60 percent of the funding for the Safe and Drug-Free Schools Program.

For specific figures outlining budget cuts that affect the poor and disadvantaged, mostly children, in society, see Michael Grunwald, "Low-Rent, Low-Income Plight Worsens," The Boston Globe (Monday, July 24, 1995), Section, Nation, p. 3. Also, see Albert Shanker, "Drawing the Line," New York Times (Sunday, July 23, 1995), E7.

4. "American Survey: Generation X-onomics," The Economist (March 19, 1994), p. 27.

5. Paul Gilroy, "'After the Love Has Gone': Bio-Politics and Ethno-poetics in the Black Public Sphere," Public Culture 7:1 (1994), pp. 65–66.

6. This is developed in Stanley Aronowitz and Henry A. Giroux, Education Still Under Siege (Westport, CT: Bergin and Garvey, 1993).

7. For two interesting analyses of this issue, see Doug Kellner, Media Culture: Cultural Studies, Identity, and Politics Between the Modern and the Postmodern (New York: Routledge, 1995); Angela McRobbie, Postmodernism and Popular Culture (New York: Routledge, 1995).

8. John Fiske, Power Plays, Power Works (London: Verso Press, 1994), pp. 58–59.

9. The literature is far too vast to cite here, but four classic examples are Stuart Hall and Tony Jefferson, Eds., Resistance Through Rituals (London: Hutchinson, 1976); Dick Hebdige, Subculture:

The Meaning of Style (London: Routledge, 1979); Paul Willis, Learning to Labor (New York: Columbia University Press, 1982); Angela McRobbie, Feminism and Youth Culture: From Jackie to Just Seventeen (London: McMillan, 1991).

10. Benita Perry, "The Contradictions of Cultural Studies," Transition, No. 53 (1991), p. 45.

11. I provide a detailed critique of this issue in Henry A. Giroux, Schooling and the Struggle for Public Life (Minneapolis: University of Minnesota Press, 1988). See also, Stanley Aronowitz and Henry A. Giroux, Education Still Under Siege (Wesport, CT: Bergin and Garvey, 1993).

12. I take up this issue in detail in Henry A. Giroux, Disturbing Pleasures: Learning Popular Culture (New York: Routledge, 1994).

13. Feminist theorists have been making this point for years. For an example of some of this work as it is expressed at the intersection of cultural studies and pedagogy, see the various articles in Henry A. Giroux and Peter McLaren, Eds. Between Borders: Pedagogy and the Politics of Cultural Studies (New York: Routledge, 1993).

14. Lawrence Grossberg, Cary Nelson, and Paula Treichler, "Cultural Studies: An Introduction," in Cultural Studies, Eds. Lawrence Grossberg, Cary Nelson, and Paula Treichler. (New York: Routledge, 1992), p. 5.

15. Tony Bennett, "Putting Policy into Cultural Studies," in Cultural Studies, Eds. Grossberg, et al., p. 32.

16. The relationship between cultural studies and relations of government are taken up in Bennett, "Putting Policy into Cultural Studies," in Cultural Studies, Eds. Grossberg, et al., pp. 23–34.

17. For representative examples of the diverse issues taken up in the field of cultural studies, see Lawrence Grossberg, Cary Nelson, and Paula Treichler, Eds., Cultural Studies (New York: Routledge, 1992); Simon During, Ed. The Cultural Studies Reader (New York: Routledge, 1993).

18. This is especially true of some of the most ardent critics of higher education. A representative list includes: William J. Bennett, To Reclaim a Legacy: A Report on the Humanities in Higher Education (Washington, D.C.: National Endowment for the Humanities, 1984); Stephen H. Balch and Herbert London, "The Tenured Left," Commentary 82:4 (October 1986), pp. 41–51; Lynne V. Cheney, Tyrannical Machines: A Report on Education Practices Gone Wrong and Our Best Hopes for Setting Them Right (Washington, D.C.: National Endowment for the Humanities, 1990); Roger Kimball, Tenured Radicals: How Politics Has Corrupted Our Higher Education (New York: Harper & Row, 1990); Dinesh D'Souza, Illiberal Education: The Politics of Race and Sex on Campus (New York:

Free Press, 1991). For a highly detailed analysis of the web of conservative money, foundations, and ideologies that connect the above intellectuals, see Ellen Messer-Davidow, "Manufacturing the Attack on Liberalized Higher Education," *Social Text*, No. 36 (Fall 1993), pp. 40–80.

19. I take up these issues in more detail in Henry A. Giroux, *Border Crossings* (New York: Routledge, 1992) and in *Disturbing Pleasures: Learning Popular Culture* (New York: Routledge, 1994).

20. Dick Hebdige, *Hiding in the Light* (New York: Routledge, 1988), pp. 17–18.

21. See Stanley Aronowitz, *Roll Over Beethoven: Return of Cultural Strife* (Hanover, NH: University Press of New England, 1993); Gayatri C. Spivak, *Outside in the Teaching Machine* (New York: Routledge, 1993); Jane Gallop, Ed., *Pedagogy* (Bloomington: Indiana University Press, 1995). See also a few articles in *Cultural Studies* edited by Grossberg, et al., op. cit. Also, see various issues of *College Literature* under the editorship of Kostas Myrsiades. It is quite revealing to look into some of the latest books on cultural studies and see no serious engagement of pedagogy as a site of theoretical and practical struggle. In David Punter, Ed., *Introduction to Contemporary Cultural Studies* (New York: Longman, 1986), there is one chapter on

identifying racism in textbooks. For more recent examples, see: Patrick Brantlinger, *Crusoe's Footprints: Cultural Studies in Britain and America* (New York: Routledge, 1990); Graeme Turner, *British Cultural Studies* (London: Unwin Hyman, 1990); John Clarke, *New Times and Old Enemies* (London: HarperCollins, 1991); Sarah Franklin, Celia Lury, and Jackie Stacey, Eds., *Off-Centre: Feminism and Cultural Studies* (London: HarperCollins, 1991). In the following books published in 1993, there is not one mention of pedagogy: Simon During, Ed., *The Cultural Studies Reader* (New York: Routledge, 1993); Valda Blundell, John Shepherd, and Ian Taylor, Eds., *Relocating Cultural Studies* (New York: Routledge, 1993).

22. I have in part answered this question in my book *Disturbing Pleasures*. It is worth repeating:

> One answer may lie in the refusal of cultural studies theorists to either take schooling seriously as a site of struggle or to probe how traditional pedagogy produces particular social histories, how it constructs student identities through a range of subject positions. Of course, within radical educational theory, there is a long history of developing critical discourses of the subject around pedagogical issues.
>
> Another reason cultural studies theorists have devoted little attention to pedagogy may be due to the disciplinary policing that leaves the marks of its legacy on all areas of the humanities and liberal arts. Pedagogy

is often deemed unworthy of being taken up as a serious project; in fact, even popular culture has more credibility than pedagogy. This can be seen not only in the general absence of any discussion of pedagogy in cultural studies texts, but also in those studies in the humanities that have begun to engage pedagogical issues. Even in these works there is a willful refusal to acknowledge some of the important theoretical gains in pedagogy that have gone on in the last twenty years. Within this silence lurks the seductive rewards of disciplinary control, a refusal to cross academic borders, and a shoring up of academic careerism, competitiveness, and elitism. Of course, composition studies, one of the few fields in the humanities that does take pedagogy seriously, occupies a status as disparaging as the field of education. Hence, it appears that the legacy of academic elitism and professionalism still exercises a strong influence on the field of cultural studies, in spite of its alleged democratization of social knowledge. [pp. 130–131]

23. Raymond Williams, *What I Came To Say* (London: Hutchinson-Radus, 1989), p. 158.

24. John Fiske, *Power Plays, Power Works* (London: Verso Press, 1994), p. 20.

25. Larry Grossberg goes so far as to argue that cultural studies "sees both history and its own practice as the struggle to produce one context out of another, one set of relations out of another." Lawrence Grossberg, "Cultural

Studies and/in New Worlds," *Critical Studies in Mass Communications* (forthcoming), p. 4.

26. Raymond Williams, *Communications*, revised edition (New York: Barnes and Noble, Inc., 1967), pp. 14–15.

27. Roger I. Simon, *Teaching Against the Grain* (New York: Bergin and Garvey, 1992), p. 15.

28. It is important to stress that the concept of pedagogy must be used with respectful caution. While there are different versions of what constitutes critical pedagogy, there are important theoretical insights and practices that weave through various approaches to it. It is precisely these insights brought to bear on a common set of problems that serve to delineate critical pedagogy as a set of conditions articulated within the shifting context of a particular political project. These problems include but are not limited to the relationship between knowledge and power, language and experience, ethics and authority, student agency and transformative politics, and teacher location and student formations.

29. Ruth Conniff, "The Culture of Cruelty," *The Progressive* (September 16, 1992), pp. 16–20.

CHAPTER ONE:
WHITE PANIC AND THE RACIAL CODING OF VIOLENCE

1. See the November 29, 1993, issue of *Newsweek*. Of course, the issue that is often overlooked in

associating gangsta rap with violence is that "gangsta rap does not appear in a cultural vacuum, but, rather, is expressive of the cultural crossing, mixing, and engagement of black youth culture with the values, attitudes, and concerns of the white majority." Quoted in bell hooks, "Sexism and Misogyny: Who Takes the Rap?" *Z Magazine* (February 1994), p. 26. See also Greg Tate's spirited defense of rap in Greg Tate, "Above and Beyond Rap's Decibels," *New York Times*, Sunday, March 6, 1994, pp. 1, 36.

2. This is most evident in the popular media culture, where analysis of crime in the United State is almost exclusively represented through images of black youth. For example, in the May 1994 issue of *The Atlantic Monthly*, the cover of the magazine shows a black urban youth, absent a shirt, with a gun in his hand staring out at the reader. The story the image is highlighting is about inner-city violence. The flurry of articles, magazines, films, and news stories about crime produced in 1994 focus almost exclusively on black youth both discursively and representationally.

3. Camille Colatosti, "Dealing Guns," *Z Magazine* (January 1994), p. 59.

4. Holly Sklar, "Young and Guilty by Stereotype," *Z Magazine* (July/August 1993), p. 52.

5. Stanley Aronowitz, "A Different Perspective on Educational Inequality," *The Review of Education/ Pedagogy/Cultural Studies* 16:2, (1994), pp. 135–151.

6. Stanley Aronowitz and Henry A. Giroux, *Education Still Under Siege* (Westport, CT: Bergin and Garvey, 1993), pp. 4–5.

7. These quotes and comments are taken from a stinging analysis of Kaus in Jonathan Kozol, "Speaking the Unspeakable," unpublished manuscript. The context for Kaus's remarks is developed in Mickey Kaus, *The End of Equality* (New York: Basic Books, 1992).

8. Paul Virilio, *Lost Dimension*, Trans., Daniel Moshenberg (New York: Semiotext(e), 1991).

9. See especially Tricia Rose, *Black Noise: Rap Music and Black Culture in Contemporary America* (Hanover, NH: University Press of New England, 1994); Andrew Ross and Tricia Rose, Eds., *Microphone Fiends: Youth Music and Youth Culture* (New York: Routledge, 1994).

10. See for example Max Horkheimer and Theodor Adorno, *Dialectic of Enlightenment* (New York: Seabury, 1972), particularly the chapter on mass culture.

11. Walter Parkes, "Random Access, Remote Control," *Omni* (January 1994), p. 54.

12. The ways in which rap artists have creatively appropriated and

used technology is taken up in Tricia Rose, *Black Noise: Rap Music and Black Culture in Contemporary America* (Hanover, NH: University Press of New England, 1994).

13. This section of the paper draws from: Henry A. Giroux, "Slacking Off: Border Youth and Postmodern Education," *Journal of Advanced Composition*, 14:2 (Fall 1994), pp. 35–46.

14. Carol Anshaw, "Days of Whine and Poses," *Village Voice* (November 1992), p. 27.

15. For a critique of the so-called twenty-something generation as defined by *Time*, *U.S. News*, *Money*, *Newsweek*, and *The Utne Reader*, see Chris de Bellis, "From Slackers to Baby Busters," *Z Magazine* (December 1993), pp. 8–10.

16. Jon Pareles, "They're Rebels Without a Cause and Couldn't Care Less," *New York Times*, Section 2 (July 16, 1995), pp. 1, 23.

17. Andrew Kopkind, "Slacking Toward Bethlehem," *Grand Street*, No. 44 (1992), p. 183.

18. It is important to recognize that discourses about Gen Xers, slackers, and grunge rockers focus almost exclusively on white youth who are dispirited over a future in which they will not have the power that an older generation of middle-class whites currently exercises in contemporary society.

19. The contours of this type of criticism are captured in a comment by Andrew Kopkind, a keen observer of slacker culture.

> The domestic and economic relationships that have created the new consciousness are not likely to improve in the few years left in this century, or in the years of the next, when the young slackers will be middle-agers. The choices for young people will be increasingly constricted. In a few years, a steady job at a mall outlet or a food chain may be all that's left for the majority of college graduates. Life is more and more like a lottery—is a lottery—with nothing but the luck of the draw determining whether you get a recording contract, get your screenplay produced, or get a job with your M.B.A. Slacking is thus a rational response to casino capitalism, the randomization of success, and the utter arbitrariness of power. If no talent is still enough, why bother to hone your skills? If it is impossible to find a good job, why not slack out and enjoy life?

Andrew Kopkind, "Slacking Toward Bethlehem," *Grand Street*, No. 44 (1992), p. 187.

20. George Lipsitz, "We Know What Time It Is," in Andrew Ross and Tricia Rose, Eds., *Microphone Fiends: Youth Music and Youth Culture* (New York: Routledge, 1994), p. 19.

21. For an analysis of black American cinema in the 1990s, see Ed Guerrero, "Framing Blackness: The African-American Image in the Cinema of the Nineties," *Cineaste*, 20:2 (1993), pp. 24–31.

22. Michael Dyson, "The Politics of Black Masculinity and the Ghetto in Black Film," in Carol Becker, Ed., *The Subversive Imagination: Artists, Society, and Social Responsibility* (New York: Routledge, 1994), p. 155.

23. Dyson, "The Politics of Black Masculinity," p. 163.

24. Itabari Njeri, "Untangling the Roots of the Violence Around Us—On Screen and Off," *Los Angeles Times Magazine* (August 29, 1993), p. 33.

25. Cornel West, "Nihilism in Black America," in Gina Dent, Ed., *Black Popular Culture* (Seattle: Bay Press, 1992), p. 40.

26. Itabari Njeri, "Untangling the Roots of the Violence Around Us—On Screen and Off," p. 34.

27. Fabienne Worth, "Postmodern Pedagogy in the Multicultural Classroom: For Inappropriate Teachers and Imperfect Spectators," *Cultural Critique*, No. 25 (Fall 1993), p. 27.

28. Pierce Hollingsworth, "The New Generation Gaps: Graying Boomers, Golden Agers, and Generation X," *Food Technology* 47:10 (October 1993), p. 30.

29. I have called this elsewhere the pedagogy of commercialism. See Henry A. Giroux, *Disturbing Pleasures: Learning Popular Culture* (New York: Routledge, 1994).

30. For an analysis of the relationship among modernist schooling, pedagogy, and popular culture, see Henry A. Giroux and Roger I. Simon, "Popular Culture as a Pedagogy of Pleasure and Meaning," in Henry A. Giroux and Roger Simon, Eds., *Popular Culture, Schooling, & Everyday Life* (Granby, MA: Bergin and Garvey, 1989), pp. 1–30; Henry A. Giroux and Roger Simon, "Schooling, Popular Culture, and a Pedagogy of Possibility," in Giroux and Simon, Eds., *Popular Culture, Schooling, & Everyday Life,* pp. 219–236.

31. Anyone who has been following the culture wars of the last decade is well aware of the conservative agenda for reordering public and higher education around the commercial goal of promoting economic growth for the nation while simultaneously supporting the values of Western civilization as a common culture designed to undermine the ravages of calls for equity and multiculturalism. For a brilliant analysis of the conservative attack on higher education, see Ellen Messer-Davidow, "Manufacturing the Attack on Liberalized Higher Education," *Social Text*, No. 36 (Fall 1993), pp. 40–80.

32. This argument is especially powerful in the work of Edward Said, who frames the reach of culture as a determining pedagogical force against the backdrop of the imperatives of colonialism. See Edward Said, *Culture and Imperialism* (New York: Alfred A. Knopf, 1993).

33. Selective examples of this work include: Carol Becker, Ed., *The Subversive Imagination* (New York: Routledge, 1994); Henry Giroux and Peter McLaren, Eds., *Between Borders: Pedagogy and the Politics of Cultural Studies* (New York: Routledge, 1994); Roger Simon, *Teaching Against the Grain* (Westport, CT: Bergin and Garvey, 1992); David Trend, *Cultural Pedagogy: Art/Education/Politics* (Westport, CT: Bergin and Garvey, 1992); James Schwoch, Mimi White, and Susan Reilly, *Media Knowledge: Readings in Popular Culture, Pedagogy, and Critical Citizenship* (Albany: SUNY Press, 1992); Lawrence Grossberg, *We Gotta Get Out of This Place: Popular Conservatism and Postmodern Culture* (New York: Routledge, 1992). See also Douglas Kellner, *Media Culture* (New York: Routledge, 1995); Jeanne Brady, *Schooling Young Children* (Albany: SUNY Press, 1995).

34. Stuart Hall, "Race, Culture, and Communications: Looking Backward and Forward at Cultural Studies," *Rethinking Marxism* 5:1 (Spring 1992), p. 11.

35. Peter Hitchcock, "The Othering of Cultural Studies," *Third Text*, No. 25 (Winter 1993–1994), p. 12.

36. Walter Parkes, "Random Access, Remote Control: the Evolution of Story Telling," *Omni* (January 1994), p. 50.

37. Stuart Hall, "Race, Culture, and Communications," p. 14.

CHAPTER TWO:
RACISM AND THE AESTHETIC OF HYPER-REAL VIOLENCE: *PULP FICTION* AND OTHER VISUAL TRAGEDIES

1. Edward S. Herman, "The New Racist Onslaught," *Z Magazine* 7:12 (December 1994), p. 24.

2. Holly Sklar, "Young and Guilty by Stereotype," *Z Magazine* 6:7/8 (July/August 1993), p. 53.

3. This issue is taken up in Christian Parenti, "Urban Militarism," *Z Magazine* 7:6 (June 1994), pp. 47–52.

4. Laurie Asseo, "Statistics on Black Crime Victims Released," *Boston Globe*, December 9, 1994, p. 3.

5. The media bashing of youth is taken up in great detail in Mike Males, "Bashing Youth: Media Myths About Teenagers," *Extra* (March/April 1994), pp. 8–14.

6. "Violence Targets America's Youth," *Centre Daily Times*, July 18, 1994, p. 4.

7. Ed Guerrero, "Framing Blackness: The African-American Image in the Cinema of the Nineties," *Cineaste* 20:2 (1993), p. 30.

8. Robert Stam and Ella Shohat, "Contested Histories: Eurocentrism, Multiculturalism, and Media," in David Theo Goldberg, Ed., *Multiculturalism: A Critical Reader* (Cambridge: Basil Blackwell, 1994), p. 319.

213

9. George Gerbner, "Miracles of Communication Technology: Powerful Audiences, Diverse Choices, and Other Fairy Tales," Janet Waski, et al., Eds., *Illuminating the Blind Spots* (New York: Ablex, 1993), p. 371. See also George Gerbner, Larry Gross, Michael Morgan, and Nancy Signorielli, "Growing Up with Television: The Cultivation Perspective," in Jennings Bryant and Dolf Zillmann, Eds., *Media Effects: Advances in Theory and Research* (Hillsdale, NJ: Lawrence Erlbaum Associates, Inc., 1993), pp. 17–41.

10. Elizabeth Kolbert, "Television Gets Closer Look As a Factor in Real Violence," *New York Times*, December 4, 1994, p. D20.

11. Anne Nelson, "Colours of Violence," *Index on Censorship* 23:162 (May/June 1994), p. 86.

12. Rustom Bharacuha, "Around Aydohya: Aberrations, Enigmas, and Moments of Violence," *Third Text* No. 24 (Autumn 1993), p. 48.

13. These figures come from a survey done by film critic Vincent Canby. Cited in Carl Nightingale, *On the Edge* (New York: Basic Books, 1993), pp. 170–171.

14. Vivian Sobchack cited in David McKinney, "Violence: The Strong and the Weak," *Film Quarterly* 46:4 (Summer 1993), pp. 16–22.

15. Rustom Bharacuha, "Around Aydohya: Aberrations, Enigmas, and Moments of Violence," *Third Text* No. 24 (Autumn 1993), pp. 51–52.

16. This issue is explored in Susan Jefford, *Hard Bodies: Hollywood Masculinity in the Reagan Era* (New Brunswick, NJ: Rutgers University Press, 1994).

17. Hannah Arendt, *Eichmann in Jerusalem: A Report on the Banality of Evil* (New York: Viking, 1963).

18. For a brilliant analysis of this culture, see David Theo Goldberg, *Racist Culture* (New York: Basil Blackwell, 1994). It is truly amazing the degree to which Goldberg's work is ignored by both the popular press and many academics who write about race, given that his writing far exceeds in both quality and insight most of what is being written about racism and Western culture.

19. See Gail Dines and Jean M. Humez, Eds., *Gender, Race, and Class in Media* (Thousand Oaks, CA: Sage, 1994); Charles Acland, *Youth, Murder, Spectacle: The Cultural Politics of "Youth in Crisis"* (Boulder, CO: Westview Press, 1995); John Fiske, *Media Matters* (Minneapolis: University of Minnesota Press, 1994).

20. In the midst of writing this article, the *New York Times Magazine* of December 18, 1994, appeared with a picture of a black woman on the front cover. The image provided the backdrop for a story on welfare.

21. Jim Naureckas, "Racism Resurgent: How Media Let *The Bell Curve*'s Pseudo-Science Define the Agenda on Race," *Extra!* 8:1 (January/February 1995), p. 12.

22. Holly Sklar, "Young and Guilty by Stereotype," *Z Magazine* 7:8 (July/August, 1993), p. 52.

23. On this issue, see Michael Dyson, *Reflecting Black: African-American Cultural Criticism* (Minneapolis: University of Minnesota Press, 1993); bell hooks, *Black Looks: Race and Representation* (Boston: South End Press, 1992).

24. Richard J. Herrnstein and Charles Murray, *The Bell Curve: Intelligence and Class Structure in American Life* (New York: Free Press, 1994), p. 526.

25. For a similar critique of the violence in Hollywood films such as *Natural Born Killers*, see "Knocking 'Em Dead At the Box Office: *Natural Born Killers*," *Border/Lines* No. 34/35 (1994), pp. 10–14.

26. It is worth noting that those positive and complex aspects of African-American life that constitute youth culture are rarely portrayed in Hollywood films. For example, representations that focus on how gangster rap "serves up white America's most cherished gun-slinging mythologies (heroic American dreams) in the form of its worst and blackest nightmares, while it empowers Black imaginations to negate the existential terror of ghetto life (and death) by sheer force of the will" are rarely acknowledged critically in the portrayal of black youth culture in the dominant media. Cited in Nick De Genova, "Gangster Rap and Nihilism in Black America: Some Questions of Life and Death," *Social Text* 13:2 (1995), p. 107.

27. Ernst Bloch, et al., "Adorno's Letter to Walter Benjamin— November 10, 1938," *Aesthetics and Politics* (London: New Left Books, 1977), p. 127.

28. For a brilliant commentary on "bigotry delivered as a joke by white men," see Derrick Z. Jackson, "Laughing off Racism," *Boston Globe*, May 24, 1995, p. 19.

29. Tarantino interviewed in Manhola Dargis, "A Bloody Pulp," *Vibe* (October 1995), p. 66.

30. David Denby, "A Thugfest," *New York* (October 3, 1994), p. 98.

31. Ruth Conniff, "The Culture of Cruelty," *The Progressive* 56:9 (September 1992), pp. 16–20.

32. Tarantino cited in Godfrey Cheshire, "Hollywood's New Hit Men," *Interview* (September 1994), p. 130.

33. Peter Travers, "Tarantino's Twist," *Rolling Stone*, No. 692 (October 6, 1994), p. 80.

34. Rustom Bharacuha, "Around Aydohya: Aberrations, Enigmas, and Moments of Violence," p. 50.

215

35. On the relationship of parody to art forms, see Linda Hutcheon, *A Theory of Parody* (New York: Routledge, 1991).

36. Rustom Bharacuha, "Around Aydohya: Aberrations, Enigmas, and Moments of Violence," p. 50.

37. Tarantino quoted in Tony Crawley, "Quentin Tarantino," *Film Review* (November 1994), p. 32.

38. Tarantino cited in Peter McAlevey, "All's Well that Ends Gruesomely," *New York Times Magazine* (December 6, 1992), p. 80.

39. Cited in Peter Biskind, "An Auteur is Born," *Premiere* (November 1994), p. 100.

40. Amy Taubin, "Eight Critics Talk About Violence and the Movies," *The Village Voice Film Special* (December 1, 1992), p. 10.

41. David Kehr, "Eight Critics Talk About Violence and the Movies," *The Village Voice Film Special* (December 1, 1992), p. 8.

42. Cited in Manohla Dargis, "A Bloody Pulp," *Vibe* (October 1995), p. 66.

43. Ice Cube cited in Robin D.G. Kelley, *Race Rebels* (New York: Free Press, 1994), pp. 209–210.

44. See Robin Kelley, ibid., especially pages 209–214.

45. bell hooks, *Yearning: Race, Gender and Cultural Politics* (Boston: South End Press, 1990), p. 177. It certainly escaped Harvard University law professor Alan A. Stone, who in his review of *Pulp Fiction* argues that:

> *Although Tarantino wants to shock us with violence, his film is politically correct. There is no nudity and no violence directed against women; in fact a man, the crime boss, gets raped and the only essentially evil people in the film are two sadistic honkies straight out of* Deliverance *who do the raping. The film celebrates interracial friendship and cultural diversity [my emphasis]; there are strong women and strong Black men, and the director swims against the current of class stereotype.*

Alan A. Stone, "Pulp Fiction," *The Boston Review* 20:2 (April/May 1995), pp. 24–25.

This is an amazing analysis, especially since it is a black youth who gets his head blown off in the back of a car, the one black woman who appears in the film is faceless, and the film is laced with racist language. But the silence about racism in this critique is equally matched by a refusal to acknowledge the demeaning portrayal of women. For example, "Honey Bunny" and the drug dealer's wife are respectively portrayed as either drug snorting and reckless or as violent and hysterical sociopaths.

46. Gary Indiana, "Geek Chic," *Artforum* 38:7 (March 1995), pp. 64–65.

47. For an interesting analysis of Tarantino's view on women, see Robin Wood, "Slick Shtick,"

Artforum 38:7 (March 1995),
pp. 63–66, 110; and bell hooks,
"Cool Tool," *Artforum* 38:7
(March 1995),
pp. 63–66, 110.

48. Cited in Lisa Kennedy, "Natural
Born Filmmaker," *Village Voice*
(October 25, 1994), p. 32.

49. Rustom Bharacuha, "Around
Aydohya," p. 56.

50. Herbert I. Schiller, *Culture Inc.*
(New York: Oxford University
Press, 1989).

51. Dole's speech cited in Adam
Petman, "Hollywood Angered
by Dole's Attack on Its 'Evil'
Offerings," *Boston Globe*, June 2,
1995, pp. 1, 20. John M. Broder,
"Dole Blasts 'Deviancy'
in Hollywood Films, Music,"
Boston Globe, June 2, 1995, p. 1.

52. Cited in "Faces of Violence,"
Rolling Stone, No. 710 (June 15,
1995), p. 60.

53. Ellen Goodman, "A New Cast,
Same Script," *Boston Globe*, June 8,
1995, p. 18. On the sheer
hypocrisy of Dole's remarks, see
Derrick Jackson, "Sen. Dole's
Amazon of Hypocrisy," *Boston
Globe*, June 9, 1995, p. 23.

54. Susan E. Neff, "Two Killed, Six
Others Hurt in Rash of Boston
Shootings," *Boston Globe* (July 15,
1995), p. 21.

55. Michael Roth, "Violence and the
De-Meaning of America," *Tikkun*
9:1 (1994), p. 87.

CHAPTER THREE:
ANIMATING YOUTH:
THE DISNEYFICATION
OF CHILDREN'S CULTURE

1. Of course, I recognize that only
within the last decade has it
become possible to obtain ani-
mated films on an everyday
basis. Also, animation as a partic-
ular representational form has
not been adequately theorized.
At the same time, I think crucial
spheres of children's culture,
outside of schooling, have not
received the attention they
deserve by cultural theorists.

2. Of course, cultural studies has a
long tradition of focusing on the
related issues of youth subcul-
tures and resistance, particularly
in relation to schools and the
workplace. But it is only recently
that critics have begun to address
in more expansive theoretical
terms how young children are
socialized within the broader
parameters and sites that consti-
tute the changing pedagogical
conditions of a postmodern/pop-
ular culture. The point here is that
social critics, including cultural
theorists, with few exceptions
write social theory according to
the presuppositions that everyone
is an adult. Jane Flax points to this
problem, for instance, in her cri-
tique of the overall body of femi-
nist theory. She writes: "For
example in [recent work] on
feminist theory focusing on
mothering and the family, there is

almost no discussion of children as human beings or mothering as a relation between persons. The modal 'person' in feminist theory still appears to be a self-sufficient individual adult." Jane Flax, "Postmodernism and Gender Relations," in Linda J. Nicholson, Ed., *Feminism/Postmodernism* (New York: Routledge, 1990), p. 54. Of course, there are exceptions to this rule; see Lauren Berlant, "The Theory of Infantile Citizenship," *Public Culture* 5:3 (Spring 1993), pp. 395–410; and Francesca Polletta, "Politicizing Childhood: The 1980 Zurich Burns Movement," *Social Text*, No. 33 (1992), pp. 82–102. For a brilliant work on children's culture, see Stephen Kline, *Out of the Garden: Toys and Children's Culture in the Age of TV Marketing* (London: Verso Press, 1995). Representative works also include: Marsha Kinder, *Playing with Power in Movies, Television, and Video Games* (Berkeley: University of California Press, 1991); Ellen Seiter, *Sold Separately: Parents and Children in Consumer Culture* (New Brunswick, NJ: Rutgers University Press, 1993); Christine Griffen, *Representations of Youth* (London: Polity Press, 1993); Angela McRobbie, *Postmodernism and Popular Culture* (New York: Routledge, 1994); Charles R. Ackland, *Youth, Murder, Spectacle* (Boulder, CO: Westview Press, 1995).

3. This is not to suggest that I believed that the world of fantasy, amusement, and entertainment could be abstracted from ideology. On the contrary, I simply did not address such ideologies as serious objects of analysis. For a critical engagement of commercialization, popular culture, and children's culture, see Marsha Kinder, *Playing With Power in Movies, Television, and Video Games* (Berkeley: University of California Press, 1991); Doug Kellner, *Media Culture* (New York: Routledge, 1995).

4. The reactionary notion that single parents or "broken" families are the source of all social ills has become a staple of both Disney films as well as standard Hollywood studio fare. Two recent Disney examples capitalizing on the virtues of "intact" families would include *I Love Trouble* (1994), which suggests that conflict between competing heterosexuals can only be resolved within marriage; *Angels in the Outfield* (1994), which posits divine intervention on the side of creating an Ozzie and Harriet family for a precocious young baseball fan. In standard Hollywood fare, this theme is pushed to absurd lengths in films such as *Milk Money* (1994), where a prostitute finds happiness and romantic bliss in the promise of family life in the suburbs; and the 1994 film version of *Miracle on 34th Street*, which shamelessly rewrites a legendary film in order to hawk the virtues of child manipulation in construct-

ing a Dan Quayle version of the traditional family.

5. Cited in Bruce Hovovitz, "Company Has Cradle-to-Grave Sway," *USA TODAY* (September 7, 1995), B1. On the specific properties involved in the merger between Disney and Capital Cities/ABC, see Jack Thomas, "For Viewers, Changes Not Expected to be Big Deal," *Boston Globe* (August 1, 1995), pp. 33, 45, especially the chart on p. 45.

6. There is an ever-growing list of authors who have been pressured by Disney, either through the refusal to allow copyrighted materials to be used or through Disney's reputation, not to publish certain works. Examples can be found in Jon Wiener, "In the Belly of the Mouse: The Dyspeptic Disney Archives," *Lingua Franca* (July/August 1994), pp. 69–72. Also, Jon Wiener, "Murdered Ink," *The Nation* (May 31, 1993), pp. 743–750. One typical example occurred in a book in which one of my own essays on Disney appears. While in the process of editing a book critical of Disney, Laura Sells, Lynda Haas, and Elizabeth Bell requested permission from Disney executives to use the archives. In response, the editors received a letter from one of Disney's legal assistants asking to approve the book. The editors declined and Disney forbade the use of their name in the title of the book, and threatened to sue

if the Disney name were used. Indiana University Press argued that it did not have the resources to fight Disney and the title of the book was changed from *Doing Disney* to *From Mermaid to Mouse*. In another instance, Routledge decided to omit an essay by David Kunzle on the imperialist messages in Disney's foreign comics in a book entitled *Disney Discourse*. Fearing that Disney would not provide permission for illustrations from the Disney archives, Routledge decided they could not publish the essay without illustrations. Discouraged, Kunzle told Jon Wiener that "I've given up. I'm not doing any more work on Disney. I don't think any university press would take the risk. The problem is not the likelihood of Disney winning in court, it's the threat of having to bear the cost of fighting them." Kunzle cited in Wiener, "In the Belly of the Mouse," p. 72.

7. This figure comes from Michael Meyer, et al., "Of Mice and Men," *Newsweek* (September 5, 1994), p. 41.

8 . The mutually determining relationship of culture and economic power as a dynamic hegemonic process is beautifully captured by Sharon Zukin's work on Disney. She writes:

> The domestication of fantasy in visual consumption is inseparable from centralized structures of economic power. Just as the earlier power of the state

illuminated public space—the streets—
by artificial lamplight, so the economic
power of CBS, Sony, and the Disney
Company illuminates private space at
home by electronic images. With the
means of production so concentrated and
the means of consumption so diffused,
communication of these images becomes
a way of controlling both knowledge and
imagination, a form of corporate social
control over technology and symbolic
expressions of power."

In Sharon Zukin, Landscapes of
Power: From Detroit to Disney World
(Berkeley: University of
California Press, 1991), p. 221.

9. Cited in Mark Walsh, "Disney
Holds up School as Model for
Next Century," Education Week,
13:39 (June 22, 1994), p. 1.

10. Cited in Tom Vanderbilt, "Mickey
goes to Town(s)," The Nation
261:6 (August 28/September 4,
1995), p. 197.

11. Tom Vanderbilt, "Mickey Goes to
Town(s)," The Nation 261:6
(August 28/September 4, 1995),
p. 199.

12. Jean Baudrillard, Simulations (New
York: Semiotext(e), 1983), p. 25.
Also, see Jean Baudrillard,
"Consumer Society," in Mark
Poster, Ed., Jean Baudrillard: Selected
Works (Stanford, CA: Stanford
University Press, 1988),
pp. 29–56.

13. Eric Smoodin, "How to Read
Walt Disney," Disney Discourse:
Producing the Magic Kingdom (New
York: Routledge, 1994), p. 18.

14. Jon Wiener, "Tall Tales and True,"
The Nation (January 31, 1994),
p. 134.

15. Actually, Disney's animated film,
The Lion King, may be the most
financially successful film ever
made. Disney's animated films
released since 1990 have all been
included in the list of the top ten
grossing films. For example, Lion
King ranked first with $253.5 mil-
lion; Aladdin ranked second with
$217.4 million; and Beauty and the
Beast ranked seventh, grossing
$145.9 million. See Thomas
King, "Creative but Unpolished
Top Executive for Hire," Wall Street
Journal (August 26, 1994), p. B1.

16. Elizabeth Bell, Lynda Haas, Laura
Sells, "Walt's In the Movies," in
Elizabeth Bell, et. al., Eds. From
Mouse to Mermaid (Bloomington:
Indiana University Press,
1995), p. 3.

17. Barbara Foley, "Subversion and
Oppositionality in the Academy,"
in Maria-Regina Kecht, Ed.,
Pedagogy is Politics: Literary Theory
and Critical Teaching (Urbana:
University of Illinois Press,
1992), p. 79.

18. A number of recent authors
address Disney's imagined land-
scape as a place of economic and
cultural power. See, for example,
Sharon Zukin, Landscapes of Power:
From Detroit to Disneyland (Berkeley:
University of California Press,
1991); Michael Sorkin, "Disney
World: The Power of Facade/The
Facade of Power," in Michael

Sorkin, Ed., *Variations on a Theme Park* (New York: Noonday Press, 1992); and see the especially impressive, Stephen M. Fjellman, *Vinyl Leaves: Walt Disney World and America* (Boulder, CO: Westview Press, 1992).

19. Cited in Renee Graham, "Can Disney Do It Again?" *Boston Globe*, Arts Etc. Section (June 11, 1995), p.57. For similar figures see Thomas R. King, "Creative but Unpolished Top Executive for Hire," *Wall Street Journal* (Friday, August 26, 1994), p. B1; Jeff Giles, "A New Generation of Genies," *Newsweek* (September 5, 1994), p. 42.

20. The term "marketplace of culture" comes from Richard de Cordova, "The Mickey in Macy's Window: Childhood Consumerism and Disney Animation," in Eric Smoodin, Ed. *Disney Discourse: Producing the Magic Kingdom* (New York: Routledge, 1994), p. 209. It is worth noting that Disney was one of the first companies to tie the selling of toys to the consuming of movies. Challenging the assumption that toy consumption was limited to seasonal sales, Disney actively pursued creating Mickey Mouse Clubs, advertising its toys in storefront windows, and linking its movies directly to the distribution of children's toys.

21. Cited in Richard Corliss, "The Mouse that Roars," *Time* (June 20, 1994), p. 59.

22. Cited in Richard Turner, "Walt Disney Presents: Forward to the Future," *Wall Street Journal* (August 26, 1994), p. B1.

23. Sallie Hofmeister, "In the Realm of Marketing, the 'Lion King' Rules," *New York Times* (July 12, 1994), p. D1.

24. For an amazing summation of the merchandizing avalanche that accompanied the movie theater version of *The Lion King*, see Sallie Hofmeister, "In the Realm of Marketing, the 'Lion King' Rules," *New York Times* (July 12, 1994), pp. D1, D17.

25. Cited in Karen Schoemer, "An Endless Stream of Magic and Moola," *Newsweek* (September 5, 1994), p. 47.

26. Tom McNichol, "Pushing 'Pocahontas,'" *USA Weekend* (June 9–11, 1995), p. 4.

27. Tony Bennett touches on this issue through his rendering of the concept of reading formation. He argues, "The concept of reading formation is an attempt to think of context as a set of discursive and inter-textual determinations, operating on material and institutional supports, which bear in upon a text not just externally, from the outside in, but internally, shaping it—in the historically concrete forms in which it is available as a text-to-be-read—from the inside out." See Tony Bennett, "Texts in History: The Determinations

of Readings and Their Texts,"
in Derek Atridge, et al., Eds.,
*Poststructuralism and the Question of
History* (Cambridge: Cambridge
University Press, 1987), p. 72.

28. Critiques of Disney's portrayal
of girls and women can be
found in Elizabeth Bell, Lynda
Haas, and Laura Sells, Eds., *From
Mouse to Mermaid* (Bloomington:
Indiana University Press, 1995);
also see Susan White, "Split
Skins: Female Agency and Bodily
Mutilation in *The Little Mermaid*,"
in Jim Collins, Hilary Radner,
and Ava Preacher Collins, Eds.,
Film Theory Goes to the Movies
(New York: Routledge, 1993),
pp.182–195.

29. Bonnie J. Leadbeater and Gloria
Lodato Wilson, "Flipping Their
Fins for a Place to Stand: 19th-
and 20th-Century Mermaids,"
Youth and Society 27:4 (June 1993),
pp. 466–486.

30. Susan Jefford develops this read-
ing of *Beauty and the Beast* in Susan
Jefford, *Hard Bodies: Hollywood
Masculinity in the Reagan Era* (New
Brunswick, NJ: Rutgers
University Press, 1994), p. 150.

31. I would like to thank Valerie
Janesick for this insight.

32. Cited in June Casagrande, "The
Disney Agenda," *Creative Loafing*
(March 17–23, 1994), p. 6–7.

33. Upon its release in 1946, *Song
of the South* was condemned by
the NAACP for its racist repre-
sentations.

34. For a historical context in which
to understand Frontierland, see
Stephen M. Fjellman, *Vinyl Leaves*
(Boulder, CO: Westview Press,
1992).

35. These racist episodes are high-
lighted in Jon Wiener, "Tall Tales
and True," *The Nation* (January 31,
1994), pp. 133–135.

36. Yousef Salem cited in Richard
Scheinin, "Angry Over
'Aladdin,'" *Washington Post*
(January 10, 1993), p. G5.

37. Howard Green, a Disney
spokesperson, dismissed the
charges of racism as irrelevant,
claiming that such criticisms
were coming from a small
minority and that "most people
were happy with [the film]."
Cited in Richard Scheinin,
"Angry Over 'Aladdin',"
Washington Post (January 10,
1993), p. G1.

38. I have taken this criticism from
Jack Shaheen, "Animated Racism,"
Cineaste 20:1 (1993), p. 49.

39. See Susan Miller and Greg Rode,
who do a rhetorical analysis of
The Jungle Book and *Song of the South*
in their chapter, "The Movie
You See, The Movie You Don't:
How Disney Do's That Old Time
Derision," in Elizabeth Bell,
Lynda Haas, and Laura Sells,
Eds., *From Mouse to Mermaid*
(Bloomington: Indiana
University Press, 1995).

40. Edward Said, *Culture and Imperialism*
(New York: Alfred A. Knopf, 1993).

NOTES TO CHAPTER THREE

41. Susan Willis brilliantly explores this theme in Susan Willis, "Fantasia: Walt Disney's Los Angeles Suite," *Diacritics* Vol. 17 (Summer 1987), pp. 83–96.

42. George Gerbner, Larry Gross, Michael Borgan, and Nancy Signorielli, "Growing Up with Television: The Cultivation Perspective," in Jennings Bryant and Dolf Zillmann, Eds., *Media Effects: Advances in Theory and Research* (Hillsdale, NJ: Lawrence Erlbaum, 1995), p. 17.

43. David Buckingham, "Conclusion: Re-Reading Audiences," in David Buckingham, Ed., *Reading Audiences: Young People and the Media* (Manchester, UK: Manchester University Press, 1993), p. 211.

44. Cited in Sharon Zukin, op. cit, 1991, p. 222. While this quote refers to Disney's view of its theme parks, it represents an ideological view of history that strongly shapes all of Disney's cultural productions. For a comment on how it affects Disney's rendering of adult films, see Henry A. Giroux, *Disturbing Pleasures* (New York: Routledge, 1994), especially pp. 25–45.

45. Stephen M. Fjellman, *Vinyl Leaves* (Boulder, CO: Westview, 1992), p. 400.

46. Rustom Bharacuha, "Around Ayodhya: Aberrations, Enigmas, and Moments of Violence," *Third Text*, No. 24 (Autumn 1993), p. 51.

47. Tony Bennett, op. cit., p. 80.

48. Eric Smoodin, "How to Read Walt Disney," Eric Smoodin, Ed., *Disney Discourse: Producing the Magic Kingdom* (New York: Routledge, 1994), pp.4–5.

49. For an example of such an analysis, see Stanley Aronowitz, *Roll Over Beethoven* (Middletown, CT: Wesleyan University Press, 1993); Henry A. Giroux, *Disturbing Pleasures: Learning Popular Culture* (New York: Routledge, 1994).

50. Inderpal Grewal and Caren Kaplan, "Introduction: Transnational Feminist Practices and Questions of Postmodernity," in Inderpal Grewal and Caren Kaplan, Eds., *Scattered Hegemonies* (Minneapolis: University of Minnesota Press, 1994).

CHAPTER FOUR:
PUBLIC INTELLECTUALS AND
POSTMODERN YOUTH

1. Charles R. Acland, *Youth, Murder, Spectacle: The Cultural Politics of Youth in Crisis* (Boulder, CO: Westview, 1995), p. 4.

2. James Alan Fox, "A Disturbing Trend in Youth Crime," *Boston Globe*, June 1, 1995, p. 19.

3. Cited in Anthony Flint, "Some See Bombing's Roots in a US Culture of Conflict," *Boston Globe*, June 1, 1995, p. 22.

4. Matthew Arnold, "Sweetness and Light," in *The Complete Prose of Matthew Arnold*, vol. 5, Ed. R.H.

Super (Ann Arbor: University of
Michigan Press, 1960–1977),
p. 113.

5. Scott is worth quoting on this
issue:

> What we are witnessing these days is
> not simply a set of internal debates
> about what schools and universities
> should teach and what students should
> learn. Journalists and politicians have
> joined the fray and added a new
> dimension to it. There is much more at
> stake in their campaign against "polit-
> ical correctness" than a concern with
> excessive moralism, affirmative action
> and freedom of speech in the academy.
> Rather, the entire enterprise of the uni-
> versity has come under attack.

See Joan W. Scott, "Multicul-
turalism and the Politics of
Identity," *October* 61 (Summer
1992), p. 12.

6. For an analysis of this issue, see
Henry A. Giroux, *Border Crossings*
(New York: Routledge, 1992),
especially chapter 10, "Writing
Against the Empire."

7. Kramer is quoted in Janny Scott,
"Journeys From Ivory Tower:
Public Intellectual is Reborn,"
New York Times (National Edition),
August 9, 1994, p. A1.

8. The concept of cultural elite as
coined by various conservatives
becomes a code word for reject-
ing the liberal media as intellec-
tually snobbish—and by default
not populist enough. Cultural
elite also functions as a referent

for disparaging higher education
for opening its doors to profes-
sors who allegedly are too left-
leaning and who allegedly
exercise a damaging influence on
the young students who inhabit
their hallowed classrooms.

9. Russell Jacoby, *The Last Intellectuals*
(New York: Basic Books, 1987).

10. For an analysis of the journalistic
assault on academic professional-
ism, see Jim Collins, *Architectures of
Excess: Cultural Life in the Information
Age* (New York: Routledge,
1995), especially chapter 5,
pp. 187–222.

11. I take this issue up in Henry A.
Giroux, *Living Dangerously* (New
York: Lang, 1993). Of course,
the left has a long history of
being dismissive of the role
that academics might play as
public intellectuals. See Noam
Chomsky, "The Responsibility
of Intellectuals" (New York:
Pantheon, 1987, originally
published in 1966), pp. 59–82;
see also, Russell Jacoby, *The Last
Intellectuals: American Culture in the Age
of Academe* (New York: Basic Books,
1987). For a different view of
academics as public intellectuals,
see C. Wright Mills, *Power, Politics,
and People*, Introduction by Louis I.
Horowitz (New York: Ballantine
Books, 1963), especially "The
Social Role of the Intellectuals,"
pp. 292–304; Pierre Bourdieu,
Homo Academicus (Stanford, CA:
Stanford University Press, 1988);
Stanley Aronowitz and Henry

Giroux, *Education Still Under Siege* (Westport, CT: Bergin and Garvey, 1993).

12. Analyses of the university as a critical public sphere can be found in Stanley Aronowitz and Henry A. Giroux, *Education Still Under Siege* (Westport, CT: Bergin and Garvey, 1994).

13. Andrew Ross, "The Fine Art of Regulation," in Bruce Robbins, Ed., *The Phantom Public Sphere* (Minneapolis: University of Minnesota Press, 1993), p. 261.

14. Mariam Hansen, "Early Cinema, Late Cinema: Permutations of the Public Sphere," *Screen* 34:3 (Autumn 1993), p. 208.

15. Chantal Mouffe, *The Return of the Political* (London: Verso, 1993), p. 70.

16. There is a long tradition of anti-intellectualism in American society that has both excluded intellectuals from public debate and dismissed them when they attempted to influence public policy. See Richard Hofstadter, *Anti-Intellectualism in American Life* (New York: Vintage, 1963).

17. Irving Kristol, "The New Face of American Politics," *Wall Street Journal*, August 26, 1994, p. A10.

18. For a trenchant analysis of the political correctness movement, see Stanley Aronowitz, *Roll Over Beethoven: The Return of Cultural Strife* (Hanover: Wesleyan University Press, 1993), especially chapter 1.

19. Gerald Graff, "Teaching the Conflicts," Darryl J. Gless and Barbara Herrnstein Smith, Eds., *The Politics of Liberal Education* (Durham, NC: Duke University Press, 1992), pp. 57–73. For an incisive rebuttal by Paulo Freire of Graff's critique of critical pedagogy, see Paulo Freire and Donaldo Macedo, "A Dialogue: Culture, Language, and Race," *Harvard Educational Review* 65:3 (Fall 1995), pp. 377–402.

20. Peter Euben, "The Debate Over the Canon," *The Civic Arts Review* 7:1 (Winter 1994), pp. 14–15.

21. Edward Said, *Representations of the Intellectual* (New York: Pantheon, 1994), p. 11.

22. Vaclav Havel, "The Responsibility of Intellectuals," *New York Review of Books* 63:11 (June 22, 1995), p. 37.

23. Edward Said, *Representations of the Intellectual* (New York: Pantheon, 1994), p. 52–53.

24. R. Radhakrishnan, "Canonicity and Theory: Toward a Poststructuralist Pedagogy," in Donald Morton and Mas'ud Zavarzadeh, Eds., *Theory/Pedagogy/Politics* (Urbana: University of Illinois Press, 1991), pp. 112–35.

25. For an excellent critique of Said's position, see Jeff Williams, "Going It Alone: Edward Said's Romance of the Autonomous Intellectual," *The Review of Education/Pedagogy/Cultural Studies* (forthcoming).

26. The term "fugitive knowledge" is taken from a class discussion with Bob Hill, one of my graduate students. See also Robert J. Hill, "Fugitive and Codified Knowledge: The Struggle to Control the Meaning of Environmental Hazards" (unpublished paper, 6 pp.). Exemplary models for connecting symbolic resistance with actual struggle as both a pedagogical and political process can be found in the work of an emerging generation of artists who produce what Suzanne Lacy calls "new genre public art." See Suzanne Lacy, Ed., Mapping the Terrain: New Genre Public Art (Seattle: Bay Press, 1995). See also Carol Becker, The Subversive Imagination (New York: Routledge, 1994).

27. Stanley Aronowitz, "A Different Perspective on Educational Equality," The Review of Education/Pedagogy/Cultural Studies (forthcoming).

28. Henry A. Giroux, Living Dangerously: Multiculturalism and the Politics of Difference (New York: Peter Lang, 1993).

29. Lauren Berlant, "The Theory of Infantile Citizenship," Public Culture 5:3 (1993), p. 407.

30. For an excellent analysis of this issue, see Arjun Appadurai, "Patriotism and Its Futures," Public Culture 5:3 (1993), pp. 411–429.

31. Stuart Hall, "What is this 'Black' in Popular Culture?" in Gina Dent, Ed., Black Popular Culture (Seattle: Bay Press, 1992), p. 22.

32. For instance, see Jim Collins, Architectures of Excess (New York: Routledge, 1995).

33. Edward Soja and Barbara Hooper, "The Spaces that Difference Makes—Some Notes On the Geographical Margins of the New Cultural Politics," in Michael Keith and Steve Pile, Eds., Place, and the Politics of Identity (London: Routledge, 1993), p. 192.

34. Michel Foucault, "Of Other Spaces," Diacritics 16:1 (Spring 1986), p. 22.

35. One of the most forceful expressions of this position can be found in Lawrence Grossberg, We Gotta Get Out of This Place (New York: Routledge, 1992); see also Stuart Hall, "Cultural Studies and Its Theoretical Legacies," in Grossberg, et al., Eds., Cultural Studies (New York: Routledge, 1992), pp. 277–286; Lawrence Grossberg, "The Formation of Cultural Studies: An American in Birmingham," Strategies No. 2 (1989), pp. 114–149.

36. Cultural studies has spawned an ongoing internal debate about a host of issues central to the rather disparate field. While it is impossible to cite this literature in any kind of extensive fashion, one classic example can be found in Meghan Morris, "Banality in

Cultural Studies," *Discourse* 10:2 (1988), pp. 3–29. More recent critical interventions can be seen in Stanley Aronowitz, *Roll Over Beethoven: Return of Cultural Strife* (Hanover, NH: University Press of New England, 1993). See also selected articles in: Sarah Franklin, Celia Lury, and Jackie Stacey, Eds., *Off-Centre: Feminism and Cultural Studies* (London: HarperCollins, 1991); Simon During, Ed., *The Cultural Studies Reader* (New York: Routledge, 1993); Valda Blundell, John Shepherd, and Ian Taylor, Eds., *Relocating Cultural Studies* (New York: Routledge, 1993). For some recent postcolonial criticisms of the racial and ethnocentric bias in British cultural studies, see Bill Schwarz, "Where is Cultural Studies?" *Cultural Studies* 8:3 (October 1994), pp. 377–93; Paul Jones, "The Myth of 'Raymond Hoggart': On 'Founding Fathers' and Cultural Policy," *Cultural Studies* 8:3 (October 1994), pp. 394–416.

37. See Chantal Mouffe, *The Return of the Political* (London: Verso, 1993), p. 8.

38. Cornel West, "America's Three Fold Crisis," *Tikkun* 9:2 (1994), p. 42.

39. Henry A. Giroux, *Disturbing Pleasures* (New York: Routledge, 1994).

40. In this instance, Worth is criticizing the work of Elizabeth Ellsworth. See Fabienne Worth, "Postmodern Pedagogy in the Multicultural Classroom: For Inappropriate Teachers and Imperfect Spectators," *Cultural Critique* No. 25 (Fall 1993), pp. 7–8.

41. Sharon Todd in her devastating critique of Elizabeth Ellsworth's essay, "Why Doesn't This Feel Empowering," points out that Ellsworth's essay not only "tends toward an out-and-out evasion of authority," but her project is not "supported by any analysis of concrete textual examples, but rather constructed out of her own experience in the classroom." The notion that a student's voice can be fashioned rather than merely discovered out of the available discourses that feminist teachers bring to the classroom seems to be lost on Ellsworth. See Sharon Todd, "Psychoanalytic Questions, Pedagogical Possibilities, and Authority," *The Review of Education/Pedagogy/Cultural Studies* 17:1 (1995), pp. 1–16.

CHAPTER FIVE:
TALKING HEADS AND RADIO PEDAGOGY: MICROPHONE POLITICS AND THE NEW PUBLIC INTELLECTUALS

1. Under pressure from Democrats and the press, Newt has not renewed his teaching contract. He has also refused the exorbitant $1.5 million advance offered by the conservative publishing empire owned by Rupert Murdoch. But this should not

raise doubts about Gingrich's skills at self-promotion or his infatuation with electronic media technology to promote himself and his public agenda.

2. Adolph Reed Jr., "Looking Backward," *The Nation* (November 28, 1994), p. 654.

3. On the evolution of politics and radio, see Edward W. Chester, *Radio, Television and American Politics* (New York: Sheed and Ward, 1969); Murray Levin, *Talk Radio and the American Dream* (Cambridge: Lexington Books, 1987); Thomas Patterson, *Out of Order* (New York: Knopf, 1993); Michael Kazin, *The Populist Persuasion* (New York: Basic Books, 1995); Peter Laufer, *Inside Talk Radio* (New York: Brick Lane Press, 1995).

4. Karen N. Peart, "Congress Tunes In," *Scholastic Update* 126:5 (November 5, 1993), pp. 20–21.

5. J. Hoberman, "Rush to Stern," *Artforum* (April 1995), p. 34.

6. John W. Kennedy, "Mixing Politics and Piety," *Christianity Today* 38:9 (August 15, 1994), p. 42.

7. Cited in Jonathan Freedland, "The Right Stuff," *The Guardian* (January 31, 1995), p. T2.

8. Limbaugh has become a one-man media industry by mer-chandising himself in a slew of products that include T-shirts, video tapes, golf hats, etc. His self-promotion efforts are almost legendary and include a TV show,

newsletter, and his best-selling books: *The Way Things Ought to Be* (Pocket Books, 1992); *See, I Told You So* (Pocket Books, 1994). One of the more interesting book length commentaries on Limbaugh can be found in Steven Randall, Jim Naureckas, and Jeff Cohen, *The Way Things Aren't* (New York: The New Press, 1995); see also, Thomas Byrne Edsall," America's Sweetheart," *New York Review of Books* 41:16 (October 6, 1994), pp. 6–10.

9. Jonathan Freedland, "The Right Stuff," *The Guardian* (January 31, 1995), p. T2.

10. See Alan Lupo, "When Democracy Gives Way to Talkmaster Tyranny," *Boston Globe* (February 16, 1993), p. 15. Lupo argues that talk radio gives rise to what he calls a "mobocracy." Richard L. Berke, "Poll Says Conservatives Dominate Talk Radio," *New York Times* (July 16, 1993), p. A12; Thomas Byrne Edsall writing in *New York Review of Books* goes so far as to claim that "for the past two years, Rush Limbaugh III has done more to shape the tone of national politi-cal discussion than any member of the House and Senate, than any cabinet level appointee, than the chairmen of both the Democratic and Republican parties or the anchors of the major network news broadcasts." See Thomas Byrne Edsall, "America's Sweetheart," *New York Review of Books* 41:16 (October 6, 1994), p. 6.

11. Editors, "Vox Populi," *The Nation* 256:8 (March 1, 1993), p. 256.

12. Lewis Lapham, "Reactionary Chic," *Harper's* (March 1995), pp. 32–33.

13. David Stout, "Broadcast Suspensions Raise Free-Speech Issues," *New York Times* (April 30, 1995), p. 28.

14. Larry Smith, "Hate Talk: Talk Radio That's All Right, All the Time," *Extra!* (March/April 1995), p. 23.

15. John Tierney, "A San Francisco Talk Show Takes Right-Wing Radio to a New Dimension," *New York Times* (February 14, 1995), p. A10.

16. Hamblin cited in Richard Corliss, "Look Who's Talking," *Time* 145:3 (January 23, 1995), p. 22.

17. John Tierney, "A San Francisco Talk Show Takes Right-Wing Radio to a New Dimension," op. cit., p. A10.

18. Cited in Ethan Waters, "The Double Life of Spencer Hughes," *Details* (June 1995), p. 139.

19. Leslie Jorgensen, "AM Armies," *Extra!* (March/April 1995), p. 20.

20. Leslie Jorgensen, p. 21.

21. Jim Naureckas, "50,000 Watts of Hate: Bigotry is Broadcast in ABC Radio's Flagship," *Extra!* (January/February 1995), p. 20.

22. Gail Pennington, "KETC Fires Host of New TV Show," *St. Louis Dispatch* 17:28 (January 28, 1995), p. A4.

23. Invoking the image of the unwashed hoards, Hughes stated "They're letting Hispanics bring 10 and 12 folks over, without green cards, stay in the buildings, open up businesses, get jobs, get on the welfare system, and there seems to be a tolerance [for this by the community]." Cited in Kenneth Jost, "Talk Show Democracy," *Congressional Quarterly Researcher* 4:16 (April 29, 1994), p. 379.

24. For a portrait of who makes up Limbaugh's constituency, see the excellent analysis by Stephen Talbot, "Wizard of Ooze," *Mother Jones* (May/June 1995), pp. 41–43.

25. Stephen Talbot, ibid., p. 43.

26. Steven V. Roberts, "Church Meets State," *U.S. News & World Report* (April 25, 1995), p. 28.

27. Ralph Reed's recent speech before a Capitol press conference in which he introduced the "Contract with the American Family" is excerpted in "Family Values II," *Boston Sunday Globe* Focus Section (May 21, 1995), pp. 45–46.

28. Times Mirror Center for the People and The Press, "The Vocal Minority in American Politics," (July 1993).

29. Kenneth Jost, "Talk Show Democracy," *Congressional Quarterly Researcher* 4:16 (April 29, 1994), p. 364.

30. Robert LaFranco, "Radio Redux," *Forbes Magazine* 153:8 (April 11, 1994), p. 60. For an insightful analysis of how American Christian fundamentalists are employing popular culture and media literacy skills to enlist youth into their organizations, see Heather Hendershot, "Shake, Rattle, & Roll: Production and Consumption of Fundamentalist Youth Culture," *Afterimage*, 22:7/8 (1995), pp. 19–22.

31. For an interesting analysis of this issue, see Rinaldo Walcott, "'Yeh Ho': Youth, Music and Cultural Politics," *Border/Lines* No. 34/35 (1994), pp. 59–63.

32. Cited in Kenneth Jost, "Talk Show Democracy," p. 365.

33. Limbaugh cited in Sherri Paris, "In Bed with Rush Limbaugh," *Tikkun* 1:2 (1995), p. 35.

34. This is a belief also shared by pollsters. See C. Richard Hofstetter, Mark Donovan, Melville Klauber, Alexandra Cole, Carolyn Huie, and Toshiyuki Yuasa, "Political Talk Radio: A Stereotype Reconsidered," *Political Research Quarterly* 47:2 (June 1994), pp. 467–479.

35. Molly Ivins argues that she has to take Rush Limbaugh seriously not because he is an offensive right-winger but "because he is one of the few people addressing a large group of disaffected people in this country." In Molly Ivins, "Lyin' Bully," *Mother Jones* (May/June 1995), p. 37.

36. Another example of the disdain that traditional media people have for talk radio can be seen in Thomas Byrne Edsall's review of Rush Limbaugh in a recent issue of *New York Review of Books*. Edsall argues that "[talk radio] lacks the corrective and ultimately enlarging presence of contrary viewpoints and external criticism; it has no potential for serious conflict or debate. Just as it is possible for people to 'dissolve' into a football game or MTV, it is now possible to dissolve into Pat Robertson's vision of the world on the Family Channel." Thomas Byrne Edsall, "America's Sweetheart," *New York Review of Books* 41:16 (October 6, 1994), p. 9. Edsall sounds as if he is suffering from a Frankfurt School hangover regarding popular culture. This is worse than overkill; it is a misrepresentation of both the actuality and the potential that talk radio holds for enlarging the sphere of democratic struggle. There is an increasing body of literature that views the interaction between talk show hosts and audiences in far more complex ways. See, for example, the study by C. Richard Hofstetter, et al., op. cit., who found that talk show listeners respond actively to such shows for a number of reasons, one of which is to express

disagreement with a guest or host. Other factors include being interested in political events, etc.

37. Richard Turner, "Don't Touch That Dial," *New York* (April 3, 1995), p. 26.

38. The quote and the general line of reasoning are taken from Robert Stam and Ella Shohat, "Contested Histories: Eurocentrism, Multiculturalism, and the Media," in David Theo Goldberg, Ed., *Multiculturalism: A Critical Reader* (Cambridge, MA: Basil Blackwell, 1994), p. 319.

39. Robert Stam and Ella Shohat, "Contested Histories," p. 318.

40. Fashion discourses always seem to breed bad topologies. In the case of current analysis about black intellectuals, the focus of the moment seems to be based on defining which black intellectuals carry more cultural, public, and popular currency than others. See Greg Thomas, "The Black Studies War," *Village Voice* (January 17, 1995), pp. 23–29. Of course, any attempt to laud blacks as critical intellectuals always seems to breed venom from conservatives. For an especially vile example of such an attack on Cornel West, see Leon Wieseltier, "All and Nothing at All," *The New Republic* (March 6, 1995), pp. 31–36.

41. Michael Bérubé, "Public Academe," *The New Yorker* (January 9, 1995), pp. 73–80.

42. This is not to suggest that progressives emulate the narrow-mindedness and simplicity of Rush Limbaugh, but take seriously what it means to take a position rather than making the articulation of many positions the point of the discourse. One striking example of a progressive talk radio broadcaster who does not flinch on defending liberalism as a political project while taking seriously the pop culture of the baby boomers is Tom Leykis. For a comment on Leykis's rising popularity, see Micah L. Sifry, "A Kick-Ass Liberal," *The Nation* (April 10, 1995), pp. 482–486.

43. Robert S. Boynton, "The New Intellectuals," *The Atlantic Monthly* (March 1995), pp. 53–70.

44. For an excellent analysis of Martin Luther King Jr. as a public intellectual linked to building a critical public sphere, see Houston A. Baker Jr., "Critical Memory and the Black Public Sphere," *Public Culture* 7:1 (Fall 1994), pp. 3–35.

45. Jon Wiener, "Looking for the Left's Limbaugh," *Dissent* (Spring 1995), p. 163.

46. I am well aware that there are many authors who take up the media, including talk radio. For instance, see the recent work of Michael Kazin, *The Populist Persuasion* (New York: Basic Books, 1995); and John Fiske's *Media Matters* (Minneapolis: University of

Minnesota Press, 1994). What is missing from these works is a sustained analysis of the pedagogical practices employed by the media. Raymond Williams refers to such practices as the media's function as an institution of permanent education. What is at stake here is expanding the pedagogical implications of the political nature of the media while simultaneously making the pedagogical more political by challenging conventional wisdom about what counts as a site of learning outside of the classroom. Of course, cultural studies theorists who do make the connection between the political and the pedagogy of the popular would include, among others, bell hooks, Douglas Kellner, Peter McLaren, Lawrence Grossberg, Michele Wallace, David Trend, Carol Becker, and Michael Dyson.

47. Hightower cited in both instances in Jon Wiener, "Looking for the Left's Limbaugh," *Dissent* (Spring 1995), p. 163.

48. Cited in Micah Sifry "A Kick-Ass Liberal," *The Nation* (April 10, 1995), p. 483.

49. Boyd cited in Denise Crittendon, "It's More Than Just Talk," *Kansas City Star* (June 29, 1995), p. F.3.

50. For an analysis of Black Liberation Radio, see John Fiske, *Media Matters* (Minneapolis: University of Minnesota Press, 1995).

51. One example of dismissing talk radio as a tool of right-wing crazies and self-serving profit mongers was expressed by David Nyhan in a recent editorial in the *Boston Globe*. Responding to the Free Speech award given to G. Gordon Liddy, Nyhan writes:

> When gum-flappers brazenly handed an "honor" to rabble-rouser G. Gordon Liddy, voicer of shoot-to-kill imprecations against federal agents, the talk-show posse was revealed for what it mainly is: a gang that would justify any kind of outrageous conduct if the ratings are high enough.

David Nyhan, "Hurting? Mad? Sorry, Term Limits Aren't the Answer," *Boston Globe* (Wednesday, May 24, 1995), p. 19. It is precisely this type of political overkill that obscures both the complexity of the talk radio field and the possibilities for using it as a forum for critical learning, dialogue, and exchange.

CHAPTER SIX: LICENSING BIGOTRY WITHOUT BEING POLITICALLY CORRECT

1. Jim Collins, *Architectures of Excess: Cultural Life in the Information Age* (New York: Routledge, 1995), p. 149.

2. For a detailed analysis of right-wing theorists, foundations, and issues that characterize the anti–political correctness movement, see Ellen Messer-Davidow,

"Manufacturing the Attack on Liberalized Education," *Social Text* No. 36 (Fall 1993), pp. 40–80.

3. Arthur Schlesinger Jr., *The Disuniting of America* (Knoxville, TN: Whittle Press, 1992).

4. Fabienne Worth, "Postmodern Pedagogy in the Multicultural Classroom: For Inappropriate Teachers and Imperfect Spectators," *Cultural Critique*, No. 25 (Fall 1993), p. 5.

5. Richard Bernstein, *Dictatorship of Virtue: Multiculturalism and the Battle for America's Future* (New York: Random House, 1994), p. 225.

6. It is worth noting how the genealogy of the term "politically correct" has been completely ignored by both the popular press and right-wing critics. In its more fashionable usage in the 1960s, the term had an ironic connotation used by leftists themselves to criticize the ideological rigidity and excessiveness of certain radical groups and individuals.

7. Toni Morrison, "Nobel Lecture 1993," *Dictionary of Literary Biography*, James W. Hipp, Ed., (Detroit: Gale Research, Inc., 1994), p. 5.

8. Laura Fraser, "Tyranny of the Media Correct: The Assault on the New McCarthyism," *Extra!* 4:4 (1991), p. 6.

9. Patrick Buchanan, "Losing the War for America's Culture?" in *Culture Wars*, Richard Bolton, Ed., (New York: The New Press, 1992), p. 33.

10. Charles Krauthammer, "U.S. Socialism's Dying Gasps," *Cincinnati Enquirer*, December 26, 1990, p. B2.

11. Ethan Waters, "Double-Talk Radio," *Details* (June 1995), p. 139.

12. Dinesh D'Souza, *Illiberal Education: The Politics of Race and Sex on Campus* (New York: The Free Press, 1991), p. 182.

13. Radical democracy in this context refers to a participatory politics based on the distribution of power across all spheres of society. It also supports a notion of political community rooted in principles of liberty, freedom, and equality that respect "diversity and makes room for different forms of individuality." Chantal Mouffe, "Citizenship and Political Identity," *October*, No. 61 (Summer 1992), p. 30; Chantal Mouffe, *The Return of the Political* (London: Verso Press, 1993); see also Stanley Aronowitz, "The Situation on the Left in the United States," *Socialist Review* 23:2 (1994), pp. 5–80.

14. See for example, Henry L. Gates Jr. "The Master's Pieces: On Canon Formation and the African-American Tradition," *The South Atlantic Quarterly* 89:1 (1990), pp. 191–199.

15. Sarah Diamond, "Notes on Political Correctness," *Z Magazine* (July/August, 1993), p. 32.

16. Rosa Ehrenreich, "What Campus Radicals? The P.C. Undergrad Is a Useful Specter," in *Are You Politically Correct: Debating America's Cultural Standards*, F. Beckwith and M. Bauman, Eds. (New York: Prometheus Books, 1993), p. 33.

17. Stephen Balch, "A Symposium on Freedom and Ideology: the Debate about Political Correctness," *The Civic Arts Review* 5:1 (1992), p. 5.

18. Allan Bloom, *The Closing of the American Mind* (New York: Simon & Schuster, 1987).

19. Stanley Aronowitz and Henry A. Giroux, *Education Still Under Siege* (Westport, CT: Bergin and Garvey, 1993), p. 167.

20. Dinesh D'Souza, *Illiberal Education: The Politics of Race and Sex on Campus* (New York: The Free Press, 1991); Roger Kimball, *Tenured Radicals*, (New York: Harper and Row, 1990); John Searle, "The Storm Over the University," *The New York Review of Books* 37:19 (1990), pp. 34–42.

21. T. Short, "Diversity and Breaking the Disciplines: Two New Assaults on the Curriculum," in *Are You Politically Correct: Debating America's Cultural Standards*, F. Beckwith and M. Bauman, Eds. (New York: Prometheus Books, 1993), p. 92.

22. Cited in Sarah Diamond, "Notes on Political Correctness," *Z Magazine* (July/August 1993), p. 92.

23. Christopher Newfield, "What Was Political Correctness? Race, the Right and Managerial Democracy in the Humanities," *Critical Inquiry* 19 (Winter 1995), p. 332.

24. Christopher Newfield, op. cit., p. 333.

25. Sarah Diamond, op. cit., p. 33.

26. John Taylor, "Are You Politically Correct?" in *Are You Politically Correct: Debating America's Cultural Standards*, F. Beckwith and M. Bauman, Eds. (New York: Prometheus Books, 1993), p. 17.

27. Silber cited in Jamin Raskin, "The Great PC Cover-Up," *California Lawyer* (February, 1994), p. 69.

28. This slavish accolade was written by Jeff Jacoby, a former work-study student of John Silber's who is now a columnist for the *Boston Globe*. The quote appeared in Jeff Jacoby, "The Government's Assault on Higher Education," *Boston Globe*, June 1, 1995, p. 19.

29. Silber cited in Jacoby, op. cit., p. 19.

30. William Kerrigan, "The Falls of Academe," in *Wild Orchids and Trotsky: Messages from American Universities*, Mark Edmunson, Ed. (New York: Penguin, 1993), 167.

31. Paglia cited in Taylor, op. cit., p. 19.

32. Robert Rozenzweig, "A Symposium on Freedom and Ideology: The Debate About Political Correctness," *The Civic Arts Review* 5:1 (1992), p. 8.

33. John Fiske, *Power Plays, Power Works* (London: Verso, 1994), p. 13.

34. Toni Morrison, "Unspeakable Things Unspoken: The Afro-American Presence in American Literature," *Michigan Quarterly Review* 28:1 (1987), p. 8. Morrison amplifies this argument in her brilliant treatise on the construction of whiteness in the literary imagination. See Toni Morrison, *Playing in the Dark: Whiteness and the Literary Imagination* (Cambridge: Harvard University Press, 1992).

35. Stanley Aronowitz, "A Different Perspective on Educational Equality," *The Review of Education/Pedagogy/Cultural Studies* 16:2 (1994), p. 148.

36. See the insightful discussion of this issue in Judith Frank, "'To Sir With Love': National Pedagogy in the Clinton Era," in Michael Bérubé and Cary Nelson, Eds., *Higher Education Under Fire* (New York: Routledge, 1995), pp. 259–275.

37. Gerald Graff, "Academic Writing and the Uses of Bad Publicity," in *Eloquent Obsessions*, Ed. Marianna Torgovnick (Durham, NC: Duke University Press, 1994), p. 215.

38. For an excellent analysis of how such risk taking emerges from and addresses the changing economic conditions in which the United States finds itself, see Joshua Cohen and Joel Rogers, "After Liberalism: Republicans are Wrecking the Place; Democrats are Watching. What Should the Rest of Us Do?" *The Boston Review* 20:2 (April/May 1995), pp. 20–23.

39. Catherine Stimpson, "Can Things Ever be Perfectly Correct?" *College Literature* 21:3 (1994), p. 197.

CHAPTER SEVEN:
THE MILK AIN'T CLEAN:
NATIONAL IDENTITY AND
MULTICULTURALISM

1. Judith Squires, "Editorial" *New Formations*, No. 24 (Winter 1994), p. v.

2. Some major critiques that center on the lack of specificity in some of the writing on diaspora, immigration, and postcolonialism can be found in: Inderpal Grewal and Caren Kaplan, "Introduction: Transnational Feminist Practices and Questions of Postmodernity," in Inderpal Grewal and Caren Kaplan, Eds., *Scattered Hegemonies* (Minneapolis: University of Minnesota Press, 1994), pp. 1–33; Ien Ang, "On Not Speaking Chinese: Postmodern Ethnicity and the Politics of Diaspora," *Social Formations*, No. 24 (March 1995), pp. 1–18; Craig Calhoun, "Nationalism and Civil Society: Democracy, Diversity, and Self-Determination," in Craig Calhoun, Ed., *Social Theory and the Politics of Identity* (Cambridge, MA: Basil Blackwell, 1994), pp. 304–335; Benita Parry, "Signs of Our Times: A Discussion of

Homi Bhabha's The Location of Culture," Third Text, Nos. 28/29 (Autumn/Winter 1994), pp. 5–24. Benita Parry, in particular, offers an important analysis regarding the theoretical pitfalls in a politics of representation in which notions of diaspora, hybridity, and difference serve to subsume "the social to textual representation [and represent] colonialism as transactional rather than conflictual." Parry, ibid., p. 12.

3. Arjun Appadurai, "Patriotism and Its Futures," Public Culture 5:3 (1993), p. 417.

4. Appadurai, "Patriotism and Its Futures," p. 418.

5. Both of these quotes are take from Judith Squires, "Editorial," New Formations, No. 24 (Winter 1994), p. vi.

6. Micaela di Leonardo echoes (though a bit too sarcastically) the need to be cautious about appropriating a transnational discourse at the expense of taking seriously the political presence and impact of the nation-state. She writes:

> In this era of self-congratulatory postmodern "transnational identity," of thinking "beyond the nation," it is important to stress the continuing existence of states with courts, prisons, standing armies, policed borders, and financial and trade politics—and particularly, the existence of what is still the world's most powerful imperial nation. States are still meaningful, the only entities that can discipline international capital—if their inhabitants aren't too busy "thinking transnationally" to pressure them to do so.

Cited in Micaela di Leonardo, "White Ethnicties, Identity Politics, and Baby Bear's Chair," Social Text 12:4 (1995), p. 166.

7. Stuart Hall, "Culture, Community, Nation," Cultural Studies 7:3 (October 1993), pp. 353.

8. This issue is discussed in Will Kymlicka, "Misunderstanding Nationalism," Dissent (Winter 1995), pp. 130–137.

9. The literature on nationalism and national identity is much too voluminous to cite here, but excellent examples can be found in Benedict Anderson, Imagined Communities (London: Verso, 1991); Partha Chatterjee, The Nation and Its Fragments (Princeton, NJ: Princeton University Press, 1993); Homi Bhabha, Ed. Nation and Narration (New York: Routledge, 1990); Edward Said, Culture and Imperialism (New York: Alfred K. Knopf, 1993); Andrew Parker, Mary Russo, Doris Sommer, and Patricia Yaeger, Eds., Nationalisms and Sexualities (New York: Routledge, 1992); Etienne Balibar and Immanuel Wallerstein, Race, Nation, Class: Ambiguous Identities (London: Verso, 1991). Some excellent recent sources can be found in: Craig Calhoun, Ed., Social Theory and the

Politics of Identity (New York: Blackwell, 1994).

10. Paul Gilroy, *The Black Atlantic: Modernity and Double Consciousness* (Cambridge: Harvard University Press, 1993), p. 3.

11. Benedict Anderson, *Imagined Communities*, 2nd edition (London: Verso, 1991), p. 6.

12. Homi K. Bhabha, "A Good Judge of Character: Men, Metaphors, and the Common Culture," in Toni Morrison, Ed., *Race-ing Justice, Engendering Power: Essays on Anita Hill, Clarence Thomas, and the Construction of Social Reality* (New York: Pantheon, 1992), p. 233.

13. Gerald Graff and Bruce Robbins, "Cultural Criticism," in Stephen Greenblat and Giles Gunn, Eds., *Redrawing the Lines* (New York: MLA, 1992), p. 434.

14. For a critique of both of these positions, see Ien Ang, "On Not Speaking Chinese: Postmodern Ethnicity and the Politics of Diaspora," *New Formations*, No. 24 (Winter 1994), pp. 1–18; Ghassan Hage, "Locating Multiculturalism's Other: A Critique of Practical Tolerance," *New Formations*, No. 24 (Winter 1994), pp. 19–34.

15. I take up the issue of Hollywood portrayal of racism and violence in Henry A. Giroux, "Racism and the Aesthetic of Hyper-real Violence: *Pulp Fiction* and Other Visual Tragedies," chapter two of this volume.

16. Pat Buchanan quoted in Charles Krauthammer, "The Real Buchanan is Surfacing," *Cincinnati Enquirer*, March 3, 1990, p. A4.

17. Rush H. Limbaugh III, *See, I Told You So* (New York: Pocket Books, 1993), p. 26.

18. For a brilliant analysis of this phenomenon, especially the marketing of Beavis and Butt-head, see Douglas Kellner, *Media Culture: Cultural Studies, Identity, and Politics— Between The Modern and the Postmodern* (New York: Routledge, 1995).

19. Homi K. Bhabha, "Beyond the Pale: Art in the Age of Multicultural Translation," *Kunst and Museum Journal* 5:4 (1994), p. 15.

20. John B. Judis and Michael Lind, "For A New Nationalism," *The New Republic* (March 27, 1995), p. 21.

21. This is paraphrased from Stuart Hall, "Culture, Community, Nation," *Cultural Studies* 7:3 (October 1993), p. 357.

22. Richard Rorty, "The Unpatriotic Academy," *New York Times*, Op-Ed Section, (February 13, 1994), p. E15.

23. Richard Rorty, "The Unpatriotic Academy," p. E15.

24. David Theo Goldberg, *Racist Culture* (Cambridge, MA: Basil Blackwell, 1993), p. 7.

25. David Theo Goldberg, ibid. p. 7.

26. Stuart Hall, "Cultural Identity and Diaspora," in Jonathan

Rutherford, Ed., *Identity, Community, Culture, Difference* (London: Lawrence & Wishart, 1990), p. 225.

27. Jonathan Rutherford, "A Place Called Home: Identity and the Cultural Politics of Difference," in Jonathan Rutherford, Ed., *Identity, Community, Culture, Difference,* p. 17.

28. Will Kymlicka, "Misunderstanding Nationalism," *Dissent* (Winter 1995), p. 132.

29. Craig Calhoun, "Nationalism and Civil Society: Democracy, Diversity, and Self-Determination," in Craig Calhoun, Ed., *Social Theory and the Politics of Identity* (New York: Blackwell, 1994), p. 311.

30. David Goldberg, "Introduction: Multiculturalism Conditions," in David Theo Goldberg, Ed., *Multiculturalism: A Reader* (Cambridge, MA: Basil Blackwell, 1994).

31. Craig Calhoun, "Nationalism and Civil Society: Democracy, Diversity, and Self-Determination," p. 327.

32. Homi Bhabha, "Beyond the Pale: Art in the Age of Multicultural Translation," *Kunst and Museum Journal* 5:4 (1994), p. 22.

33. David Theo Goldberg, "Introduction: Multicultural Conditions," in David Theo Goldberg, Ed., *Multiculturalism: A Critical Reader* (Cambridge, MA: Basil Blackwell, 1994), p. 15.

INDEX

INDEX

River's Edge (film), 33, 34–35, 39
Robertson, Pat, 149
Rorty, Richard, and new nationalism, 195–199
Ross, Andrew, 123
Rozenzweig, Robert, 176

Said, Edward, 107, 127, 128, 212n
Salem, Yousef, 105
Savage, Michael, 147
Schindler's List (film), 56–57, 60, 62
Schneider, Peter, 106
schools, 91, 121, 122
 See also education
Schwarzenegger, Arnold, 61, 85
Scott, Joan W., 120, 224n
Searle, John, 173
Sells, Laura, and Disney, 95, 219n
Shaheen, Jack, 105
Shohat, Ella, 154
Silber, John, 7
 on political correctness, 175
Simpson, O.J., 66
Sklar, Holly, 67
Slacker (film), 21, 33, 36–38, 39
Smoodin, Eric, on Disney, 94–95, 111
Snoop Doggy Dogg, 27
social criticism, 180, 197
Song of the South (film), 104, 106, 222n
space, politics of, 132–133
Speilberg, Steven, 62
Squire, Judith, 186
Stallone, Sylvester, 85
Stam, Robert, 154
standards, in education, 171–174, 181
Stern, Howard, 143, 148, 194
Stimpson, Catharine, 184
Stone, Alan A., 216n
Stone, Oliver, 62, 63, 86
Sugar Hill (film), 42, 55
symbolic violence, 62–63
Talbot, Stephen, 148
talk radio, 141–161, 230–231n

and politics, 143–145
and progressives, 152–161, 231n
and racism, 147–149
and violence, 146–147
and youth market, 150–151
Tarantino, Quentin, 70–82
 and race, 79–82
 and violence, 77–79
Taubin, Amy, 79
Taylor, John, 175
teaching. See education; pedagogy
television, and violence, 58, 60
Three Little Pigs, The (film), 106
Time magazine, 66
Todd, Sharon, 227n
True Lies (film), 61, 85
True Romance (film), 68, 81, 84
Turner, Richard, on Rush Limbaugh, 154

unemployment, 12, 28
Unforgiven (film), 62, 63

Van Sant, Gus, 34
violence, 28
 in films, 40–46, 83–89
 and identity, 11–12
 kinds of, in films, 59–65
 media coverage of, 56
 and Quentin Tarantino, 77–79
 and racism, 55–88
 and talk radio, 146–147
Virilio, Paul, 31

Walt Disney Company, 89–113
 accountability of, 112–113
 and gender identity, 100–104
 influences of, 92–97
 merchandising of, 92–93,
 97–98, 221n
 movie music of, 99, 105–106
 and pedagogy, 99–101, 107,
 108–113
 and racial stereotypes, 104–107